MEXICO

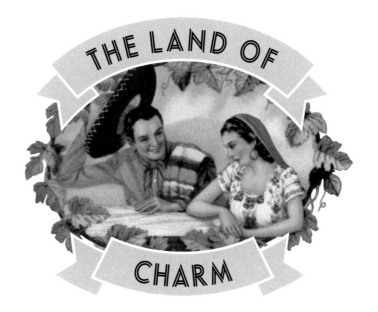

THE LAND OF

CHARM

edited by
MERCURIO LÓPEZ CASILLAS

texts by
MERCURIO LÓPEZ CASILLAS / JAMES OLES

presentation
STEVEN HELLER

EDITORIAL RM MEXICO BARCELONA

MMXXII

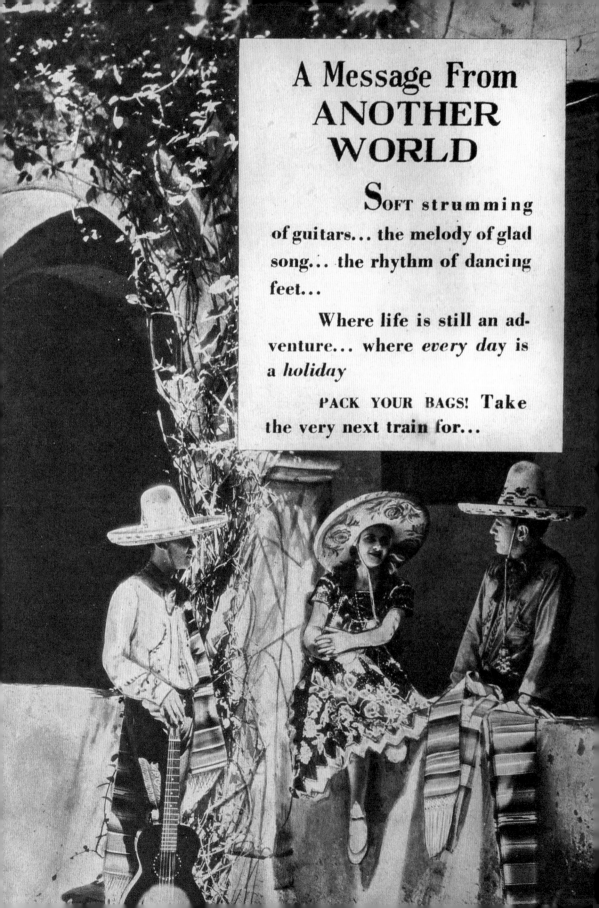

A Message From ANOTHER WORLD

SOFT strumming of guitars... the melody of glad song... the rhythm of dancing feet...

Where life is still an adventure... where *every day* is a *holiday*

PACK YOUR BAGS! Take the very next train for...

Driving
down to
MEXICO

Printed in México

SOUVENIR OF

México

Mr. & Mrs. Jack Rainey

Swedesboro,

New Jersey.

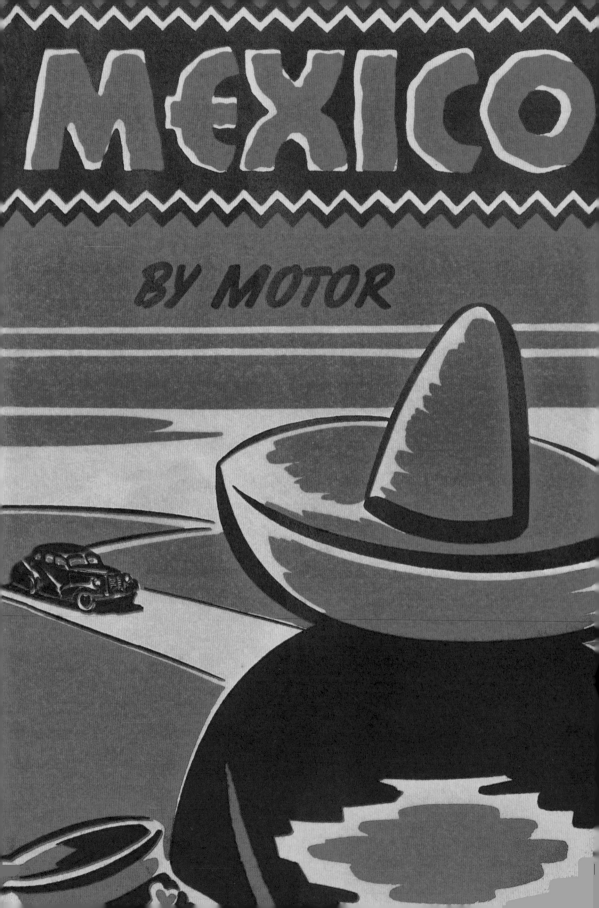

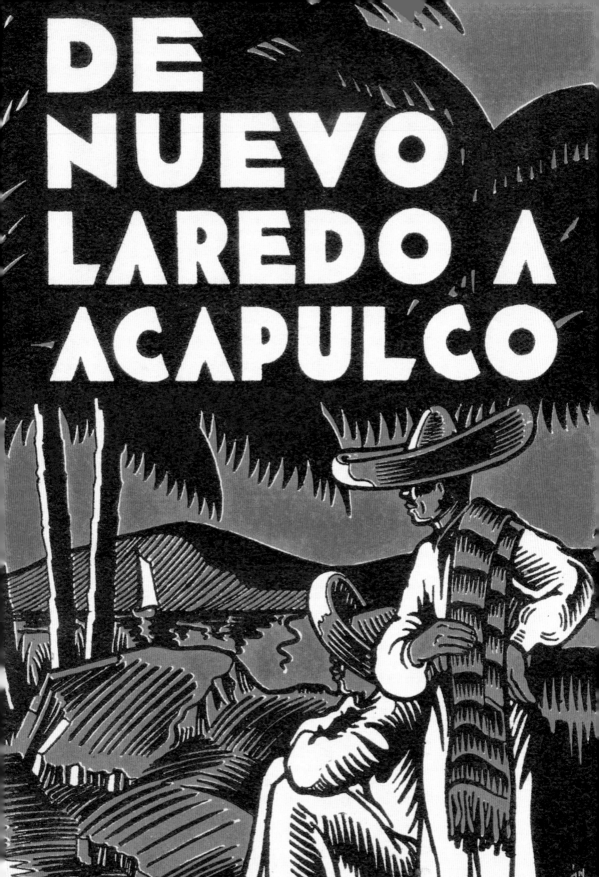

Jimmy writes from MEXICO

SUNSHINE
over the BORDER

by DAVID S. OAKES

Impressions
of a
Visit to Mexico

LOTERIA · NACIONAL

LA DANZA DE LA PLUMA.

A. Gómez R.

ENERO ★ 1938
DOMINGO LUNES MARTES MIÉRCOLES JUEVES VIERNES SÁBADO

DOMINGO	LUNES	MARTES	MIÉRCOLES	JUEVES	VIERNES	SÁBADO
						1
2	3	4	5	6	7	8
9	10	11	12	13	14	15
16	17	18	19	20	21	22
23 30 24 31	25	26	27	28	29	

FEBRERO ★ 1938

DOMINGO	LUNES	MARTES	MIÉRCOLES	JUEVES	VIERNES	SÁBADO
		1	2	3	4	5
6	7	8	9	10	11	12
13	14	15	16	17	18	19
20	21	22	23	24	25	26
27	28					

MARZO ★ 1938

DOMINGO	LUNES	MARTES	MIÉRCOLES	JUEVES	VIERNES	SÁBADO
		1	2	3	4	5
6	7	8	9	10	11	12
13	14	15	16	17	18	19
20	21	22	23	24	25	26
27	28	29	30	31		

ABRIL ★ 1938

DOMINGO	LUNES	MARTES	MIÉRCOLES	JUEVES	VIERNES	SÁBADO
					1	2
3	4	5	6	7	8	9
10	11	12	13	14	15	16
17	18	19	20	21	22	23
24	25	26	27	28	29	30

MAYO ★ 1938

DOMINGO	LUNES	MARTES	MIÉRCOLES	JUEVES	VIERNES	SÁBADO
1	2	3	4	5	6	7
8	9	10	11	12	13	14
15	16	17	18	19	20	21
22	23	24	25	26	27	28
29	30	31				

JUNIO ★ 1938

DOMINGO	LUNES	MARTES	MIÉRCOLES	JUEVES	VIERNES	SÁBADO
			1	2	3	4
5	6	7	8	9	10	11
12	13	14	15	16	17	18
19	20	21	22	23	24	25
26	27	28	29	30		

JULIO ★ 1938

DOMINGO	LUNES	MARTES	MIÉRCOLES	JUEVES	VIERNES	SÁBADO
					1	2
3	4	5	6	7	8	9
10	11	12	13	14	15	16
17	18	19	20	21	22	23
24 31	25	26	27	28	29	30

AGOSTO ★ 1938

DOMINGO	LUNES	MARTES	MIÉRCOLES	JUEVES	VIERNES	SÁBADO
	1	2	3	4	5	6
7	8	9	10	11	12	13
14	15	16	17	18	19	20
21	22	23	24	25	26	27
28	29	30	31			

SEPTIEMBRE ★ 1938

DOMINGO	LUNES	MARTES	MIÉRCOLES	JUEVES	VIERNES	SÁBADO
				1	2	3

OCTUBRE ★ 1938

DOMINGO	LUNES	MARTES	MIÉRCOLES	JUEVES	VIERNES	SÁBADO
						1

NOVIEMBRE ★ 1938

DOMINGO	LUNES	MARTES	MIÉRCOLES	JUEVES	VIERNES	SÁBADO
		1	2	3	4	5

DICIEMBRE ★ 1938

DOMINGO	LUNES	MARTES	MIÉRCOLES	JUEVES	VIERNES	SÁBADO
				1	2	3

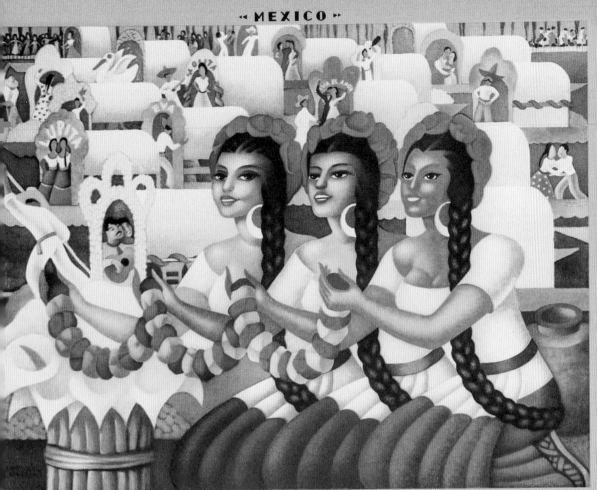

ORGE GONZALEZ CAMARENA

DIA DE LAS FLORES.

FERIAS, COSTUMBRES Y DANZAS DEL MEXICO NUESTRO, VAN ESFUMANDOSE LAMENTABLEMENTE. SURGEN A VECES, DECOLORADAS POR EL TIEMPO, MARCHITAS COMO ESTAMPAS DE VOLUMENES OLVIDADOS, MIXTIFICADAS POR LA INVASION ARROLLADORA DE MODAS EXTRANJERAS.

ACASO, LA FIESTA DE LAS AMAPOLAS EN EL CANAL DE LA VIGA, ES UNA DE LAS POCAS QUE CONSERVAN EL CARACTER Y LA INTENCION, LA FRESCURA Y LA ALEGRIA DE OTROS SIGLOS. EN LAS CANOAS ENFLORADAS DEL VIERNES DE DOLORES, SE APIÑAN EN RAMILLETE SALPICADO DE BRISA, ROSTROS DE MUJER MORENA, CANTADORAS REGIONALES QUE TRIUNFARON EN EL PALENQUE Y EN LOS JARABES, TRASNOCHADORES Y CHARROS, CASTORES FASTUOSOS Y REBOZOS DE SANTA MARIA, TODO SOBRE UN PAISAJE MAÑANERO, PUNTEADO DE SAUCES, JUNTO A LAS GRANJAS DONDE HUMEA EL ATOLE DE MAIZ Y SE DESHOJAN LOS TAMALES CERNIDOS PARA EL DESAYUNO. DUPLICA SU SILUETA BRIOSA EN LAS AGUAS DORMIDAS EL PENCO TORDILLO, QUE MUEVE CON DONAIRE, UN RANCHERO VENTUROSO. ONDEAN LAS BANDEROLAS DE PAPEL EN EL TECHO DE PAJA DE LOS JACALES Y LA MUSICA POPULAR, JUGUETEA EN LAS CUERDAS DEL GUITARRON, EN EL ARPA QUE LLEGO DE SANTA ANITA Y EN EL VIOLIN DE OCOTE, QUE PARECE LLORAR ENTRE LAS MANOS INDIGENAS. CORONAS DE AMAPOLAS ENTRE EL PELO BRILLANTE, PETALOS DE SANGRE EN LAS BOCAS HUMEDAS.

VIERNES DE DOLORES, QUE GONZALEZ CAMARENA, EN UN ALARDE GENIAL DE COMPOSICION, DE RITMO Y EQUILIBRIO, APRISIONA EN ESTE CUADRO, PONIENDO PERFUME VIEJO Y VISION ACTUAL, EN GALLARDA Y PERFECTA ESTILIZACION.

1938 NOVIEMBRE 1938

DOM.	LUN.	MAR.	MIE.	JUE.	VIE.	SAB.
Luna Llena Dia 7	C. Menguante Dia 14	**1** Todos los Santos	**2** Fieles Difuntos	**3** San Hilario	**4** San Carlos Borromeo	**5** San Zacarias
6 San Leonardo	**7** San Ernesto	**8** San Severiano	**9** San Teodoro	**10** S. Andres Av.	**11** San Martin	**12** San Aurelio
13 San Diego	**14** San Serapion	**15** San Leopoldo	**16** San Fidencio	**17** San Gregorio	**18** San Hesiquio	**19** San Ponciano
20 San Felix	**21** San Mauro	**22** Sta. Cecilia	**23** San Clemente	**24** San Crisogono	**25** Sta. Catarina	**26** San Conrado

"LUCES DE REFLECTOR"

REVISTA
DE
REVISTAS
EL·SEMANARIO·NACIONAL

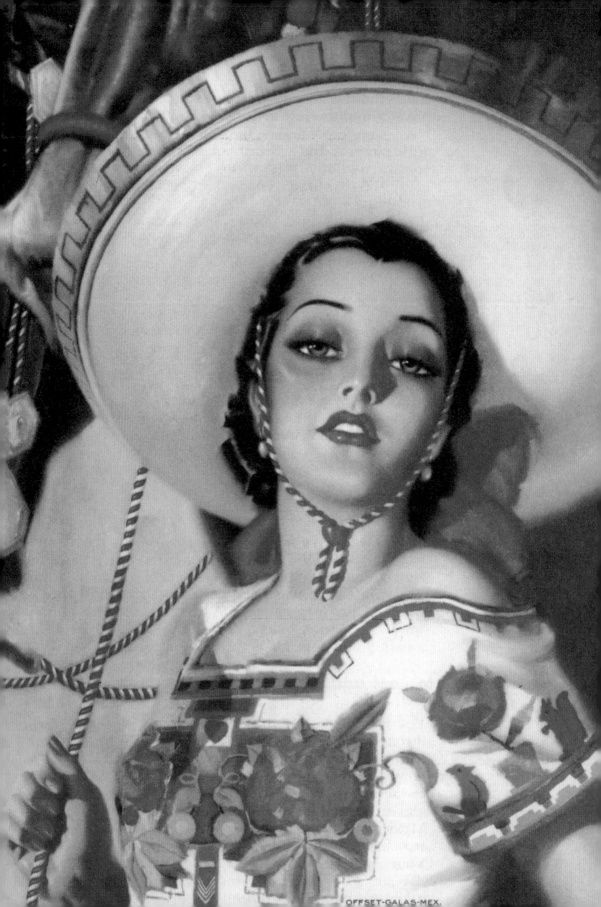

OFFSET-GALAS-MEX.

Travel via National Railways of Mexico

EUGENÍA DE LLORCA

VEA

Nº 211
NOVIEMBRE 26 DE 1948
$1.⁰⁰
MEXICO, D.F.

A.Herrera
MÉX.

01 *Vea*, period 2, no. 211, Mexico, November 26, 1948
Cover: Eugenia de Llorca, photo by Armando Herrera <small>RR</small>

VIVA MEXICO! VIVA GRAPHIC DESIGN!

STEVEN HELLER

After four years of Donald Trump's vicious anti-Mexican jingoism, it is a welcome relief to refocus my attention on the Mexico known for its prolific and abundant modern art heritage on a par with early-twentieth century Europe and mid-century United States; the Mexico that also inspired an impressive legacy of political and social (and socialist) design commentary and the progressive periodicals (*revistas*) that published them; the Mexico that produced a wealth of printed material that can stand beside any of the innovative graphic design and typography from the past. From the treasure trove of the Mexican avant-garde—exhaustively chronicled in the 2010 book and exhibition *México Ilustrado: Libros, Revistas y Carteles 1920–1950*—to a wellspring of quotidian magazines, newspapers, and travel and tourist books, many designed with swagger and flair, Mexico is only now receiving its overdue share of notice in art and design histories. And with this book, *Mexico. The Land of Charm*, much of the nation's otherwise ephemeral graphic, photographic, and typographic "applied art" is finally receiving the attention it deserves—because this book proves that Mexico is an important link in the history of Western graphic design style and form.

As a child in New York during the mid-fifties, I was unwittingly introduced to Mexican popular culture through one piece of art: José Clemente Orozco's 1931 painting *Zapatistas* showing a procession of Mexican peasant guerrillas going to their death during the *Revolución Mexicana*. A framed reproduction of the work hung for as long as I could remember over my father's boyhood bed in my grandparents' Bronx, New York apartment. Having immigrated to the United States from Eastern Europe around 1915, my grandparents had, to my knowledge, never set foot—or even considered visiting—Mexico. They were probably indifferent to the Mexican Revolution which

this painting so emotionally depicts. It may have been left behind by an earlier tenant, during a time when Mexico was one of many wellsprings of avant-garde art. But neither my grandparents nor my father ever explained the meaning of the picture to me or why it was randomly hanging in a child's bedroom—and I never asked why. However, I was mesmerized by the expressionistic solemnity of the peasants, "as stiff," to quote a review in *The New York Times*, "as the machetes they carry, locked in a grim forced march."

Orozco's somber imagery haunted me as child, yet later, as a young adult, it inspired me as well. Mexican art or political history was far removed from my sphere of consciousness—frankly, I had not even tasted Mexican cooking until I was in my early twenties. The little I did know about the history of America's southern neighbor initially came through popular movies like Elia Kazan's 1952 biopic *Viva Zapata!* starring Marlon Brandon as the iconic peasant rebel leader and John Wayne's 1960 *The Alamo* starring Wayne as the American folk hero Davy Crockett, who fought and died for Texas's independence from the Mexican empire. As I got older, however, an interest in Mexican revolutionary culture captured my attention, particularly through a growing awareness of the great Mexican muralists Orozco, Diego Rivera, and David Alfaro Siqueiros (the big three). I also learned about the profound number of cultural and political periodicals published in Mexico City and began to acquire a few as part of a more inclusive collection. I had a particular fondness for newspapers and magazines as the activist medium of choice.

During the late 1960s, I was deeply involved in American "underground" leftwing publishing as an editor, designer, and illustrator. Earlier in the century, from 1910 to 1920, Mexico had been transformed by revolution, where artists played a major role in its

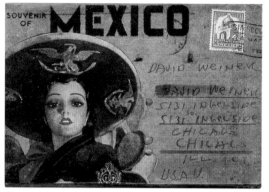

02

revolutionary culture; in the 1960s, this was mirrored in US counterculture. In fact, the Mexican cartoonist who most piqued my interest—and with whom I could personally identify—was the printer, publisher, and illustrator José Guadalupe Posada (1852–1913); he produced literally thousands of pre-revolutionary and revolutionary critical newspaper broadsheets and pamphlets featuring comic woodcuts that satirized politics, religion, oligarchy, and social castes and customs. He rebelled against the exploitation of the poor of his day and conceived an iconic repertory of *calaveras*, human skulls and skeletons. These *memento mori* were inspired by the staple imagery from the *Día de Muertos* (Day of the Dead) and were used to project Posada's biting yet witty protests against government, clergy, and class. Other than the vintage paper they were printed on, there was a certain timelessness to his satire, which contributed to why these woodcuts widely influenced young illustrators and cartoonists working for many North American underground papers in the mid-sixties. Posada's work was a combustible blend of playfulness and acerbity in a manner that directly prefigured and influenced the American style of subversive comic strips of the anti-Vietnam War movement.

In addition to Posada, another estimable Mexican caricaturist, illustrator, and painter caught my attention and enlivened the visual landscape. Miguel Covarrubias (1904–1956) not only defined his time, but arguably his work was also influential beyond the border. He received more attention in the United States than in Mexico, exerting his influence on popular art with a refined yet original drawing style that helped define the cosmopolitan, art moderne aesthetics of the late twenties and thirties, as well as through his contributions to the era's principal magazines, with *Vanity Fair*, *The New Yorker*, and *Fortune* among the most visible that published his work.

Many Mexican artists and designers worked in the US and Europe, cross pollinating their culture with the dominant international styles of the time. Look at some of the magazine layouts and typographic treatments for various artifacts herein and you will see how ancient Mexican forms had become contemporary. Mayan and Aztec design conceits, for instance, were seamlessly integrated into Art Deco motifs. At the same time, Russian Constructivism as well as other European and American avant gardes pervaded the Mexican visual language.

On my first and only pilgrimage to Mexico, made in the early eighties to witness the burgeoning Mexican protest movement, I toured the hot spots of Mexican popular and polemical art. I was blown away by the use of primary and secondary colors, from the ultra-modernist home and studio of Diego Rivera to the grand hacienda of Frida Kahlo, and even to the walled fortress of Leon Trotsky. Mexico City was filled with surreal and socially symbolic art in abundance. Coming by chance across a richly endowed exhibition of Covarrubias drawings at a museum near Chapultepec Park was the *pièce de résistance* of my trip. Then, in Oaxaca, I felt joy from seeing all of the Day of the Dead souvenirs—thousands of miniature skeletons that filled the streets with color and comedy—complimented by contemporary protest posters calling for equal rights and justice; these items were evidence that design still played a huge role in Mexican culture.

This book contains all the artifacts that I was unable to locate on my expedition. The contents further prove Mexico to be a capital of graphic design exuberance—and an invaluable addition to the sociology of graphic endeavor.

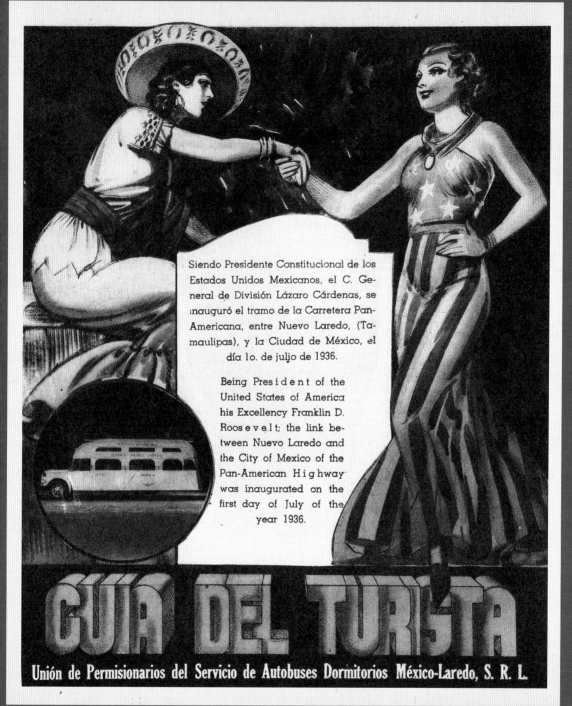

Siendo Presidente Constitucional de los Estados Unidos Mexicanos, el C. General de División Lázaro Cárdenas, se inauguró el tramo de la Carretera Pan-Americana, entre Nuevo Laredo, (Tamaulipas), y la Ciudad de México, el día 1o. de julio de 1936.

Being President of the United States of America his Excellency Franklin D. Roosevelt; the link between Nuevo Laredo and the City of Mexico of the Pan-American Highway was inaugurated on the first day of July of the year 1936.

GUIA DEL TURISTA

Unión de Permisionarios del Servicio de Autobuses Dormitorios México-Laredo, S. R. L.

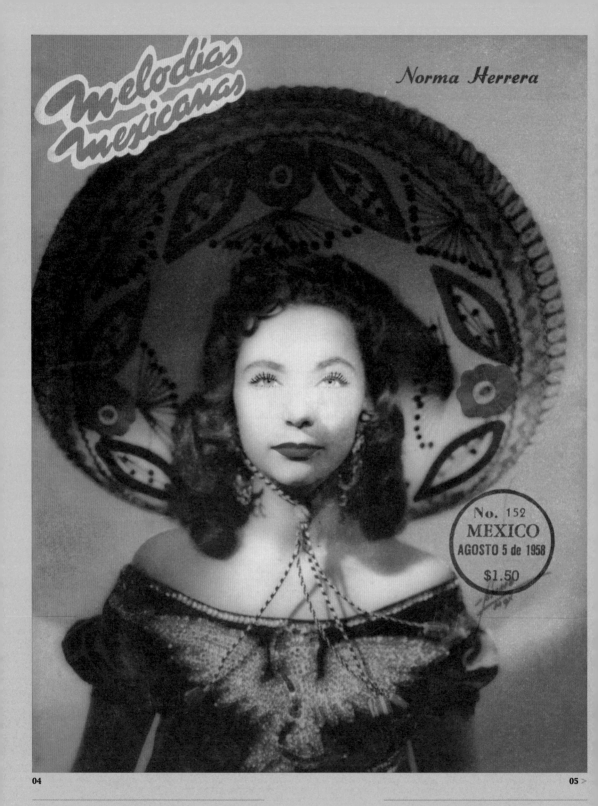

Melodías Mexicanas

Norma Herrera

No. 152
MEXICO
AGOSTO 5 de 1958
$1.50

04 | *Melodías Mexicanas*, n.º 152, México, August 5, 1958 | Songbook | Cover: Norma Herrera, photo by Herrera | RR

05 | *Mexico. Vacation Lands Unlimited*, ca. 1950. México, National Railways of Mexico | Cover | RR

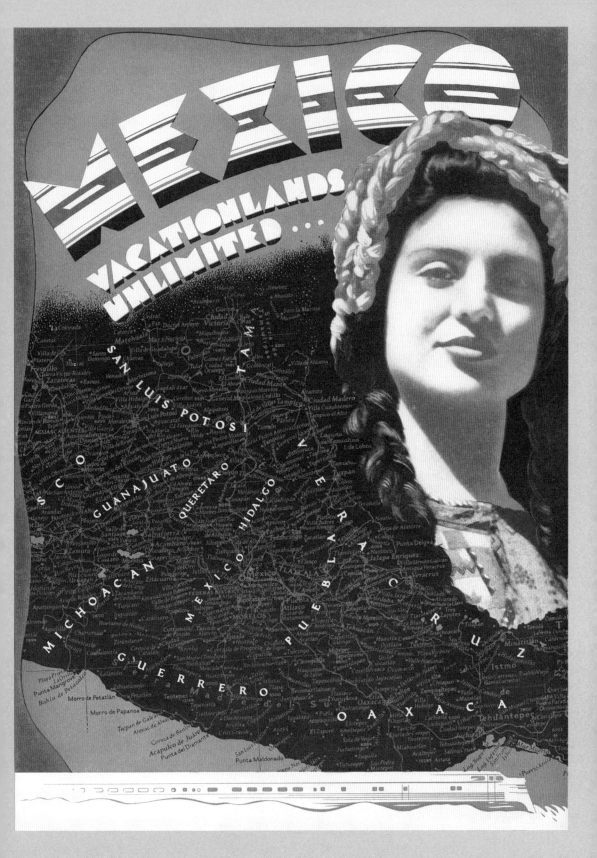

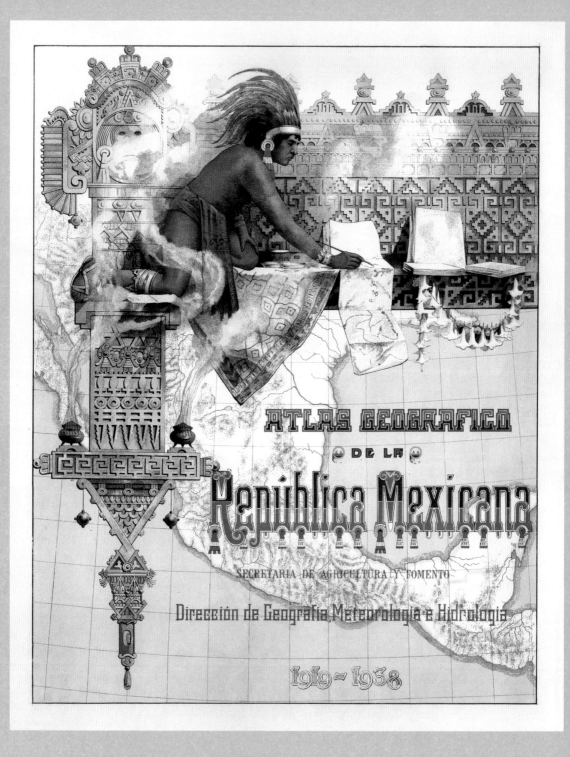

ATLAS GEOGRAFICO DE LA Republica Mexicana

SECRETARIA DE AGRICULTURA Y FOMENTO

Dirección de Geografía, Metereología e Hidrología

1919~1938

01 | *Atlas geográfico de la República Mexicana 1919–1938.*
Mexico, Secretaría de Agricultura y Fomento, Dirección de
Geografía, Metereología e Hidrología, 1938 | Cover | RLQ

INTRODUCTION

Two hundred years ago, in the year 1821, Mexico was born as an independent nation from Spanish rule. Mexican leaders, from the moment of the nation's birth, would seek and impose symbols to represent the new nation's people. The search for symbols, however, was limited by the struggle between liberals and conservatives, each with their differing national projects and emblems. Both of these political factions made use of the printing press and lithography to extend their ideologies, and with these printing systems the beginnings of the values of Mexicanness began to be sketched out. When Emperor Maximilian I met his defeat and the liberals finally triumphed, the content and image of Mexican identity were gradually given more definition. However, because the positivist idea of progress had its sights set on Europe as a paradigm for development, during the Porfiriato, the governing elite preferred to uphold the pre-Hispanic past as the country's sole identifying feature.

With the decline of the Porfirio Díaz dictatorship, a group of intellectuals who met at the Ateneo de la Juventud (Atheneum of Youth) refused the positivist position and proposed a return to popular culture and its creations as a means to redeem Mexican identity. The Ateneo group remained active during the Revolution and set up the Universidad Popular Mexicana (Mexican Popular University) as a way of propagating their ideas, although it was not until Álvaro Obregón became president that the university was given full governmental support for its notion of an idealized Mexico, reduced to a number of regional types, a few invented traditions, and the Spanish language as the sole national tongue. Struggles between different revolutionary factions had deeply divided the nation and there were also sharp social differences, and so some of the members of the old Ateneo, through the Secretariat of Public Education, proposed a strategy to bring the country together by defining the Mexican identity with images emblematic of equality and unity, where everyone was welcome and political and class differences were erased, creating a demagogic equity which served the purposes of the post-revolutionary governments. Although the model was initially proposed by government institutions, it soon gained the support of private initiatives, and the image of a contented rural Mexico, inhabited by chinas poblanas, charros, Tehuanas and the occasional powerful Native American, was forged.

The popularization of this model was made possible by an exceptional medium: printed matter and multiple reproduction in the thousands. Books, magazines, newspapers, and other published materials flooded the country with the new Mexican ideal. Famous painters lent their hand to the production of these images as well as little-known or anonymous artists, illustrators, caricaturists, photographers, and advertisers, all working towards the design of a common message. The idea of the Mexican paradise was not only aimed at the local populace; its national exoticism was also intended to entice foreigners, particularly from the United States, to visit and invest their capital in the nation.

The new values of Mexicanness were disseminated for over 50 years on paper and cardboard, the main means of communication in that period. Thousands and thousands of books, magazines, newspapers, pamphlets, calendars, leaflets, advertisements, flyers, menus, board games, musical scores, posters, postcards, maps, packets, tickets, stickers, and stamps issued from the presses. Gathering together this mass of printed matter has required an entire research team and several years' work; although by the end of the task, we also had to acknowledge that pieces would always be missing from it.

For *Mexico. The Land of Charm*, we had to select from several hundred items published from 1910 to 1960, paring our material down to a significantly representative collection of images of the Mexican aesthetic model mentioned above. We grouped our selection into several different themes: *Pre-Hispanismo*, The Neocolonial Style, Revolutions, Mexico City, Going Inland, The Fertile Land, Typical Costume, *Fiesta*, and Allegories.

This colorful heritage amazes Mexicans and foreigners alike. It arouses feelings, because the issues it brings up are often still relevant. Nevertheless, a hundred years after its invention, the idea of Mexicanness is starting to lose ground, owing to the fact that many people feel it does not represent them and call for a dignified consideration that refuses the objectification of women, disdain towards the indigenous population, and the denial of Afrodescendents. Mexico is transforming and demanding new symbols. What remains here is a printed testimony of an idealized world which filled many naïve hearts with a sense of national pride.

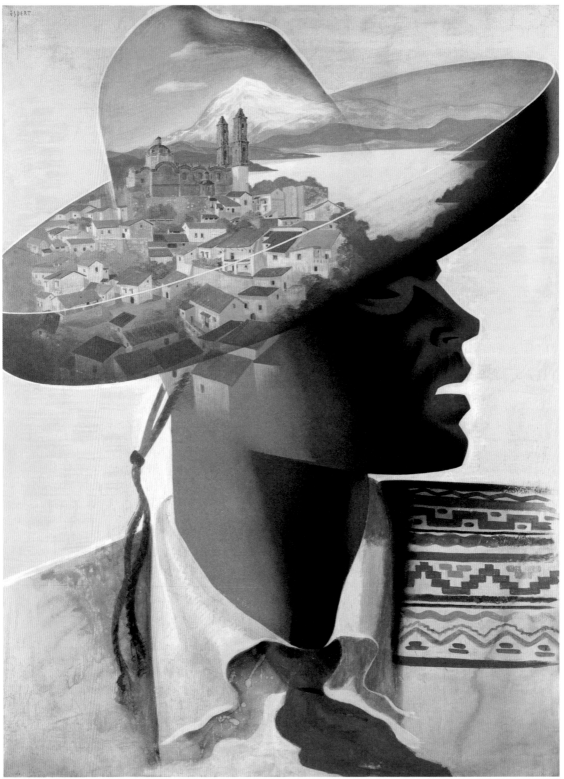

02

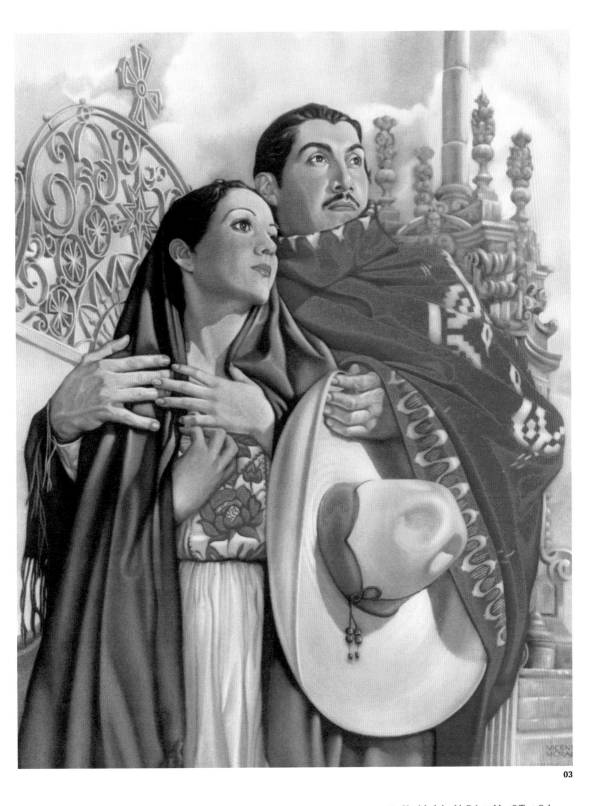

03

02 José Espert, untitled, Mexico, ca. 1940
Poster Watercolor MS

03 Untitled, [n.d.]. Printed by Offset Galas
Flyer Drawing by Vicente Moral RR

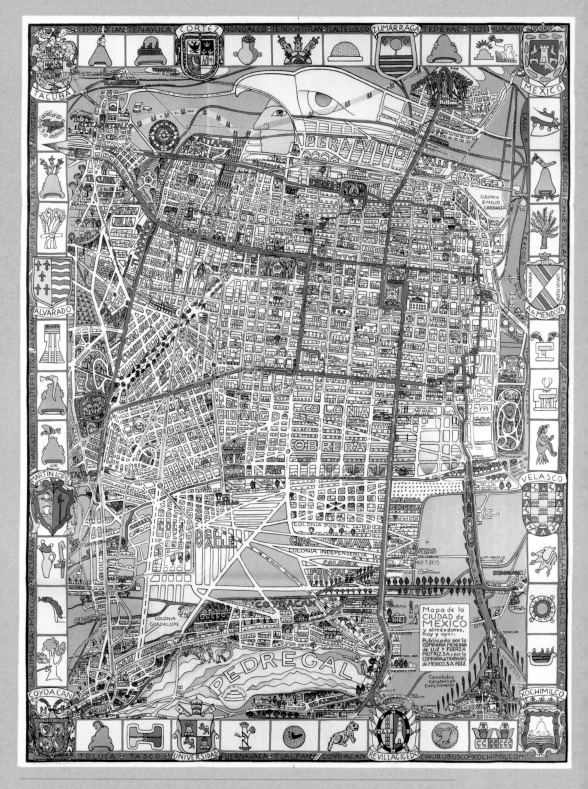

01 | *Mapa de la Ciudad de México y sus alrededores, hoy y ayer*. Mexico, Compañía Mexicana de Luz y Fuerza
Motriz, Compañía de Tranvías de México, 1932 | Map | Conceived and realised by Emily Edwards | RR

PRE-HISPANISMO

In 1987, researchers Silvia Garza and Wanda Tommasi noted that, "Throughout the country are endless testimonies to our past: although only 100,000 archaeological zones are claimed to exist, we can state that underneath almost the entirety of today's Mexico lie the remains of pre-Hispanic civilizations."[1] Two hundred years ago, this was not a known fact, but ever since Mexico's emergence as an independent nation there has been an interest in recuperating its extraordinary heritage. This has been led, in the first place, by governmental institutions such as the Mexican National Museum, the National Museum of Anthropology, the Secretariat of Public Education, and the National Institute of Anthropology and History; and secondly, by different interpretations by artists, sculptors, architects, photographers, artisans, and designers, whose work has tended to seek visual impact over historical accuracy. This section of the book is dedicated to the latter tendency, known as *pre-Hispanismo*.

The pre-Hispanic inclination existed throughout the nineteenth century, and there are many occurrences of it which range from the Mexican coat of arms, which portrays the myth of the founding of Tenochtitlán, to late nineteenth century creations by graduates from the San Carlos Academy of Fine Arts. Two artists from the academy would actively encourage the idealization of the Mexico that existed before the Spanish Conquest: Saturnino Herrán and Diego Rivera. Herrán died young, but his work left a solid grounding for Rivera's extraordinary endeavour. In the throes of the revolutionary struggle, Herrán painted phenomenal works portraying the ancient Mexicans with melancholy expressions and bare torsos. Thousands of copies of *Pegaso, Revista de Revistas* and *El Universal Ilustrado* **(fig. 26)** magazines had their covers magnificently illustrated with his commissions. Not long after, Rivera entered the scene and adopted the pre-Hispanic archetype in his own oil paintings, murals, illustrations for books and magazines, and even in his own collections and way of life; Rivera, a muralist who worked with large formats, also turned his hand to decorating printed matter, as we see in his work for the editor Frances Toor: the covers of *Mexican Folk-Ways* **(fig. 07)** and the guidebooks for his frescos in Cuernavaca **(figs. 02 and 08)**. Another artist who obeyed

1. Silvia Garza T. González, Wanda Tommasi de Magrelli. *Atlas cultural de México. Arqueología* (Mexico: SEP-INAH/Planeta, 1987), 11.

the pre-Hispanic urge was Jorge Enciso, a noteworthy painter, illustrator, and designer of emblems, whose work is unfortunately limited to his commissions as a civil servant. Enciso's artistic inclinations were devoted to his indispensable, monumental work *Sellos del antiguo México* (Stamps from Ancient Mexico) **(fig. 06)**.

José Clemente Orozco recalls that in the 1920s, "Many people believed that art before Cortés was our true tradition, and even talked of a 'renaissance of indigenous art.'"[2] *Pre-Hispanismo* generated enthusiasm and was soon no longer the exclusive concern of elites and artists. It entered the common vocabulary as "Indianismo," "Primitivismo," "Americanismo," and other terms. The government also did not hesitate to include it in long runs of printed matter including banknotes **(fig. 21)** and postage stamps **(figs. 19, 20 and 22 to 25)**, while the aesthetic also claimed its place in popular taste. The quasi-anonymous work of designers, draftspeople, and photographers brought the new tendency into advertising, magazines, newspapers, and books of all kinds; printing presses issued thousands of images of Eagle Knights, pyramids, and fretwork, all encouraging the predilection for the glorious past.

2. José Clemente Orozco, *Autobiografía* (Mexico: Ediciones Occidente, 1948), 59.

Although there are nuances to pre-Hispanismo's portrayal of pre-Columbian cultures, it is nevertheless reductionist and hegemonic; it focuses almost exclusively on the Aztecs and Maya and only three archaeological sites: Teotihuacán **(figs. 10 to 13)**, Chichén Itzá and Mitla, as can be seen in many postcards from the period. *Pre-Hispanismo* idealizes these civilization's past as a stolen paradise, and it is also an eclectic approach that does not respect specific features of each group, preferring to simply combine them indistinctly. This tendency continues to exist in printed matter, literature, folk art, and many people's tastes and preferences.

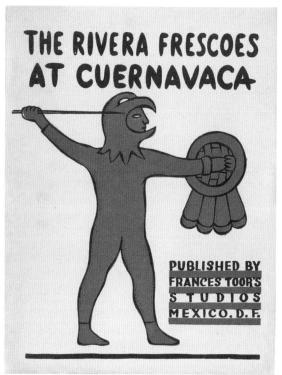

02

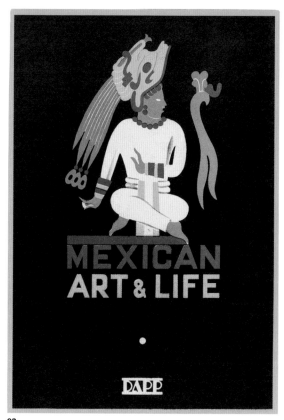

03

04

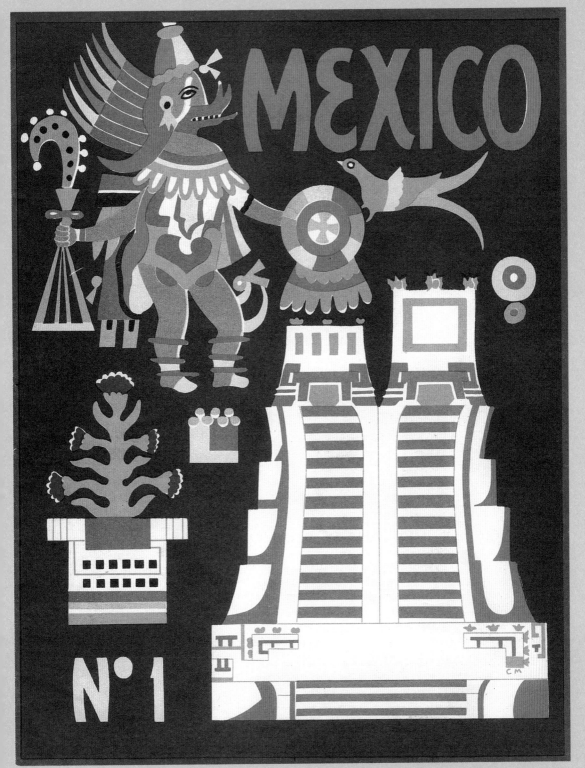

05

SELLOS·DEL ANTIGUO MEXICO

06 | Jorge Enciso, *Sellos del antiguo México*. Mexico, [Author's edition], 1947 | Cover by Jorge Enciso | MLC

07 | *Mexican Folkways*, vol. 6, no. 1, Mexico, 1930 | Cover by Diego Rivera | RR

08 | Emily Edwards, *Frescoes by Diego Rivera in Cuernavaca*. Mexico, Editorial Cultura, 1932 | Cover by Diego Rivera | MLC

09 | Alfonso Caso *et al.*, *Máscaras mexicanas*. 2nd Exhibition by Sociedad de Arte Moderno. Mexico, January 1945 | Cover attributed to José Chávez Morado | MLC

MEXICAN FOLK-WAYS D.R.

1930
1

ESPAÑOL	ENGLISH
ARTE	ART
ARQUEOLOGIA	ARCHAEOLOGY
LEYENDAS	LEGENDS
FIESTAS	FESTIVALS
CANCIONES	SONGS

VOL. VI

75 CENTAVOS
50 CENTS

07

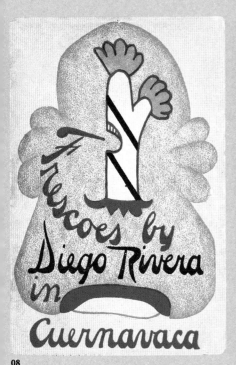

08

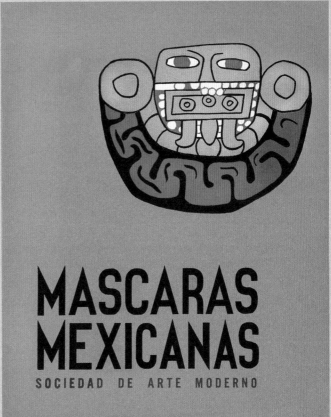

MASCARAS MEXICANAS
SOCIEDAD DE ARTE MODERNO

09

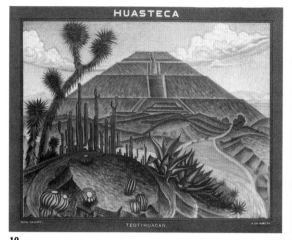

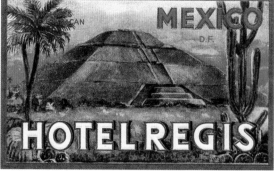

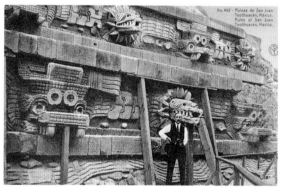

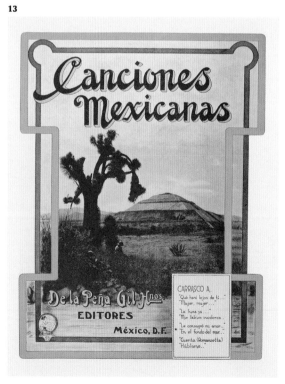

10 | *Teotihuacán en la carretera Pan-Americana*, year XVII, no. 857. Mexico, La Huasteca, [n.d.]. Printed by Offset Galas | Loose calendar page | Painting by Raúl Gamboa | MLC

11 | *Pirámides de Teotihuacán*, [n.d.]. Mexico, Hotel Regis | Luggage sticker | RR

12 | *Ruinas de San Juan Teotihuacán. México*, [n.d.]. Published in Mexico by Félix Martín | Postcard | JO

13 | *Canciones mexicanas*. Piano works and songs published by De la Peña Gil Hermanos. Mexico, 1920 | RR

14 | *Modern Mexico*, vol. 9, no. 2, July 1937, United States | Cover | RR

15 | *Modern Mexico*, vol. 9, no. 3, August 1937, United States | Cover | RR

MODERN

July
1937

MEXICO

MODERN
August
1937
MEXICO

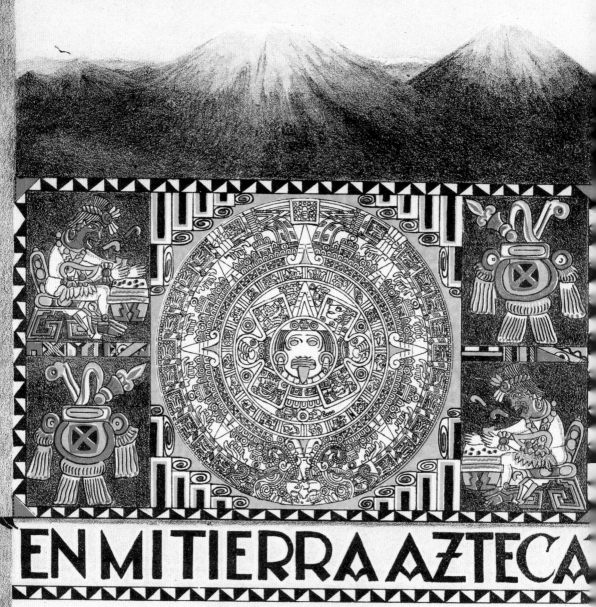

EN MI TIERRA AZTECA

FOX-TROT
POR
AL HEGBOM Y BILLY MEEK

Propiedad del Autor para todos los Países. Depositado conforme a la Ley

◆ A. WAGNER Y LEVIEN SUCS., S. en C. ◆

1a. Capuchinas 21 MEXICO Apartado Núm. 353

MERIDA PUEBLA GUADALAJARA MONTERREY VERACRUZ TAMPICO

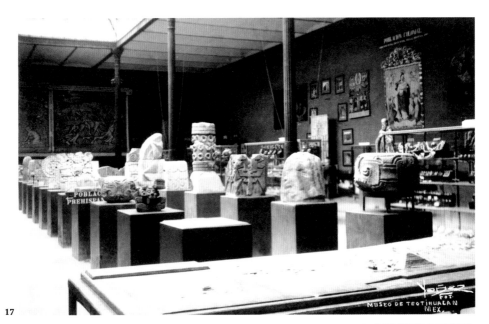

17

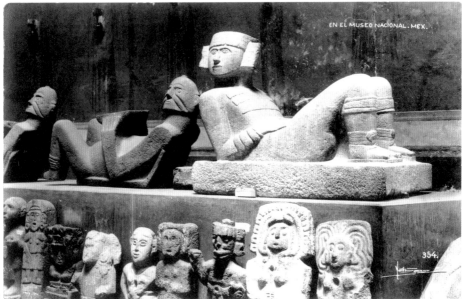

16 **18**

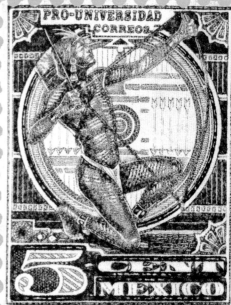

19 | *Pro-Universidad*. Postal Service.
[5 centavos]. Mexico. [State Printing Works,
Mexico, 1934] | Postage stamp | MLC

20 | *El hombre pájaro azteca*. Air mail.
[40 centavos]. Mexican Postal Service.
[State Printing Works, Mexico, 1935] |
Postage stamp | MLC

19

20

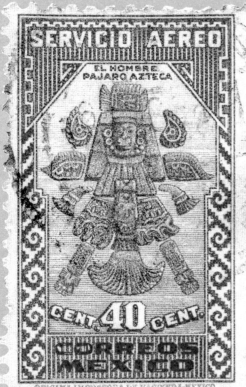

21 | One-peso banknote issued by Banco
de México, August 27, 1969. Printed by
American Bank Note Company, New York
(abnc). The only one-peso note issued by
the Banco de México in its entire history. |
Front: Aztec calendar | MLC

22 | [Eagle warrior]. Mexican Postal Service.
Air mail. 20 centavos. State Printing
Works, Mexico, 1937 | Postage stamp | MLC

23 | Mexican Postal Service. One peso. Air
mail. State Printing Works, Mexico, 1934 |
Postage stamp | MLC

24 | Mexican Postal Service. Five centavos.
Air mail. State Printing Works, Mexico,
1934 | Postage stamp | MLC

25 | Teotihuacán Mexico. Dragon Temple
of Quetzalcóatl. Mexican Postal Service.
Air mail. 10 centavos. State Printing
Works, Mexico, 1934 | Postage stamp | MLC

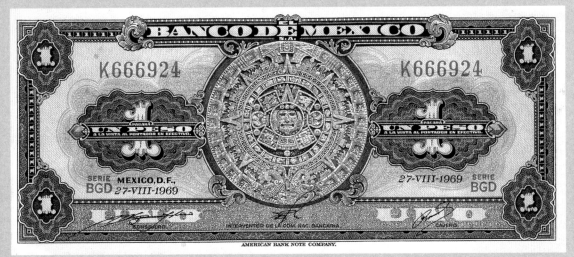

21

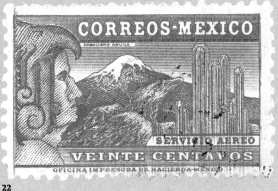

22

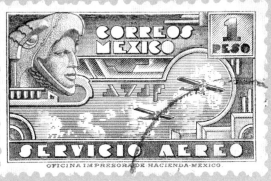

23

24

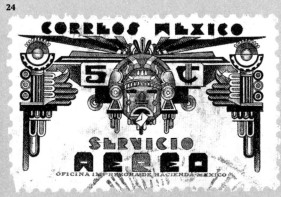

25

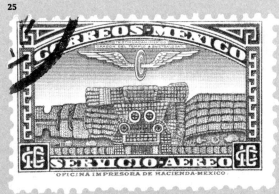

AÑO I.- NUM. 19 México, 14 de Septiembre de 1917 Precio: 40 centavos en la Capital

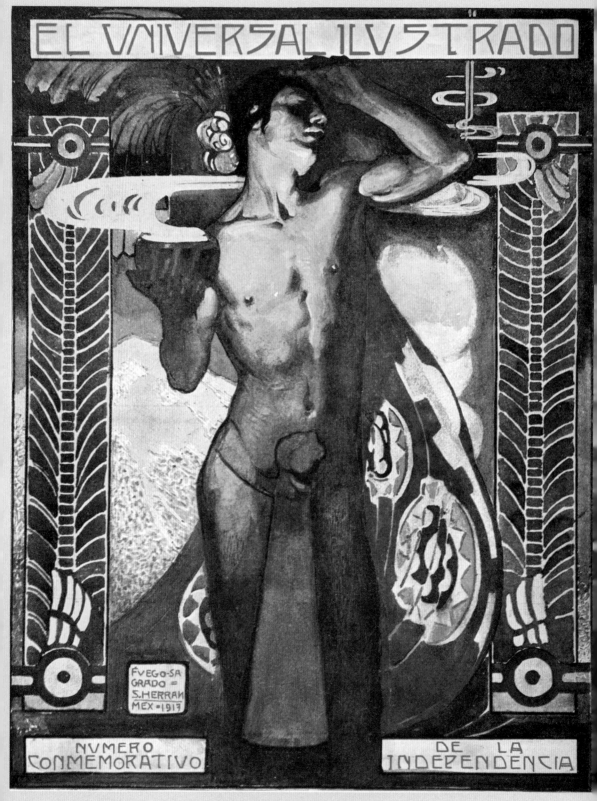

EL VNIVERSAL ILVSTRADO

NVMERO CONMEMORATIVO

DE LA INDEPENDENCIA

FUEGO SAGRADO

Dibujo de Saturnino Herr

EXIJA UD. CON ESTE NUMERO EL SUPLEMENTO GRATUITO DE NOVELA QUE LO ACOMPAÑA

26

27 28

29

26 *El Universal Ilustrado*, year I, no. 19, Mexico, September 14, 1917. Issue commemorating Independence Cover: "Fuego sagrado," drawing by Saturnino Herrán MLC

27 *El Ilustrado*, year XVIII, no. 909, Mexico, October 1934. Special issue on the city of Monterrey, N.L., on the occasion of the III "Gran Feria de Octubre" Cover illustration by Carlos Neve RR

28 *Revista de Revistas*, year XVII, no. 857, Mexico, 1926. Published by *Excélsior* Cover: "Fantasía india," illustration by Mariano Martínez MLC

29 *¡¡Qué chulos ojos!! Canción mexicana creación de María Conesa*. Repertorio Nacional de Música, S.A., Mexico, [n.d.] Cover showing María Conesa MLC

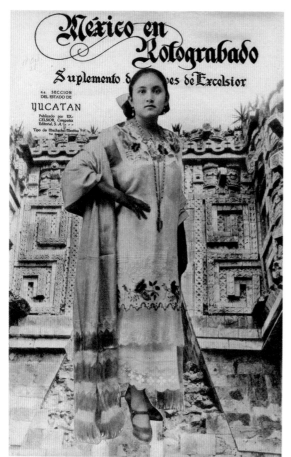

30

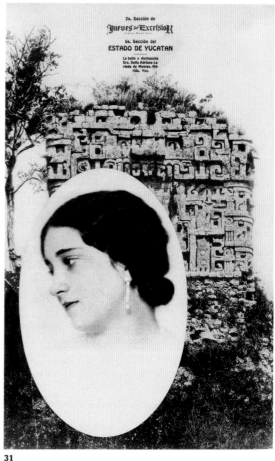

31

30 | *México en Rotograbado*, October 18, 1928. Mexico, Excélsior Compañía Editorial S.A. | Cover: "Tipo de muchacha mestiza," photo by Pedro Guerra | RLQ

31 | *Jueves de Excélsior*, April 3, 1930. Mexico, Excélsior Compañía Editorial, S.A. | Photo caption on cover: "The beautiful, distinguished Sra. Doña Adriana Laviada de Montes," | RLQ

32 | *Papel y Humo*, year II, no. 7, August 1933. Issue dedicated to the State of Guerrero. Mexico, Compañía Manufacturera de Cigarros El Águila, S.A. | Cover showing María Luisa Zea, illustration by A. Gómez R. | RR

33 | *Danzarina con tucán / Dancer with Toucan*, 1942, Mexico, Printed by Offset Galas | Drawing by Armando Drechsler | RR

34 | *México en fotografías*, no. 1, [n.d.]. Mexico, Editorial Fischgrund | Cover by Luis Osorno Barona | RR

35 | *México*, vol. I, no. 1, June 1931, Mexico, Tostado Grabador, S.C.J. | Cover showing Raquel Torres | MLC

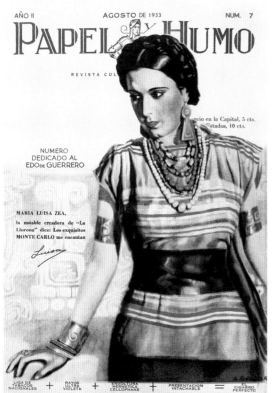

32

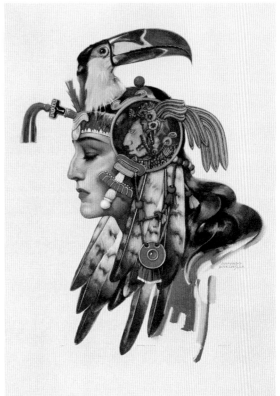

33

34

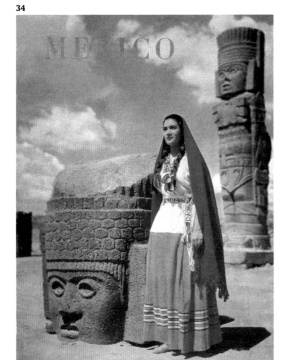

35

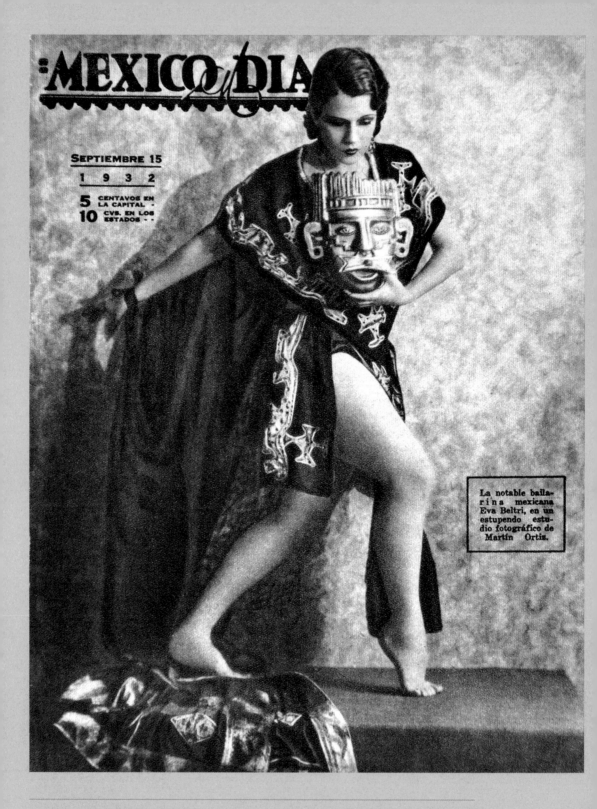

La notable baila-
r i n a mexicana
Eva Beltri, en un
estupendo estu-
dio fotográfico de
Martín Ortiz.

36 | *México al día*, September 15, 1932. Mexico, Fotograbadores y Rotograbadores Unidos, S.C.L. | Caption on cover: "The outstanding Mexican dancer Eva Beltri, a wonderful photographic study by Martín Ortiz." | MLC

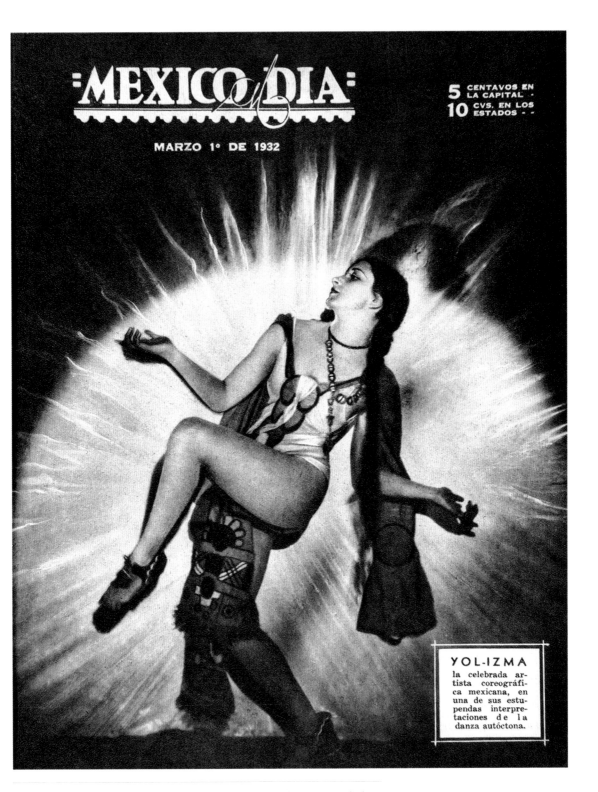

37 *México al día*, year V, vol. 1, March 1, 1932. Mexico, Fotograbadores y Rotograbadores Unidos, S.C.L. Caption on cover: "YOL-IZMA the famous Mexican choreographic artist, in one of her superb interpretations of autochthonous dance." MLC

ℭ American Art & Life

In the 400 th. Anniversary of Printing in Mexico.

July 1939 · No. 7 · DAPP

THE NEOCOLONIAL STYLE

After the conquest of Mexico 500 years ago, the Spaniards demolished temples and burned codices to erase the traces of the dominated cultures. The pre-Hispanic world was relegated to the margins and the New Spanish society settled into castes, with each of the social strata contributing with its talents to the construction of fabulous civilian and religious works in the European style, though with some locally manufactured elements. During the nineteenth century, the heritage of the viceroyalty was maintained in good condition until the Reform and its new laws, when ecclesiastical assets were confiscated, nuns defrocked, and many churches and convents abolished, leaving a desolate scenario. The Porfiriato showed some concern for Mexican historical assets through the National Museum which, from 1887 onwards, had its own means of dissemination in the *Anales,* a publication whose pages hosted important artists such as José María Velasco, Félix Parra, Antonio Cortés, Mateo A. Saldaña, and Valerio Prieto, who specialized in delicate illustrations, vignettes, decorated capitals, ex libris, and ornamental designs, all clearly in the neocolonial style.

Between October 1913 and July 1914, in the midst of armed conflict, the architect Federico E. Mariscal gave a number of speeches under the theme "National architecture" at Universidad Popular Mexicana, in which he not only proclaimed that love for one's country also meant loving one's ancestors and the buildings of one's homeland but also dictated a new canon: "Mexico's architecture should therefore also be the architecture conceived and developed during the three centuries of the viceroyalty, when 'the Mexican' came into being and acquired an independent life of its own."[1] Mariscal recommended the neocolonial style and developed it as a symbol of true Mexicanness; however, his supposed imitation of the style was also influenced by the Spanish Colonial Revival movement that had come into vogue in the United States in the early twentieth century.

"The old" became new, and the graphic arts were soon to reflect the neocolonial influence. Ernesto *El Chango* García Cabral frequently introduced archaic motifs into his compositions for *Revista de Revistas* **(fig. 12)**; Jorge Enciso retrieved designs from Talavera pottery and decorated books and periodicals; Gabriel Fernández Ledesma **(fig. 01)** and Francisco Díaz de León **(figs. 03 and 04)**, both from Aguascalientes, became master woodcutters and imitated the burin's characteristic imprint in their drawings to "age" them; Enrique A. Cervantes, a historian, editor and draftsman, worked extensively on 12 monographic books and a numbered edition of eight wonderful *Álbumes de ciudades coloniales* (Colonial City Albums), each with a cloth-bound folder and original, numbered photographic prints. Advertisers, too, did their part to promote emblematic colonial cities such as Guanajuato **(fig. 13)**, Taxco, Querétaro **(fig. 14)**, and Uruapan on postcards, triptychs, leaflets, guidebooks, maps, and posters.

The most peculiar of the neocolonial style's excesses was suffered by the National Palace in 1926–7. Among other misfortunes, the old building, headquarters of the viceroyalty **(fig. 16)**, had its facade remodeled and third floor built onto it. Ironically, its New Spanish remnants were destroyed and substituted with the neocolonial style still present today **(fig. 17)**. The Spanish Colonial Revival, as it is known, gradually lost its standing as a symbol of Mexicanness and only persisted in "rustic" furniture and architectural designs for houses and living spaces.

1. D. Federico E. Mariscal, D. Federico E. *La patria y la arquitectura nacional*, 2nd edition. (México: Impresora del Puente Quebrado, 1970),12.

01 *Mexican Art & Life*, no. 7, July 1939. Mexico, DAPP. Issue dedicated to the 400th anniversary of the printing press in Mexico. Cover by Gabriel Fernández Ledesma MLC

02 | Anita Brenner, *Idols behind Altars*. New York, Payson & Clarke Ltd., 1929 | Book jacket by Jean Charlot | MLC

03 | Mariano Silva y Aceves, *Campanitas de plata. Libro de niños. 54 maderas originales de Díaz de León*. Mexico, Editorial Cultura, 1925 | Cover by Francisco Díaz de León | BSA

04 | Manuel Toussaint, *Oaxaca*. Illustrated with 16 wooden cameos by Díaz de León. Mexico, Editorial Cultura, 1926 | Cover by Francisco Díaz de León | RR

05 | *Mexican Folkways*, vol. 1, no. 3, Mexico City, October–November, 1925. | Cover by Jean Charlot | RLQ

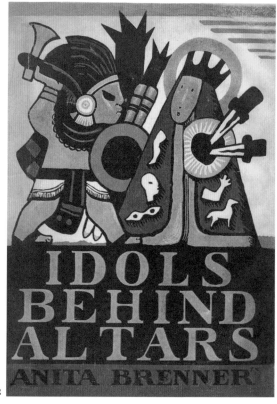

02

03

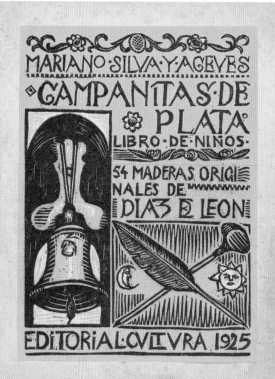

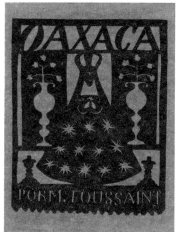

04

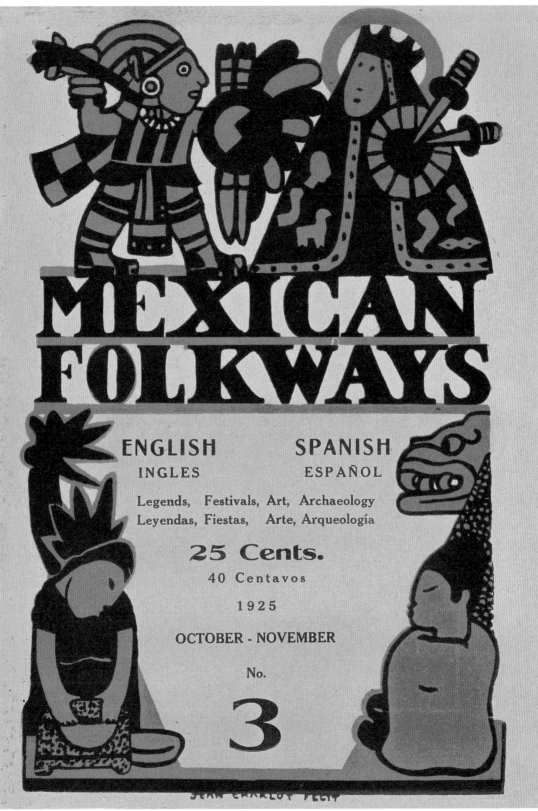

MEXICAN FOLKWAYS

ENGLISH SPANISH
INGLES ESPAÑOL

Legends, Festivals, Art, Archaeology
Leyendas, Fiestas, Arte, Arqueología

25 Cents.
40 Centavos

1925

OCTOBER - NOVEMBER

No.

3

JEAN CHARLOT FECIT

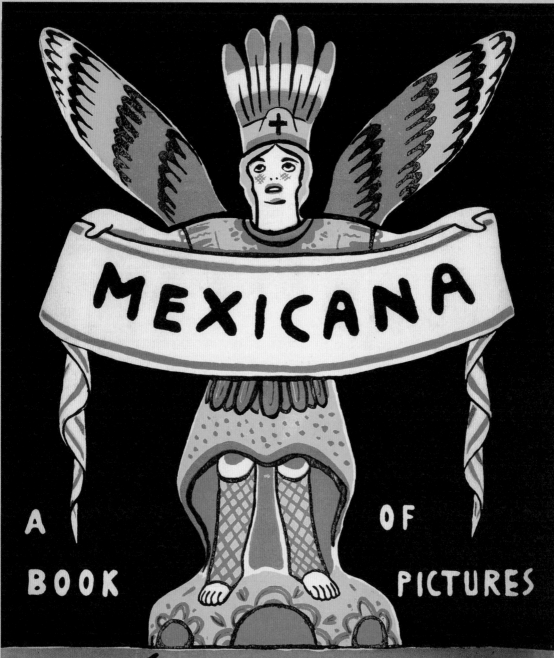

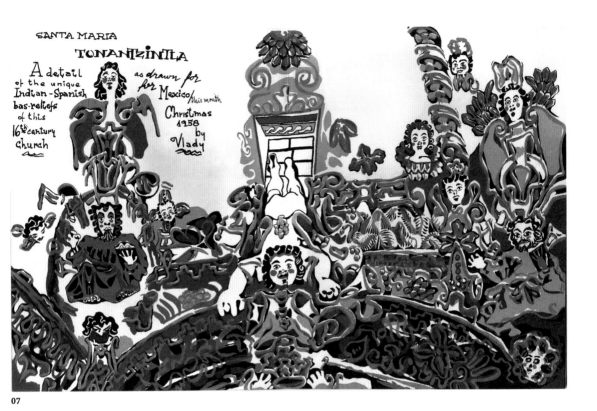

07

06 René d'Harnoncourt, *Mexicana.
A Book of Pictures*. New York, Alfred
A. Knopf, 1931 Book jacket by René
d'Harnoncourt BSA

07 *Mexico / this Month*, December 1958.
In this issue: Guadalupe, Age of Haciendas,
Christmas Art. Mexico, Editorial Gráfica de
Mexico, S.A. Double-page spread: "Santa
María Tonantzintla. A detail of the unique
Indian-Spanish bas-reliefs of this 16th
century church," illustration by Vlady RLQ

08 *Mexico / this Month*, December 1959. In
this issue: 20 days of Christmas, Yolanda's
wedding, search for Eden. Mexico,
Editorial Gráfica de México, S.A. Cover by
Vlady and Pedro Friedeberg RLQ

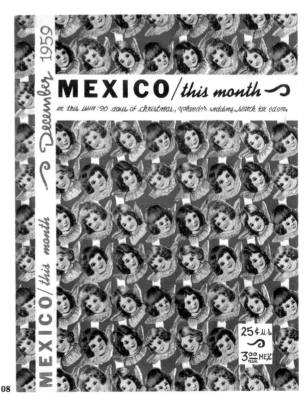

08

09 | *México*, year I, no. 2, October 1941. Departamento de Turismo, Asociación Mexicana de Turismo | Cover by Gabriel Fernández Ledesma | MLC

10 | *Platería mexicana*. Mexico, Editorial Stylo, 1952 | Cover by Zita Canessi | Photos by Juan Guzmán. Art photographs for the museum collection by Manuel Álvarez Bravo | MLC

11 | Susan Smith, *Made in Mexico*. Decorated with photographs and drawings by Julio Castellanos. New York, Alfred A. Knopf, 1930 | Book jacket | BPV

09

MUSEO NACIONAL DE ARTES E INDUSTRIAS POPULARES

PLATERIA MEXICANA

10

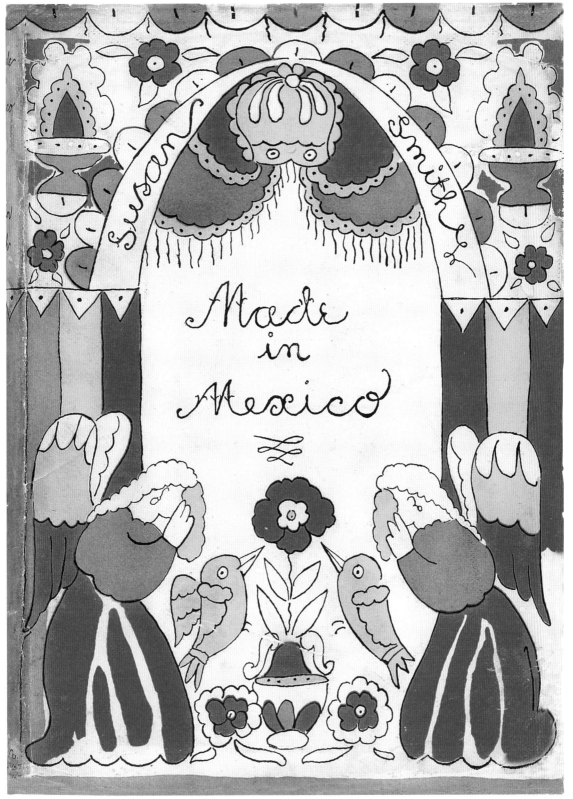

11

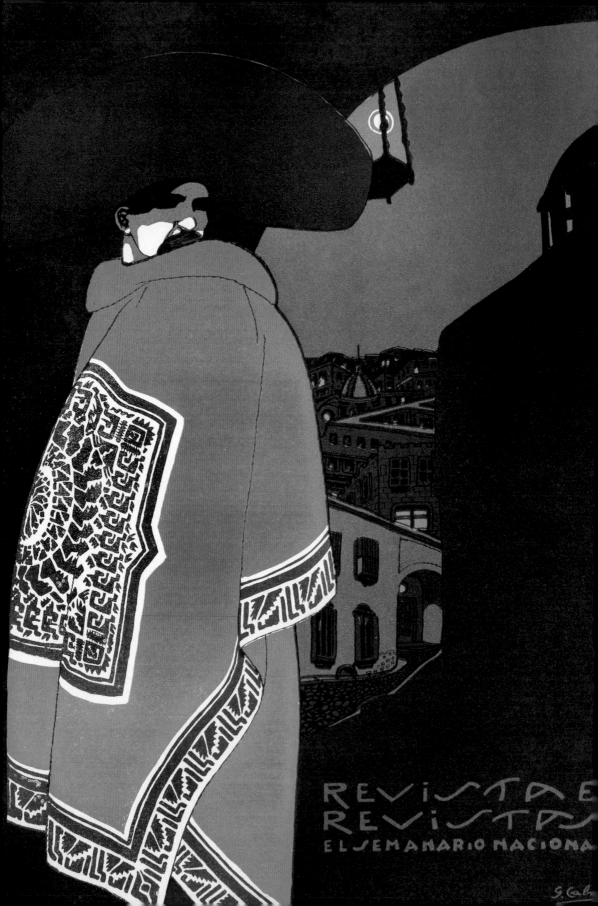

REVISTA DE
REVISTAS
EL SEMANARIO NACIONAL

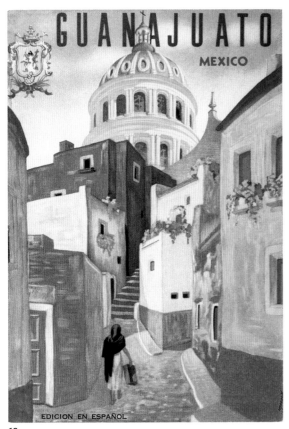

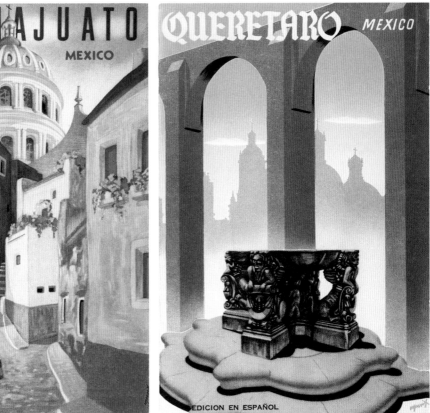

13

14

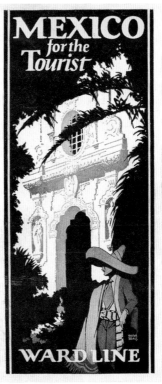

12 *Revista de Revistas*, year XVII, no. 858, October 17, 1926. Cover drawing by Ernesto García Cabral RR

13 *Guanajuato, México*. Spanish edition. Departamento de Turismo de la Secretaría de Gobernación, Asociación Mexicana de Turismo. Printed by Offset Galas, ca. 1944 Guidebook Cover by José Espert Arcos RR

14 *Querétaro, México*. Spanish edition. Departamento de Turismo de la Secretaría de Gobernación, Asociación Mexicana de Turismo. Printed by Offset Galas, ca. 1944 Guidebook Cover by José Espert Arcos RR

15 *Mexico for the Tourist. Ward Line*. USA, Ward Line [Mexican Subsidiary of New York & Cuba Mail Steamship Company], ca. 1920 Tourist pamphlet Cover by Victor Beals JO

12

15

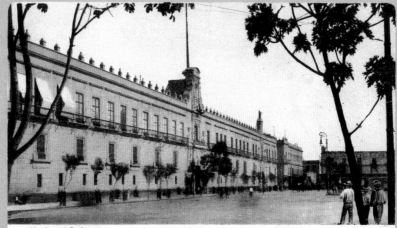

National Palace. *La Cañada, 8 – 21 – 05.*

7948. J. G. Hatfer, Mexico.

16

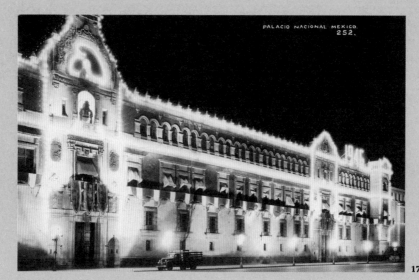

PALACIO NACIONAL MEXICO.
252.

17

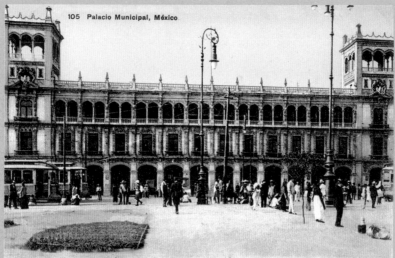

105 Palacio Municipal, México

18

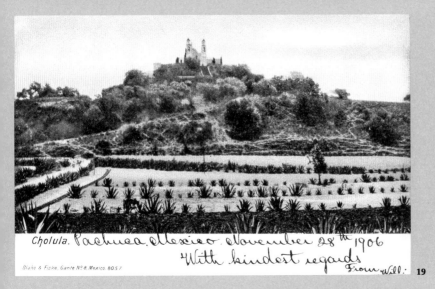

Cholula. Pachuca. Mexico. November 28th 1906 With kindest regards From Will.

Blake & Fiske, Gante N° 8, Mexico. 8057.

19

20

16 | *National Palace*, ca. 1905. Published in Mexico by J. G. Hatton | Postcard | RLQ

17 | *Palacio Nacional*, [n.d.]. Mexico. | Postcard | RR

18 | *Palacio Municipal*, [n.d.]. Published in Mexico by J. Suter & Company | Postcard | RLQ

19 | *Cholula*, ca. 1906. Published in Mexico by Blake & Fiske | Postcard | RR

20 | *La Catedral de Mexico desde el Palacio Municipal*, ca. 1941. Mexico | Postcard | Photo by Yáñez | RLQ

LA CATEDRAL DE MEXICO DESDE EL PALACIO MUNICIPAL.

374.

21 | *Vea*, year II, no. 64, January 17, 1936. Mexico, Fotograbadores
y Rotograbadores Unidos, S.C.L. | Caption on cover: "Diana
Mackalen, beautiful Mexican artist," photo by César | MLC

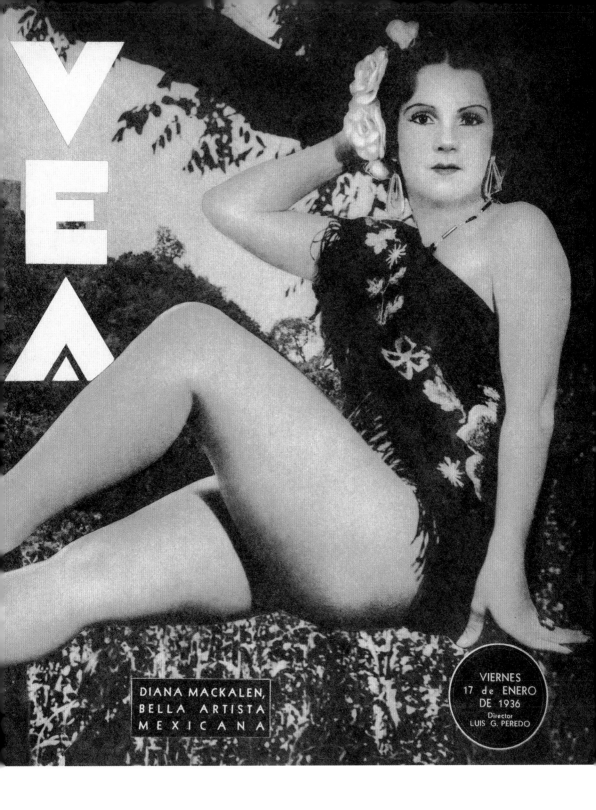

VEA

DIANA MACKALEN,
BELLA ARTISTA
MEXICANA

VIERNES
17 de ENERO
DE 1936
Director
LUIS G. PEREDO

NVESTRA CIVDAD

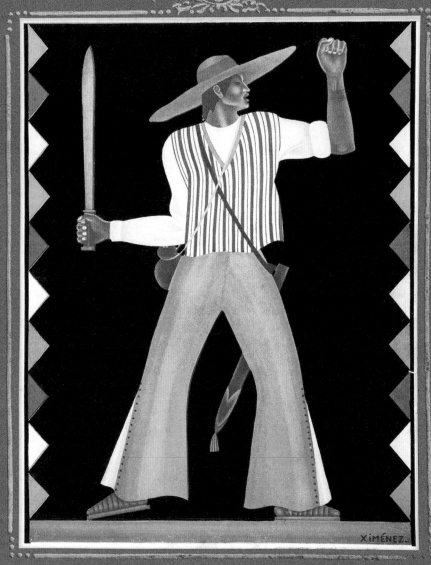

XIMÉNEZ.

SEPTIEMBRE 1930

Organo del Departamento
del DISTRITO FEDERAL

PRECIO: $ 0.50

Impreso en los Talleres Gráficos de la Nación

REVOLUTIONS

If we choose to fixate on history as a series of bronze figures on pedestals, Cuauhtémoc was one of the earliest Mexican heroes to be raised onto a pedestal. It was, however, the nineteenth century that gave birth to the greatest number of such figures. The 11 years of struggle for independence produced legends like the priests Miguel Hidalgo and José María Morelos; common people like El Pípila **(fig. 04)**; foreigners such as Javier Mina; women—Josefa Ortiz; and Afrodescendents like Vicente Guerrero, among others. Years later, 5,000 soldiers died in the Mexican-American War (1846–1848); among them were the Boy Hero Martyrs, and a further 4,000 civilians also perished. The Second French Intervention (1862–1867) resulted in another 40,000 deaths, including that of General Ignacio Zaragoza. With so many heroic burials, the Pantheon of San Fernando was soon fully occupied, but the parade of the famous in their hearses marched on, so that the Alameda changed its name to Calle de los Héroes and the Paseo de la Reforma filled with sculptures. All of these figures were given emblematic status in the national schools' curriculum and were recognized by all students in public education.

Porfirio Díaz also acquired national hero status. Díaz's birthday happened to coincide with the anniversary of the Mexican Independence, and this was an ideal pretext for his image to be printed side by side with that of Miguel Hidalgo in books, magazines, newspapers, and widely-circulated printed matter like flyers and postcards. Diaz's figure was raised to its highest glory during the celebrations of the Centenary of Independence, but it only took a few months of the Madero-led revolution for the dictator who had ruled for 31 years to be ousted from his podium and fall from hero to villain in national history.

Unlike previous social struggles, the Mexican Revolution and its participants were immediately depicted in images, first appearing in satirical political magazines and also in the prints of José Guadalupe Posada and then in photography and film. The theme of the revolution was soon disseminated in all kinds of published matter: books, magazines, newspapers, pamphlets, sheet music, and advertisements. By 1914, the revolutionaries had become an emblem of Mexicanness, and images of popular leaders like Emiliano Zapata and Francisco Villa appeared on the covers of widely circulated weekly publications such as *Revista de Revistas* and *La Ilustración Semanal* **(figs. 05 and 06)**. At the end of the struggle, the idea of a people's revolution led by Villa, Zapata, and the Convention of Aguascalientes failed to succeed; victory was won by the Constitucionalistas and a group from Sonora with their project for capitalist modernization. The peasant and workers' struggle was given recognition only in murals and different publications **(figs. 10, 16 and 18)**, whose writers mythicized the recent revolutionary past.

With the 20th of November festivities, the postrevolutionary governments appropriated the figures of the leaders and fused them together, erasing their ideological differences, as is explained by the historian Enrique Florescano: "What these rituals sought was not to rescue the truth of history but to turn the revolutionary past into the setting stone that would legitimize the acting government. So that, rather than maintaining the factionalism of their origins, the governments of the Revolution chose to laud the leaders of the past as the fathers of the current nation."[1]

The government's demagogic discourse was seamlessly upheld by the work of the Taller de Gráfica Popular (Peoples' Graphic Workshop), particularly in the folder *Estampas de la Revolución Mexicana* **(fig. 11)**. With the students' movement of 1968, the revolutionary leaders' figures were eventually restored to their legitimate place in social struggle.

1. Enrique Florescano, *Imágenes de la patria a través de los siglos* (México: Taurus, Secretaría de Cultura de Michoacán, 2005), 405.

01 *Nuestra Ciudad*, year II, no. 6, September 1930. Mexico, Talleres Gráficos de la Nación. Cover illustration by Alfredo Ximénez MLC

LA ANTORCHA

02

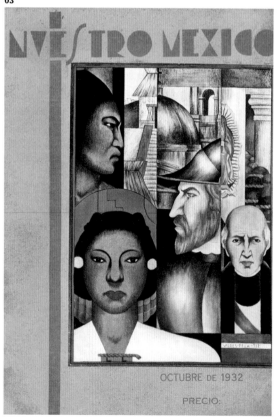

03

OCTUBRE DE 1932

PRECIO:

02 | *La Antorcha*, vol. I, no. 14, January 3, 1925 | Cover | RLQ

03 | *Nuestro México*, year I, no. 7, October 1932. | Cover drawing by Valdés-Peza | MLC

04 | *Horizonte*, vol. I, no. 6, Mexico, September 1926 | Cover by Ramón Alva de la Canal | RLQ

HORIZONTE

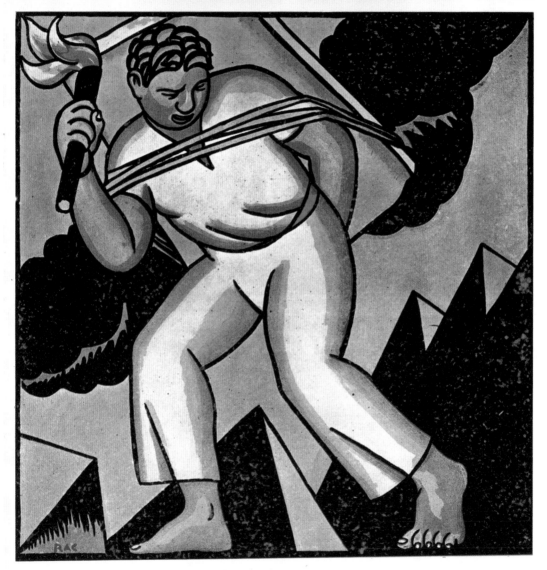

SEPTIEMBRE 1926
PRECIO-30¢

La Ilustracion Semanal

AÑO II NUM 62 MEXICO 7 DICIEMBRE 1914. CONFERENCIAS EN CUERNAVACA.

25¢

FOT. SCHLATTMAN . PROP.

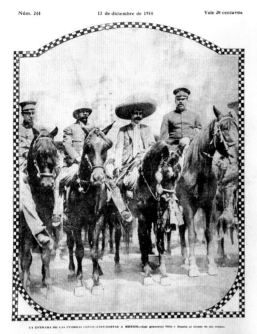

Núm. 244 13 de diciembre de 1914 Vale 20 centavos

LA ENTRADA DE LAS FUERZAS CONVENCIONALISTAS A MEXICO.—Los generales Villa y Zapata al frente de las tropas.

REVISTA & REVISTAS
EL SEMANARIO NACIONAL

06

05 *La Ilustración Semanal*, year II, no. 62, December 7, 1914. Conferences at Cuernavaca. Mexico, Compañía Periodística Mexicana, S.A. | Cover by Schlattman | RR

06 *Revista de Revistas*, no. 244, Mexico, December 13, 1914. | Caption on cover: "Constitutionalist forces enter Mexico. Generals Villa and Zapata leading the troops." | MLC

07 *La Ilustración Semanal*, year I, no. 30, April 27, 1914. Mexico, Compañía Mexicana Periodística, S.A. | Cover: a soldier of the revolution, photogravure by Tostado Grabador | MLC

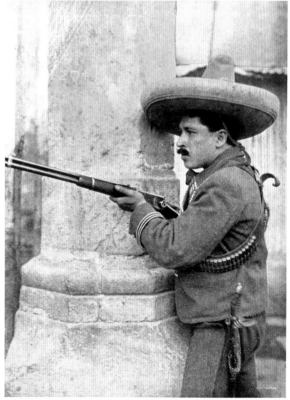

< **05** **07**

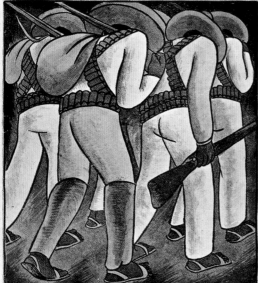

08

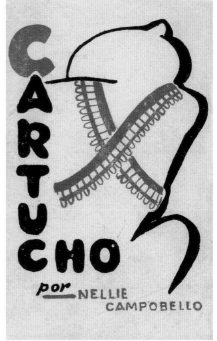

09

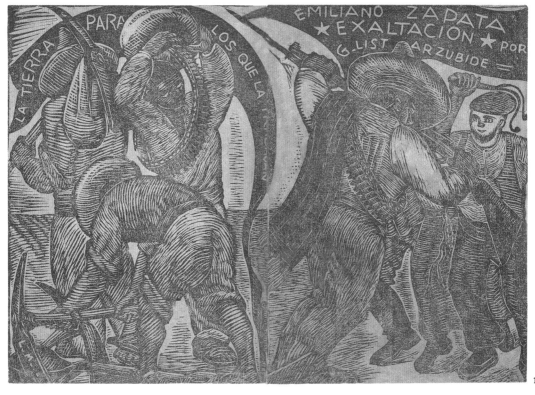

10

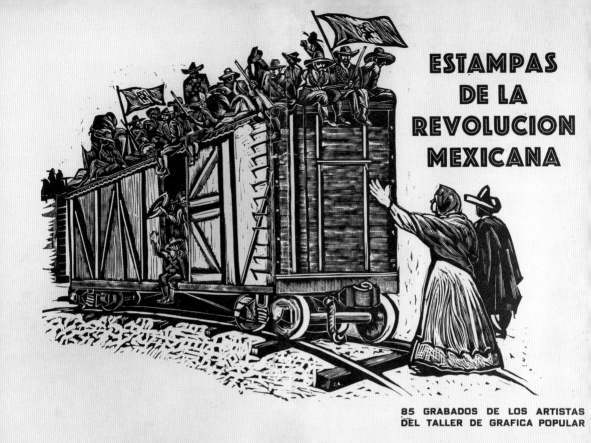

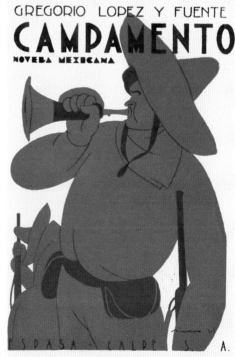

12

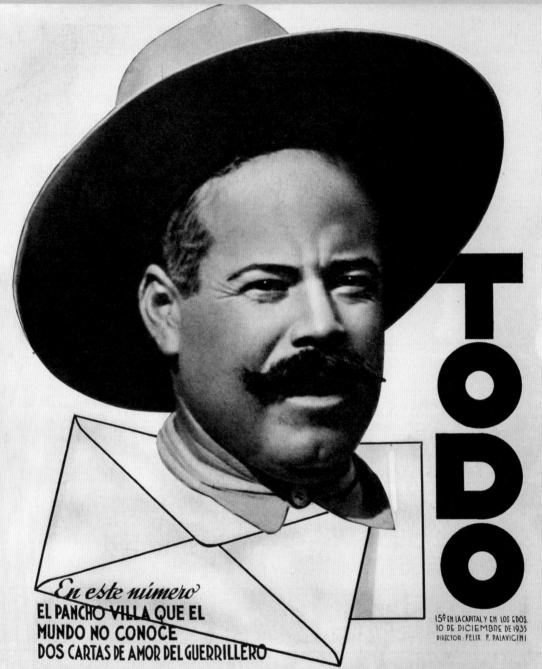

TODO

En este número
EL PANCHO VILLA QUE EL
MUNDO NO CONOCE
DOS CARTAS DE AMOR DEL GUERRILLERO

15¢ EN LA CAPITAL Y EN LOS EDOS.
10 DE DICIEMBRE DE 1935
DIRECTOR: FELIX F. PALAVICINI

13

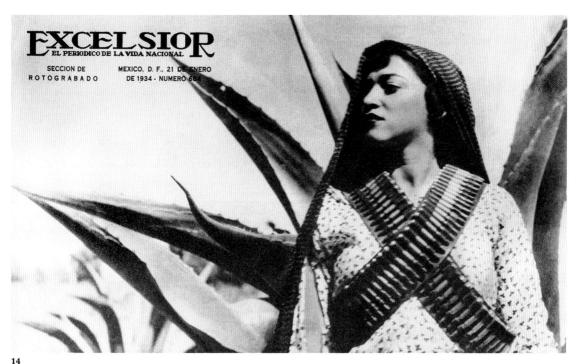

14

13 *Todo*, December 10, 1935. Mexico,
Editorial Todo Caption on cover: "In this
issue: the Pancho Villa the world doesn't
know. Two love letters from the guerilla,"
by Nellie Campobello. Portrait of Pancho
Villa MLC

14 *Excélsior*, no. 684, Mexico, January 21,
1934. Rotogravure section Page 1
(fragment): "El alma de la Revolución.
'La Soldadera'." Photo by Luis Márquez RR

15 Concha Michel, *Canciones
revolucionarias*. Mexico, 1929 Cover photo
by Tina Modotti JO

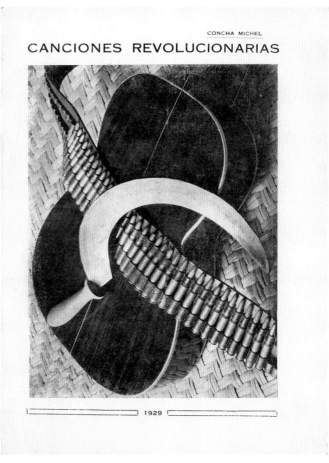

15

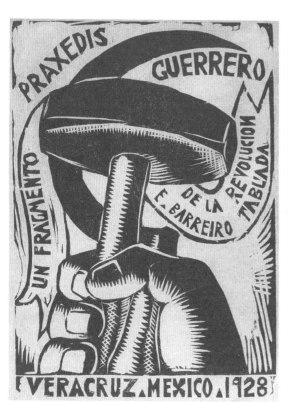

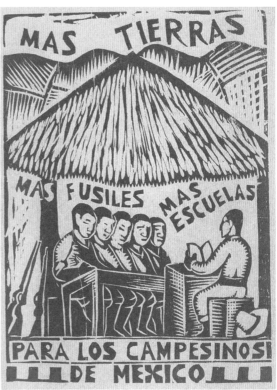

16

18 >

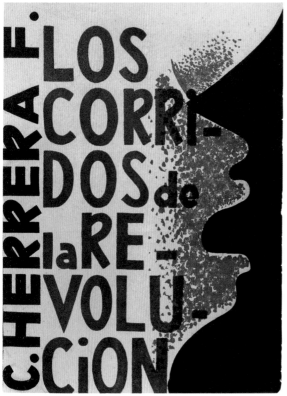

17

16 | Enrique Barreiro Tablada, *Práxedis Guerrero. Un fragmento de la Revolución*. Córdoba, Veracruz, Ediciones Norte, 1928 | Front and back covers by Leopoldo Méndez | RR

17 | *Corridos de la revolución*. Selection and prologue by Celestino Herrera Frimont. Woodcut prints by Leopoldo Méndez. Pachuca, Hidalgo, Ediciones del Instituto Científico y Literario, 1934 | Cover by Leopoldo Méndez | BSA

18 | José Reyes Pimentel and "a writer comrade," *Despertar lagunero*. Mexico, Talleres Gráficos de la Nación, 1937. Photos by Enrique Gutmann and Antonio Carrillo Jr. | Edition of 40,000 copies | Cover by Alfonso Maldonado. Back cover by Salvador Pruneda | RR

DESPERTAR LAGUNERO

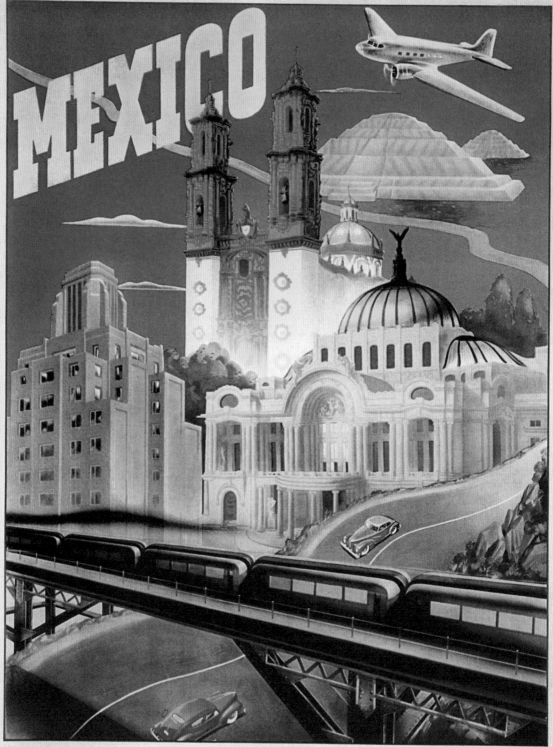

MEXICO

DEPARTAMENTO DE TURISMO
SECRETARIA DE GOBERNACION

MEXICO, D. F.

ASOCIACION MEXICANA DE TURISMO

01

MEXICO CITY

The settlement of Xochimilco is one of the capital's most popular tourist destinations. Its Nahuatl name means "floating flower field." The borough's inhabitants still maintain the ancient system of *chinampa* cultivation on human-made islands, whose canals are the last remnant of the Mexica's vast transport system. From the pre-Hispanic era onwards, Tenochtitlán transported its agricultural produce in canoes from Xochimilco, and the system continued to be used throughout the viceroyalty and the nineteenth and early twentieth centuries. Vessels would set out from the south and travel through the villages of Culhuacán, Ixtacalco, Santa Anita, Tultenco and Mixhuca, whose main stretch was known as the Paseo de la Viga **(figs. 26 and 27)**; finally reaching the Merced watercourse and the Acequia Real (Royal Canal), which ended at the Zócalo. Xochimilco's potential as a tourist destination was first developed from 1910 to 1920; docks were constructed, and the city was advertised in magazines, newspapers, guidebooks, posters and postcards, advertisements, sheet music, and even the tickets for the traditional lottery **(figs. 23 to 26, 29 and 30)**, fashioning its image as an emblematic site. However, as Xochimilco was becoming famous and establishing its progress and modernity, its canals happened to dry up. Pipelines were built for the city's rivers, and the spectacular lake system died out.

Chapultepec, an enclave in the heart of Mexico City, also has a pre-Hispanic origin. Its name means "grasshopper hill," and it housed the reservoirs and baths of the tlatoani Moctezuma. In 1785, viceroy Bernardo de Gálvez ordered the construction of what would soon be known as Chapultepec Castle. By 1840, the castle's interior also housed the Heroic Military Academy, where the Boy Heroes would die in the Mexican-American War seven years later. During the Second French Intervention, Maximilian I and Carlota took up residency in the building as Emperor and Empress of Mexico, as is shown in Justino Fernández's wonderful map **(fig. 19)**. The castle was used as the presidential home from the government of Sebastián Lerdo de Tejada until that of Plutarco Elías Calles. After 1944, it was given over to the Natural History Museum **(figs. 20 to 22)**. The zoo was built in 1923, and Chapultec, with its forest, lake, and history, art and anthropology museums, has become one of the most represented, most visited sites in Mexico.

Among the many symbolic streets and avenues in Mexico City is the Paseo de la Reforma (Promenade of the Reform), originally Paseo del Emperador and Paseo de la Emperatriz (Promenade of the Emperor / of the Empress), whose construction took place under Maximilian I. In the Restored Republic, its name was changed to Paseo Degollado in honor of the politician and military general Santos Degollado; although it was finally given its current name in 1870. During the Porfiriato, the promenade acquired an array of historical monuments, among which the most outstanding work is considered to be the Angel of Independence (1900–1910), **(fig. 02)**. Two buildings were left unfinished by the Porfirio Díaz government, which would later become landmarks of the capital city: the Palacio de Bellas Artes (Palace of Fine Arts, 1904–1934) **(fig. 09)** and the Palacio Legislativo (Legislative Palace), whose structure was used to build the Monument to Revolution (1910–1938).

After the Revolution, the city acquired a modern touch, with prominent skyscrapers dominating the landscape. The first of these to be built was the 50-meter-high La Nacional (1932–1937) **(fig. 12)**. Soon after its construction, it was superseded by the Corcuera buildings, 125 meters high, and El Moro, the home of the National Lottery offices (1938–1946) **(fig. 15)**. This period reached its peak with the building of the Torre Latinoamericana (1948–1956) **(fig. 13)**, 182 meters and 45 storeys high, which for 16 years was the highest skyscraper in the world outside the United States.

With the application of the economic model of stabilizing development, or the "Mexican Miracle" (1946–1970), Mexico City attained its modernity and became an enticing site for investors and tourists, with its glorious past and great traditions advertised in reams of printed matter.

01 *Mexico*, ca. 1940. Mexico, Departamento de Turismo, Secretaría de Gobernación, Asociación Mexicana de Turismo
Poster RR

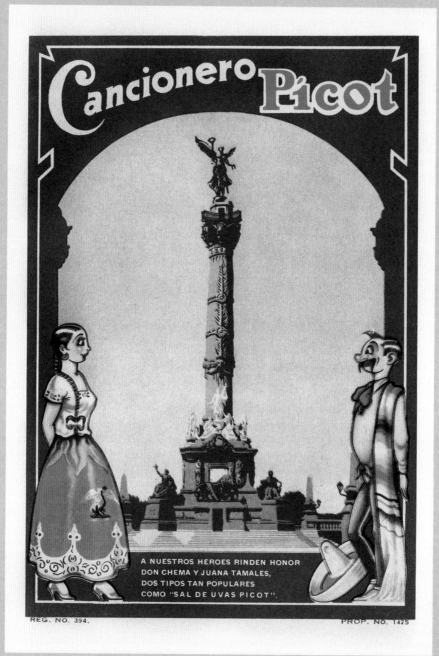

02

02 | *Cancionero Picot*, 12.ª ed. Offset Galas, Mexico, 1936 | Songbook | Cover by César Berra; background: Angel of Independence | RR

03 | *Alameda y Calle Mariscala. México*, ca. 1909 | Postcard | RLQ

04 | *Cutting the grass. Alameda, City of Mexico*, ca. 1925. Published in Mexico by J. G. Hatton | Postcard | RR

05 | *Sunday Morning in the Alameda, City of Mexico*, [n.d.]. Published in Mexico by J. G. Hatton | Postcard | JO

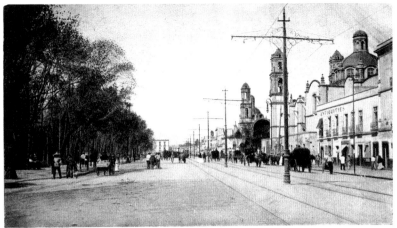

J. K. 21. México.
Regist. *Alameda y Calle Mariscala. México*

03

Cutting the grass, Alameda, City of Mexico.

J. G. Hatton, Mexico 3423

04

Sunday morning in the Alameda, City of Mexico.

3422 J. G. Hatton, Mexico.

05

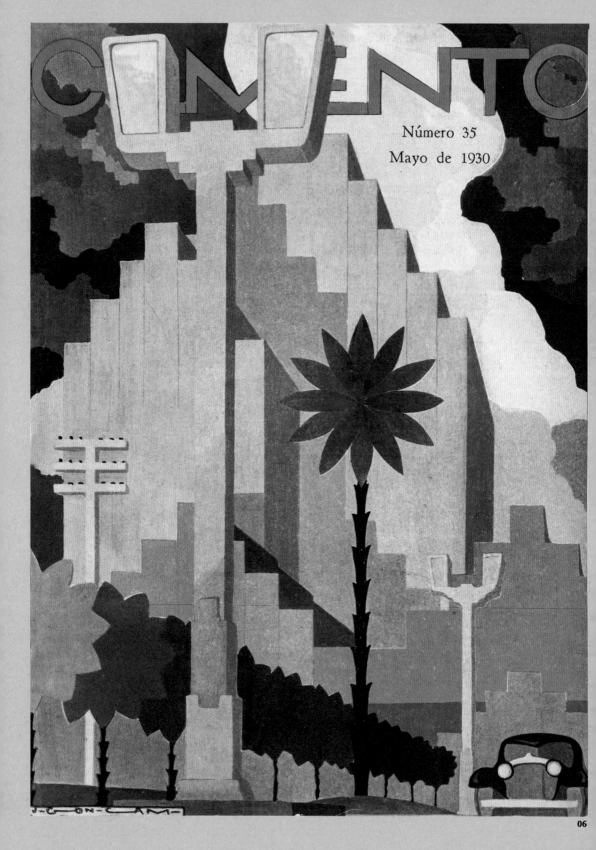

CIMENTO

Número 35
Mayo de 1930

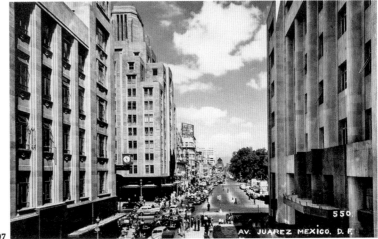

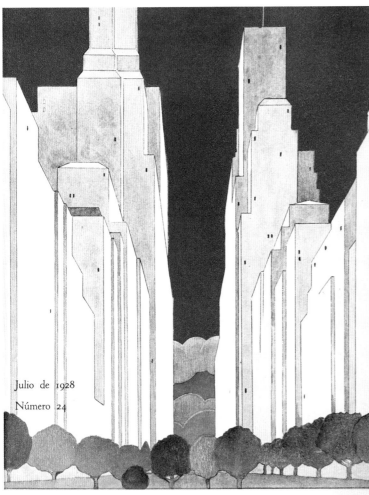

06 | *Cemento*, no. 35, Mexico, May 1930.
Comité para Propagar el Uso del
Cemento Portland. Cover drawing
by Jorge González Camarena MLC

07 | *Av. Juárez, Mexico, D.F.*, [n.d.]. Mexico
Postcard RR

08 | *Cemento*, no. 24, Mexico, July 1928.
Comité para Propagar el Uso del
Cemento Portland] Cover drawing
by Gil García MLC

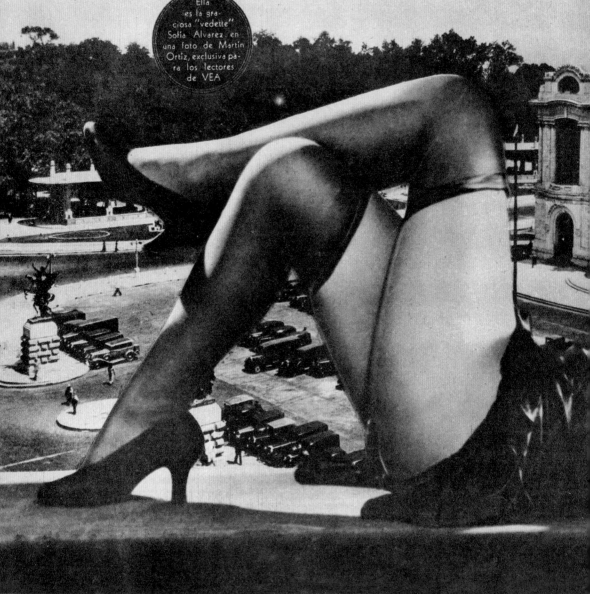

09 | *Vea*, year I, no. 1, November 2, 1934. Mexico, Fotograbadores y Rotograbadores Unidos, S.C.L. | Caption on back cover: "Exclusively for Vea readers, our lovely 'vedette,' Sofía Alvarez, in a photo by Martín Ortiz." | MLC

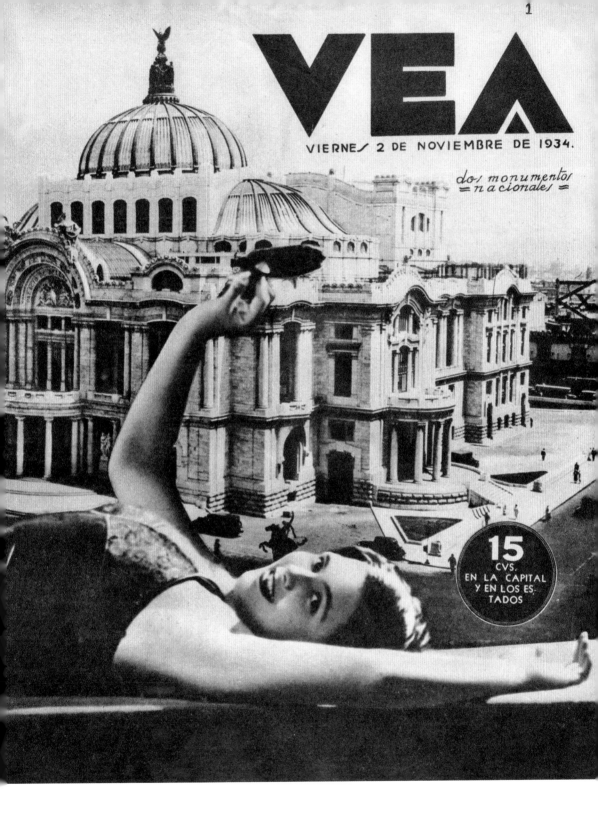

VEA

VIERNE/ 2 DE NOVIEMBRE DE 1934.

dos monumentos nacionales

15 CVS. EN LA CAPITAL Y EN LOS ES-TADOS

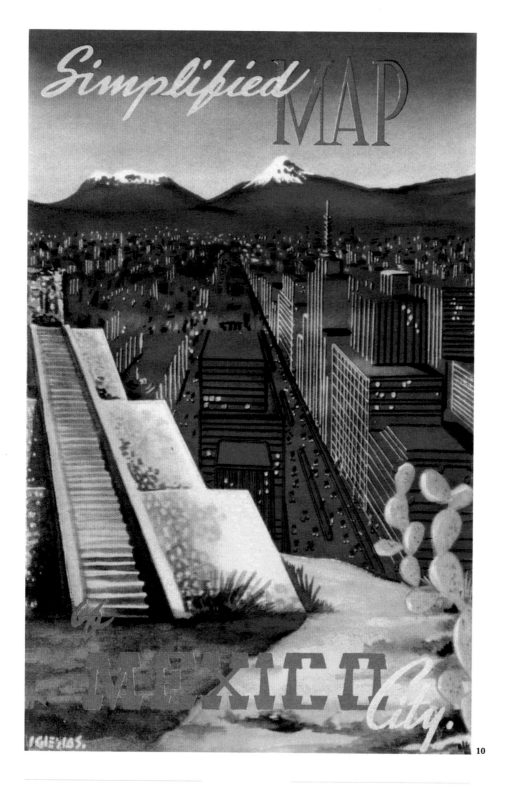

10 | *Simplified Map of Mexico City*, Mexico,
Banco Nacional de Mexico, [n.d.] | Map
Cover by Iglesias | RLQ

11 | *Mexico, The Great Metropolis*, ca. 1940.
Mexico, Dirección General de Turismo |
Poster | Illustration by A. Regaert | RR

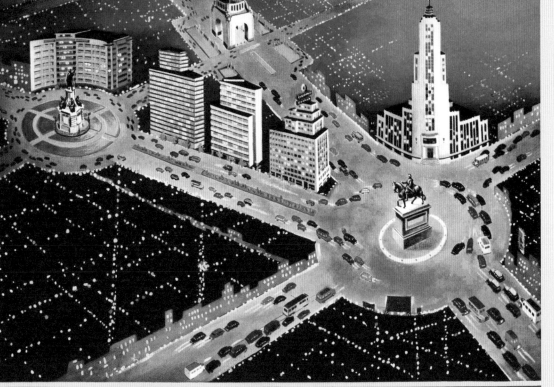

MEXICO

THE GREAT METROPOLIS

DIRECCION GENERAL DE TURISMO

AV. JUAREZ 89 **MEXICO, D.F.**

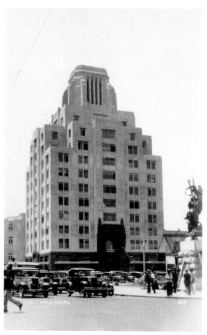

12

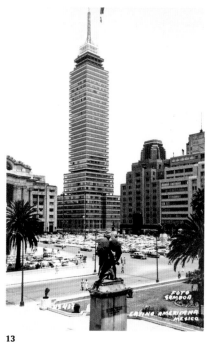

13

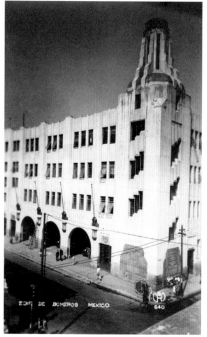

14

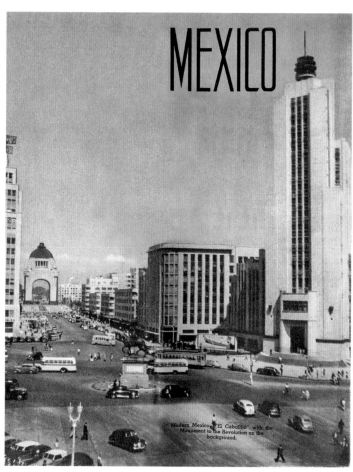

Modern Mexico. "El Caballito" with the Monument to the Revolution on the background.

15

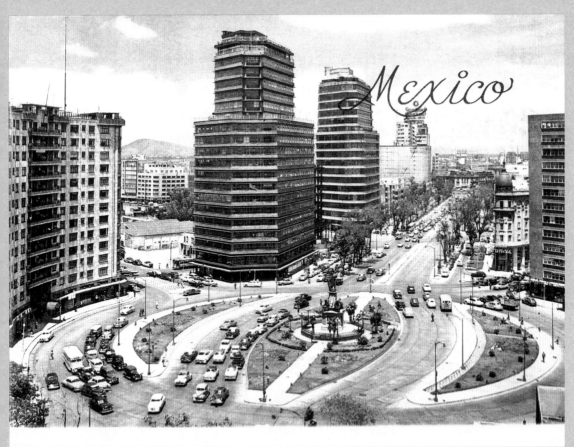

16

MEXICO

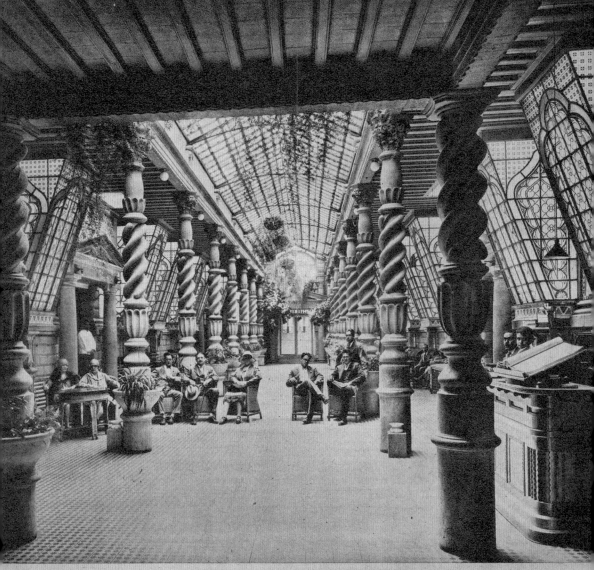

THE GREAT SUNNY, FLOWER-DECKED LOBBY.

HOTEL GENEVE
~ MEXICO CITY ~

17

MEXICO MEXICO

HOTEL GENEVE FROM LIVERPOOL STREET.

OTEL GENEVE HOTEL GENEVE
MEXICO CITY MEXICO CITY

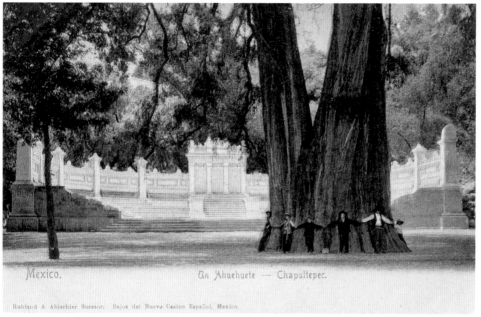

Mexico. Un Ahuehuete — Chapultepec.

Ruhland & Ahlschier Sucesor. Bajos del Nueve Casino Español, Mexico.

18

19

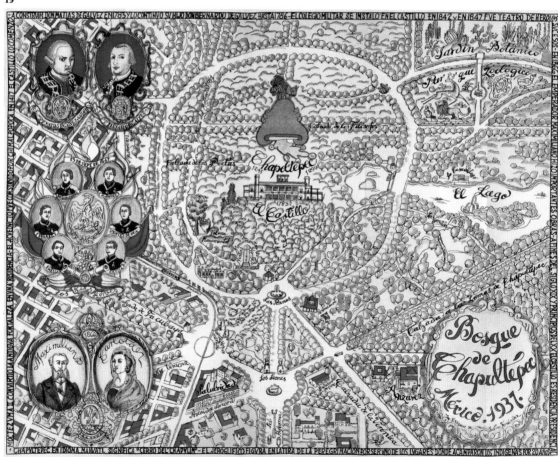

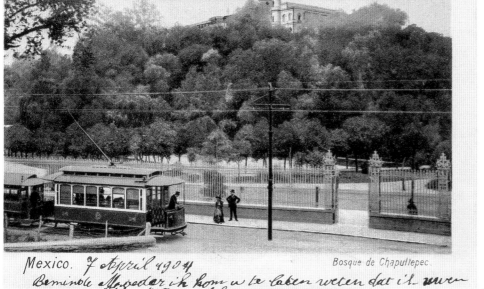

Mexico. 7 April 1904
Bosque de Chapultepec.

[handwritten message]

20

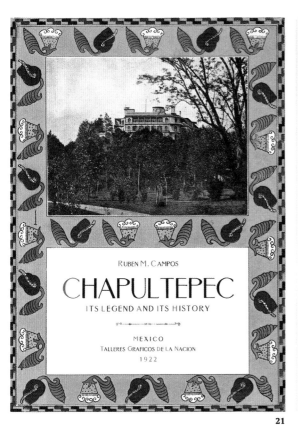

RUBEN M. CAMPOS

CHAPULTEPEC

ITS LEGEND AND ITS HISTORY

MEXICO
TALLERES GRAFICOS DE LA NACION
1922

21

ENTRANCE TO
CHAPULTEPEC PARK

22

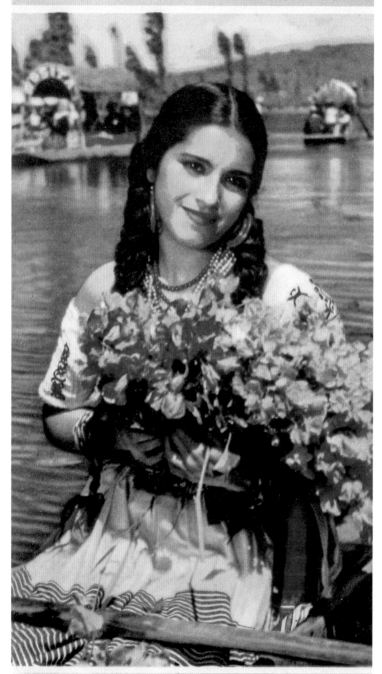

MEXICO

THE LAND OF CONTRASTS

18 | *Un ahuehuete – Chapultepec*, [n.d.]. Published in Mexico by Ruhland & Ahlschier Sucesor | Postcard | RR

19 | *Bosque de Chapultepec*, Mexico, 1937 | Map by Justino Fernández | MLC

20 | *Bosque de Chapultepec*, ca.1904. Mexico | Postcard | RR

21 | Rubén M. Campos, *Chapultepec, its Legend and its History*. Mexico, Talleres Gráficos de la Nación, 1922 | Cover | RLQ

22 | *Mexico*, 1931. Published by Compañía Telefónica y Telegráfica Mexicana | Guidebook | Caption on cover: "Entrance to Chapultepec Park" | RR

23 | *Mexico, the Land of Contrasts*, Mexico, Departamento de Turismo de la Secretaría de Gobernación, [n.d.]. Printed by Offset Galas | Tourist brochure | Cover | RR

24 | *Así es México*. Mexico, Departamento de Turismo de la Secretaría de Gobernación, Asociación Mexicana de Turismo, Mexico, 1945. Printed by Offset Galas | Tourist brochure | Cover | RR

23

24 >

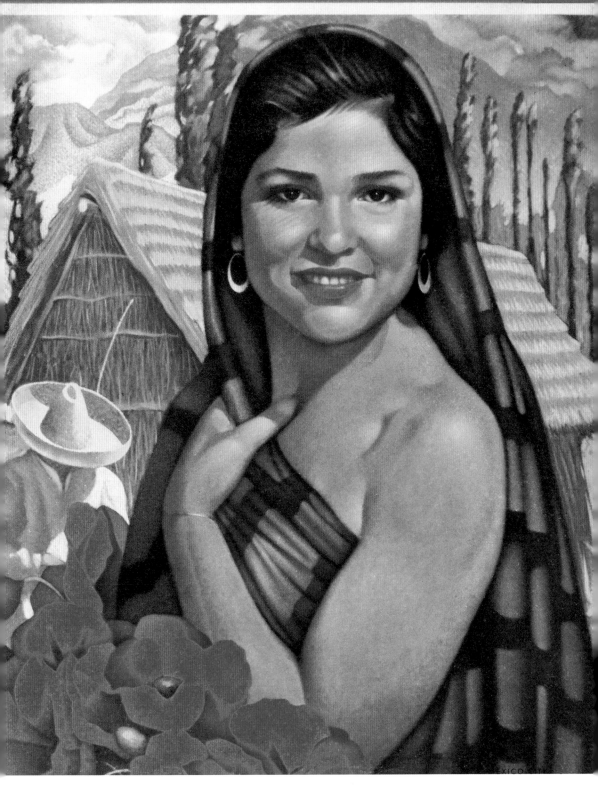

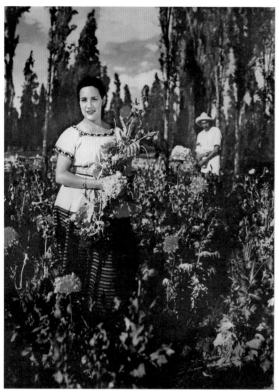

25

J. K. 46. México. *Canal de La Viga.* México.
Regist.

27

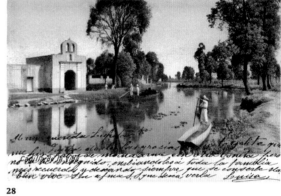

28

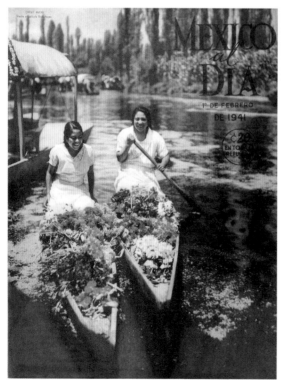

26

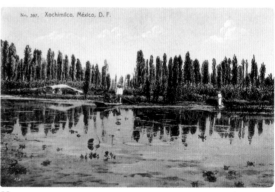

No. 397. Xochimilco, México, D. F.

29

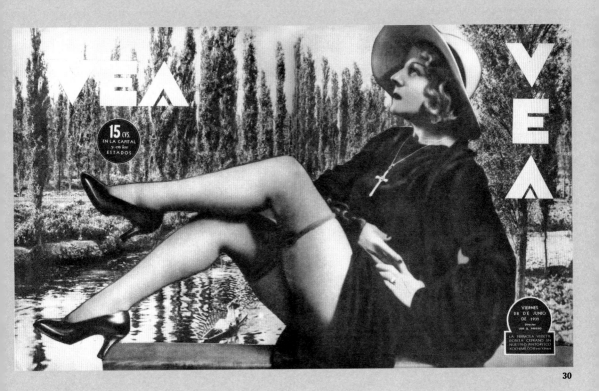

30

Handy..

MYSTERIOUS... COLORFUL... EXOTIC...

MEXICO!

NATIONAL RAILWAYS OF MEXICO
(WORKERS' ADMINISTRATION)

01

GOING INLAND

Thoroughfares in pre-Hispanic times consisted of paths and lanes along which paid carriers and slaves transported goods on their backs to different territories. The tracks were also frequented by salesmen, warriors, tax collectors and payers, and messengers. With the arrival of the Spaniards, some of them fell into disuse, while others were extended or transformed by the constant passage of pack mules and carts as well as the newly-introduced horses. Little by little the Camino Real de Tierra Adentro (Royal Road of the Interior Land), which led from the capital of New Spain to the four cardinal points—northwards to Santa Fe, south to Guatemala, eastwards to Veracruz and west to Acapulco. Travel routes, however, were long, tortuous, slow, and expensive, and this lasted into the nineteenth century until the construction of the railroads.

Guidebooks for foreigners, calendars, almanacs, and yearbooks were the first publications containing regional information for travelers. While these were circulated, foreigners from different countries were arriving and also leaving superb testimonies of their travels, such as chronicles and splendid albums with lithographic prints and engravings, all of which served to advertise Mexico outside its own borders.

The proliferation of lithography studios after 1840 meant that images of everyday customs and regional traditions could be circulated in illustrated books and magazines, and the distribution of images was massively incremented by the advent of photography and, particularly, the invention of the postcard and its rapid popularization. At the end of the nineteenth century, the Universal Postal Union introduced its regulatory 9 x 12 cm format and stipulated that it cost half the price of a normal letter to send. Mexican postcards were chromolithographs, photo-etchings, or phototypes, and the ease and low cost of the format made them the perfect items to collect or exchange. Postcards were made of the most emblematic and picturesque sites of the 32 states of the Mexican Republic (figs. 06, 08, 09, 16 to 18, 24 to 31 and 42).

At the end of its Revolution, Mexico was essentially an agricultural nation and was devastated, with poor transport networks and few railroads or tracks for mechanized vehicles or commerce. These conditions were a hindrance to the government's project of capitalist modernization. Measures were gradually taken, but in 1925 President Plutarco Elías Calles gave his support to the construction of modern roads with materials adequate for cars and trucks. The national transport network grew exponentially, and licensed aircraft soon began to cross the skies (fig. 02), improving communications with distant regions.

By 1929, increasing numbers of foreign visitors were arriving in Mexico, particularly from the United States, and the Comisión Mixta Pro Turismo (Mixed Pro-Tourism Committee) was set up by the government as the first institution for managing tourism and the income generated by it. The flow of tourists grew, and during the presidency of Manuel Ávila Camacho the "peso contra peso" (peso for peso) campaign was launched: the federal government would give one peso for each one earned from private endeavor to advertising Mexico as a tourist destination. Because most foreign tourists were from the United States, most of the posters, maps, guidebooks, and brochures to this end were in English (figs. 01, 03, 04, 13, 14 and 39 to 41). These advertisements were not exclusive, and local tourism also grew, with several sites becoming almost compulsory recreational destinations and others, such as Acapulco, highly popular (figs. 46 to 48).

01 *Handy.. Mysterious... Colorful... Exotic... Mexico!* National Railways of Mexico. Printed by Offset Galas, Mexico, ca. 1950 Poster Illustration by José Espert Arcos RR

TRANSPORTES AÉREOS DE CHIAPAS
GERENTE: FRANCISCO SARABIA
TUXTLA GTZ. CHIAPAS

VIAJE USTED A TRAVÉS DE CHIAPAS
Y HASTA LA CIUDAD DE MÉXICO
PASANDO POR OAXACA
UTILIZANDO NUESTROS
AVIONES

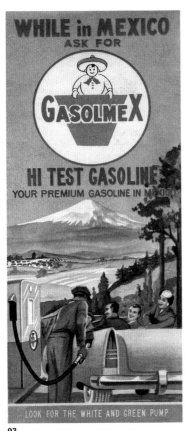

03

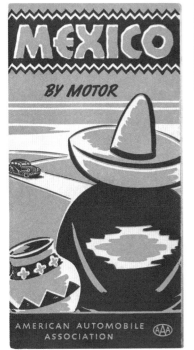

04

05

02 *Ilustrado*, year XIX, no. 970, Mexico, December 12, 1935. MLC

03 *Caminos de Mexico, Mexican Highways*. Mexico, Club de Viajes Pemex, ca. 1950 Roadmap. Advertisement by Gasolmex RLQ

04 *Mexico by Motor*. Washington, D.C., American Automobile Association, 1947 Roadmap JO

05 *AMA* magazine, year I, no. 1, July 1953. Mexico, Editorial Letras. Cover by Daniel Núñez JO

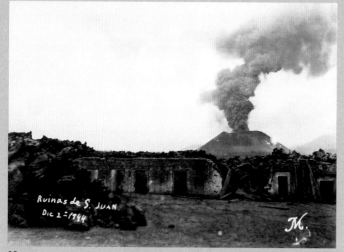

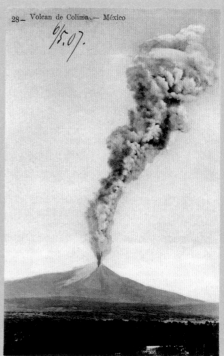

06

07

08

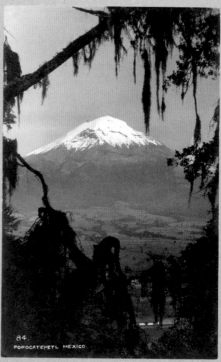

06 | *Ruinas de S. Juan*, 1944. Mexico | Postcard | RR

07 | *Mexico*, ca. 1960 | Photo album of the Mexican Republic | RLQ

08 | *Volcán de Colima.—Mexico*, ca. 1907. Mexico | Postcard | Photo by Z. Saucedo | RLQ

09 | *Popocatépetl, México*, [n.d.]. Mexico | Postcard | RLQ

10 | *Mexico bello.* Waltz for piano solo by Miguel Lerdo de Tejada, 2nd ed., [n.d.]. Mexico, A. Wagner, Levien Sucs. | Score | Cover, with photos by Arriaga | RLQ

09

2ª Edición.

MEXICO BELLO

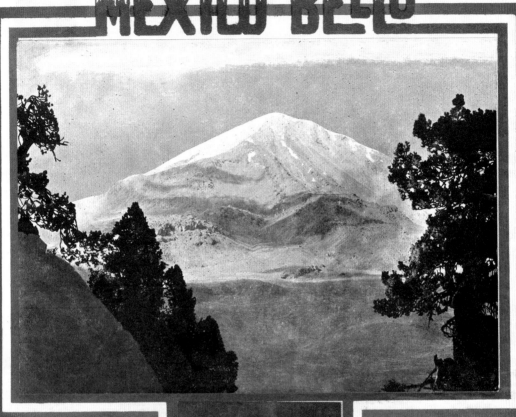

Amparo, Vals
Ana María, Vals
Vals Tuyo
Souvenir de México, Vals
Consentida, Vals
Siempre te amaré, Vals
Amor mexicano, Vals
Al amanecer, Vals
Bondad, Vals
Al fin solos, Schottisch
Baile de Sorpresa, Schottisch
Los Apuros, Danzas
Virtudes, Danzas
Caracteres, Danzas
Pecados, Danzas
Buena Vista, Two-step
Calandrias, Two-step
Caricaturas, Two-step
Siempre adelante, Two-step
Victoria-Luisa, Two-step
Las Golondrinas Two-step
Dicen que no, Danza para Canto y P.
Perjura, Danza para Canto y Piano
El Ratoncito, Danza para Canto y P.
Sin Ti, Danza para Canto y Piano
Te amo y Cuba Danza para Canto y P.
A México, Danza para Canto y Piano
Anhelos, Danza para Canto y Piano
Ya soy feliz, Danza para Canto y Piano

VALS

para Piano solo
por

Miguel Lerdo de Tejada.

Propiedad del Autor Depositado conforme a la ley, 1908
DE VENTA UNICAMENTE EN LOS GRANDES
REPERTORIOS DE MUSICA DE
A. Wagner y Levien Sucs.
1a. Capuchinas 21.—MEXICO.—Apartado núm. 352
Puebla, Guadalajara, Monterrey, Veracruz.

10

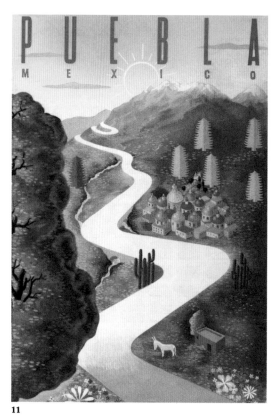

11

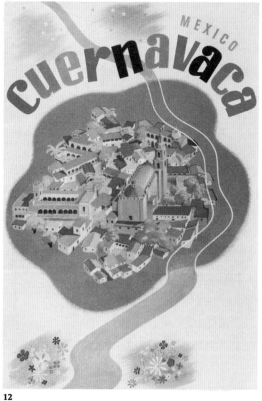

12

13

11 *Puebla, México*. Asociación Mexicana de Turismo, Departamento de Turismo de la Secretaría de Gobernación. Printed by Offset Galas, Mexico, 1941 Guidebook Photos by Hugo Brehme RR

12 *Cuernavaca, México*. Mexico, Asociación Mexicana de Turismo, 1940. Printed by Offset Galas JO

13 *Touring in Mexico*, Mexico, Tours Digest, published by National Tourist Commission of Mexico, 1949 Back and front covers with map by Cortés RLQ

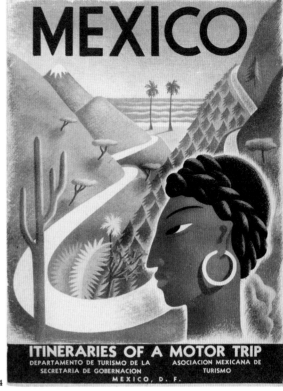

14

14 *Mexico. Itineraries and Approximate Costs of a Motor Trip to Mexico*. Mexico, Departamento de Turismo de la Secretaría de Gobernación, ca. 1948 Guidebook Cover attributed to José Espert Arcos JO

15 *Morelia, Pátzcuaro, Uruapan, México*. Spanish edition. Asociación Mexicana de Turismo, Departamento de Turismo de la Secretaría de Gobernación. Printed by Offset Galas, Mexico, 1943 Guidebook Cover by José Espert Arcos RR

15

16

17

18 **19 >**

16 | *El viejo campanero / The Old Indian Sexton*. Sexton, [n.d.]. Series Arco Iris, published in Mexico by Fischgrund | Postcard | Photo by Luis Márquez | JO

17 | *Aguadoras. Oaxaca, México*. 1937. Series Arco Iris, published in Mexico by Fischgrund | Postcard | Photo by Luis Márquez | JO

18 | *Calle del Campanero / The Billman Street*, [n.d.]. Guanajuato, Mexico | Postcard | RR

19 | *El Maestro Rural*, dedicated to rural education, vol. IV, no. 5, March 1, 1934. Mexico, Secretaría de Educación Pública, printed by Talleres Gráficos de la Nación | Cover | RLQ

EL MAESTRO RURAL

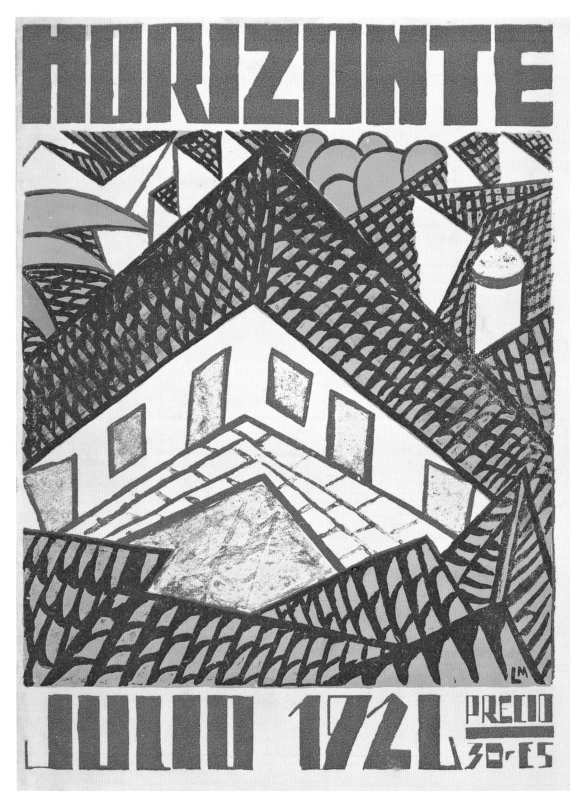

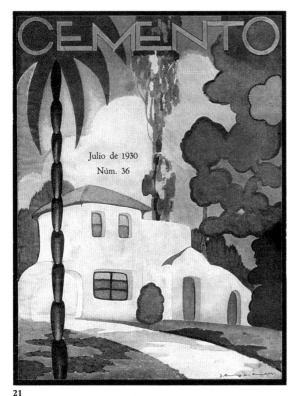

21

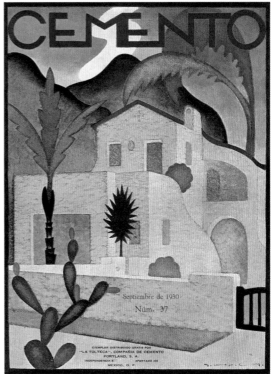

22

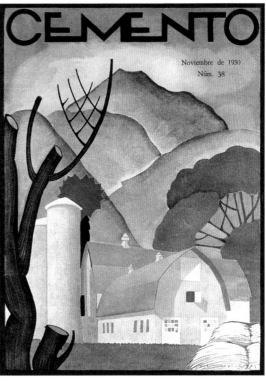

23

20 *Horizonte*, Jalapa, vol. I, no. 4, July 1926 Cover by Leopoldo Méndez CEL

21 *Cemento*, no. 36, July 1930. Mexico, Comité para Propagar el Uso del Cemento Portland Cover by Jorge González Camarena RLQ

22 *Cemento*, no. 37, September 1930. Mexico, Comité para Propagar el Uso del Cemento Portland Cover by Jorge González Camarena RLQ

23 *Cemento*, no. 38, November 1930. Mexico, Comité para Propagar el Uso del Cemento Portland Cover by Jorge González Camarena RLQ

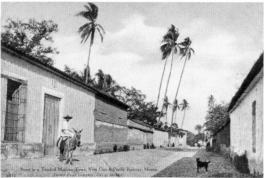

24

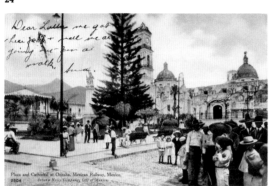

25

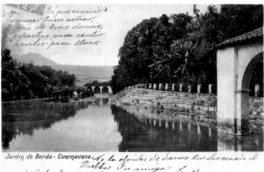

26

27

28

29

30

24 | *Street in a Tropical Mexican Town, Vera Cruz & Pacific Railway, Mexico*, [n.d.]. Published in Mexico by Sonora News Company | Postcard | JO

25 | *Plaza and Cathedral at Orizaba, Mexican Railway, Mexico*, ca. 1909. Published in Mexico by Sonora News Company | Postcard | RLQ

26 | *Jardín de Borda – Cuernavaca*, ca. 1894. Published in Mexico by Jacobo Granat | Postcard | RLQ

27 | *Old Gateway at Amecameca, Interoceanic Railway, Mexico*, [n.d.]. Published in Mexico by Sonora News Company | Postcard | Photo by Percy S. Cox | JO

28 | *Amecameca. Los volcanes*, ca. 1906. Published in Mexico by Ruhland & Ahlschier Sucesor | Postcard | RLQ

29 | *Casino de Tehuacan*, Mexico, [n.d.] | Postcard | RLQ

30 | *Puente de Metlac—Veracruz, Mexico*, [n.d.]. Published in Mexico by J. Suter & Co. | Postcard | RLQ

31 | *Ahuehuete de Santa María del Tule. Oaxaca, México / Ahuehuete of Saint Mary of Tule. Oaxaca, Mexico*, [n.d.]. Published in Mexico by Félix Martín | Postcard | JO

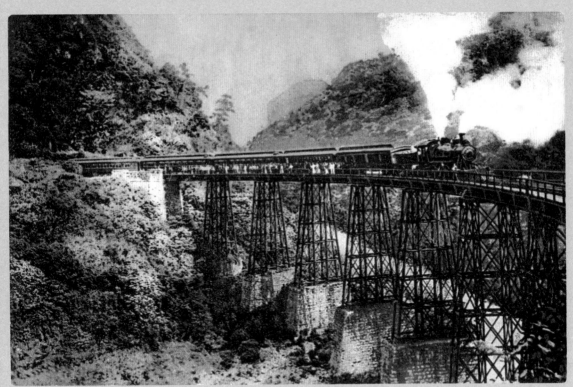

30

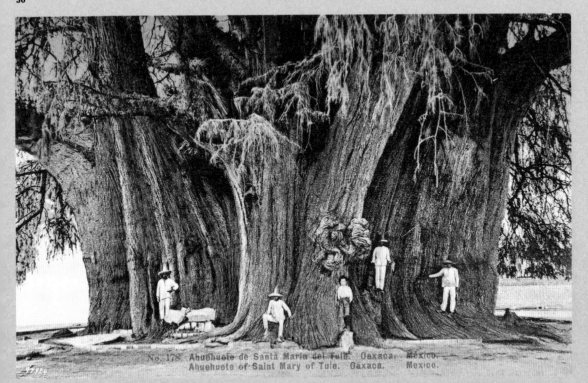

No. 178 Ahuehuete de Santa Maria del Tule. Oaxaca. Mexico.
Ahuehuete of Saint Mary of Tule. Oaxaca. Mexico.

31

Jueves de Excelsior

Director: Manuel Horta.

Número 445
VALE 15 Cvs.

MEXICO, D. F., JUEVES
18 DE DICIEMBRE DE 1930.

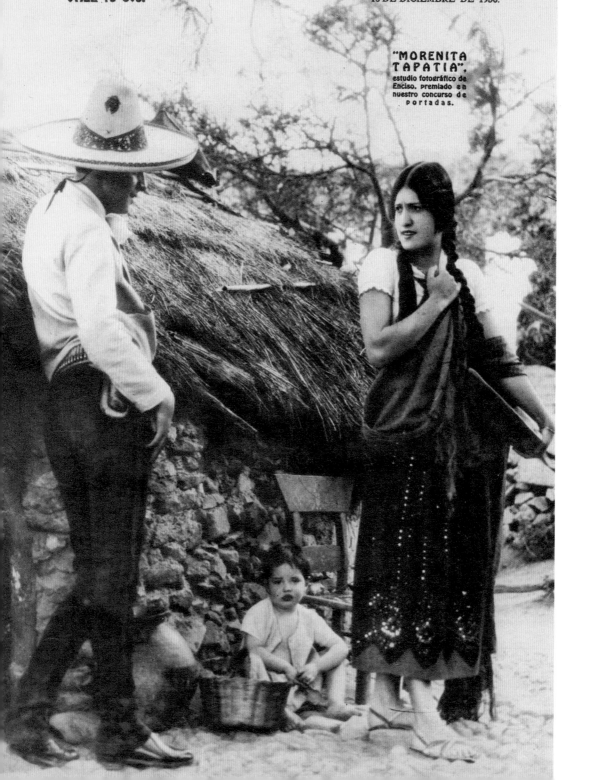

"MORENITA TAPATIA", estudio fotográfico de Enciso, premiado en nuestro concurso de portadas.

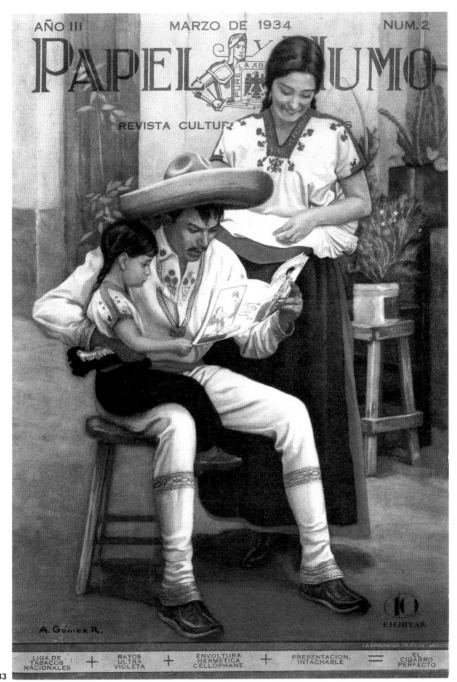

32 33

32 *Jueves de Excélsior*, no. 445, Mexico City, Thursday, December 18, 1930 Photo caption on cover "*Morenita tapatía*: photographic study by Enciso, the award winner in our Cover competition." RLQ

33 *Papel y Humo*, year III, no. 2, March 1934. Mexico, Compañía Manufacturera de Cigarros El Águila, S.A. Cover by A. Gómez R. RLQ

MEXICAN
ART & LIFE

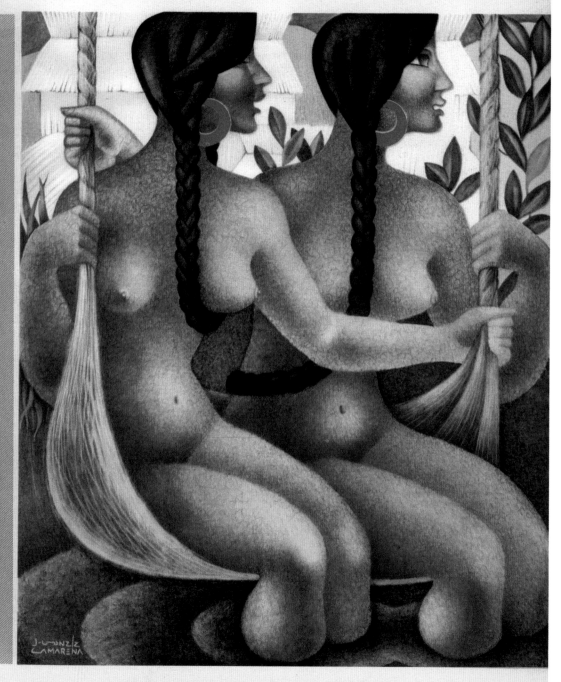

SPRINGTIME by JORGE GONZALEZ CAMARENA.

APRIL 1939 ★ Nº 6 ★ D·A·P·P

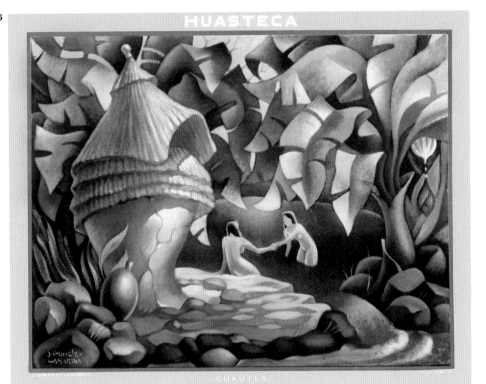

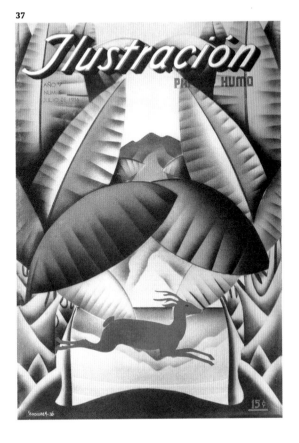

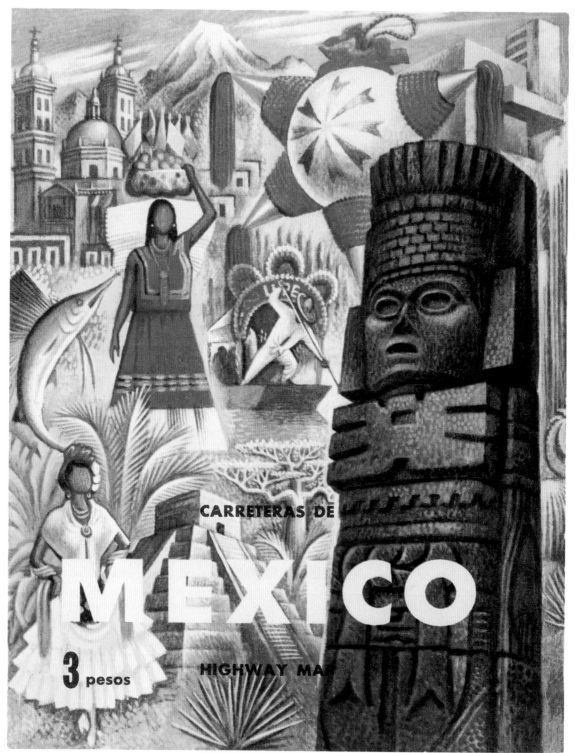

CARRETERAS DE

MEXICO

3 pesos

HIGHWAY MAP

38

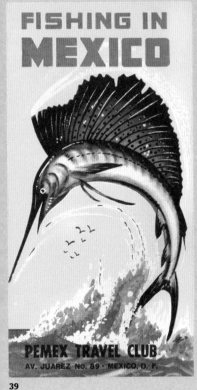

39

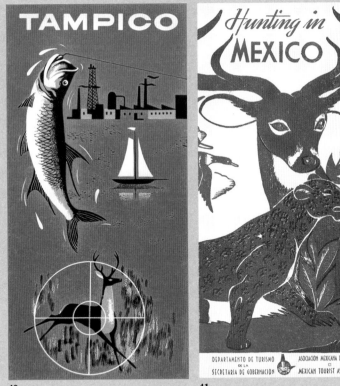

40

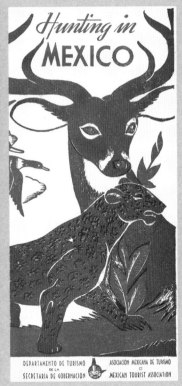

41

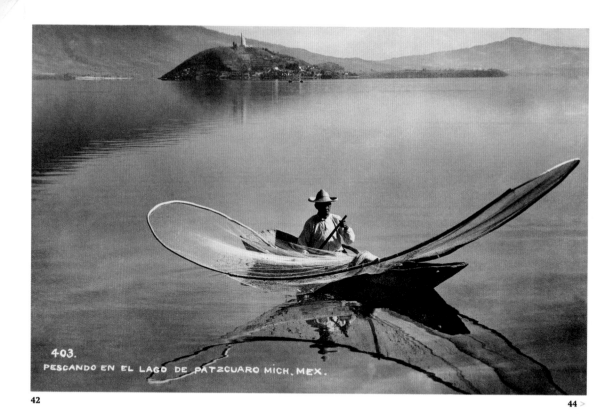

42

44 >

42 | *Pescando en el lago de Pátzcuaro, Mich.,*
Mex. Mexico, 1930–1950 | Postcard | JO

43 | *Mexico.* Asociación Mexicana de
Turismo / Mexican Tourist Association,
ca. 1950. Printed by Offset Galas, Mexico |
Postcard | Drawing by Jorge Bueno | RR

44 | *Revista de Revistas,* year XVI, no. 789,
Mexico, June 21, 1925. Published by
"Excélsior", Compañía Editorial S.A.
| Cover: "Un pescador del lago de
Pátzcuaro," drawing by Ernesto García
Cabral | MLC

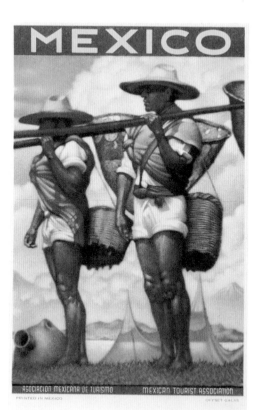

43

REVISTA DE REVISTAS
EL SEMANARIO NACIONAL

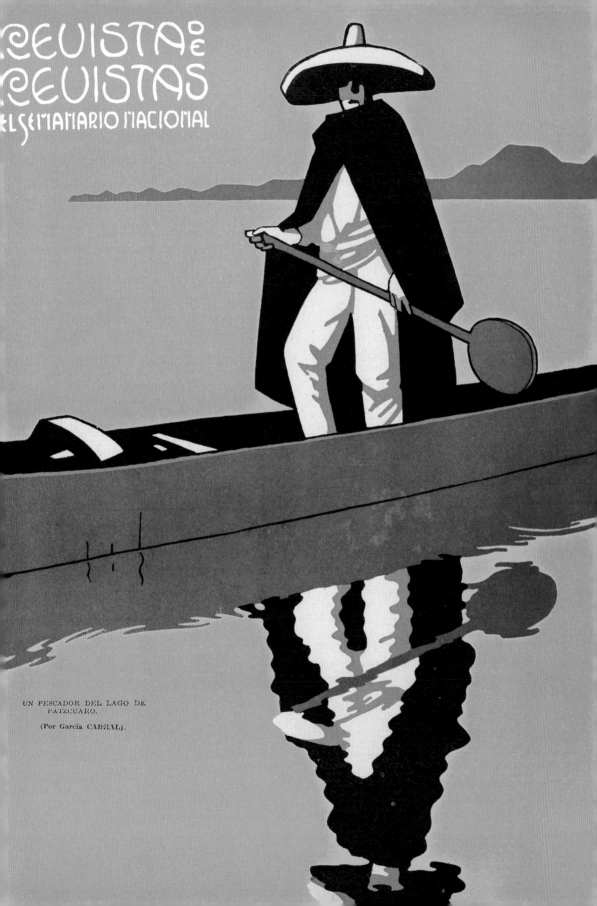

UN PESCADOR DEL LAGO DE PATZCUARO.

(Por García CABRAL).

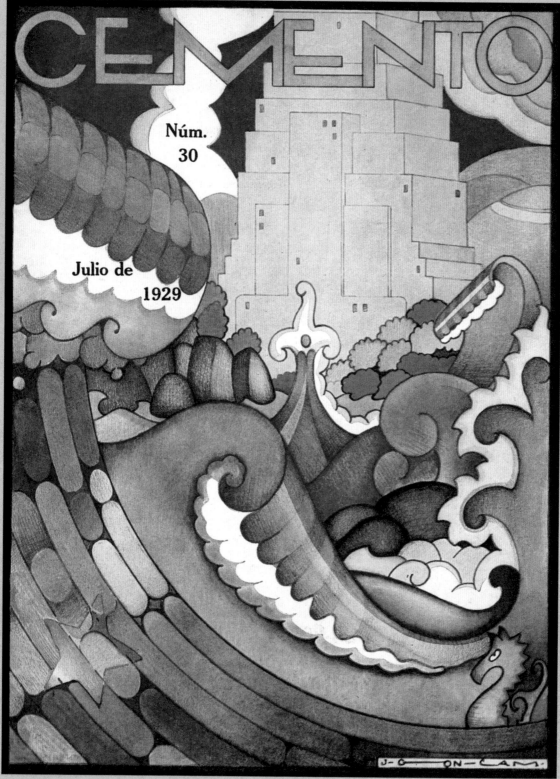

CEMENTO

Núm. 30

Julio de 1929

45

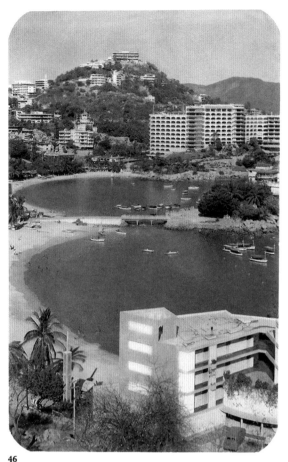

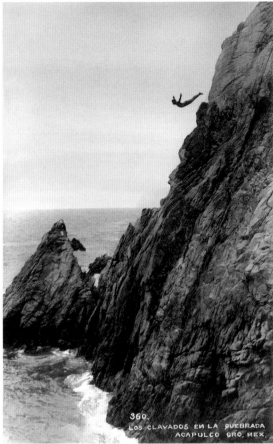

46
47

45 *Cemento*, no. 30, July 1929. Mexico,
Comité para Propagar el Uso del Cemento
Portland Cover by Jorge González
Camarena RLQ

46 *Vista de Caleta y Caletilla*, Acapulco,
Gro., Mexico, [n.d.] Postcard RLQ

47 *Los clavados en La Quebrada, Acapulco
Gro.*, Mexico, [n.d.] Postcard RLQ

48 *Acapulco, Mexico.* Acapulco, an
Adventure in living, B series, no. 3.
Mexico, Departamento de Turismo de la
Secretaría de Gobernación, Asociación
Mexicana de Turismo. Printed by Galas,
ca. 1941 Cover by José Espert Arcos RLQ

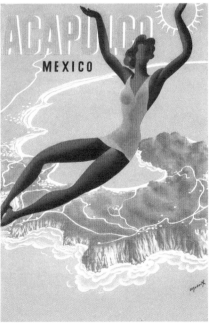

48

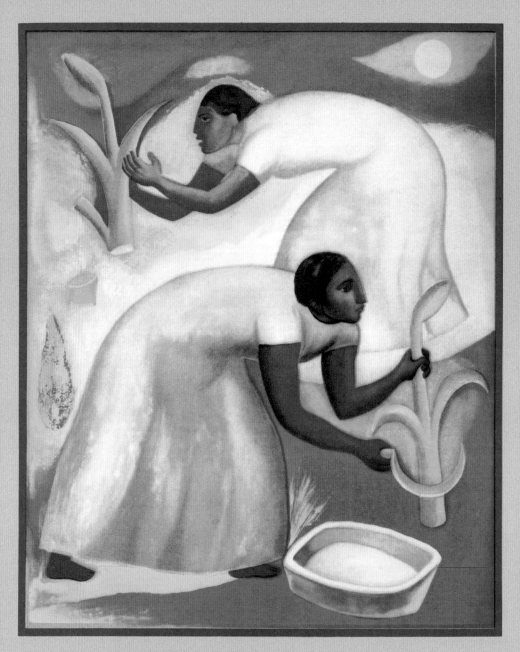

MEXICAN
ART & LIFE
Nº 4 · OCTOBER 1938 · D·A·P·P

THE FERTILE LAND

Pre-Hispanic Mexico contributed some essential foods to world cuisine. Cocoa, the tomato, and the avocado were among its produce, but sweet fruits such as the sapodilla, pawpaw, capulin cherry, pineapple, sapote, guava, mamey, yellow plum, and cactus fruit, as well as lesser-known ones like the pitaya, Manila tamarind, the quenepa, custard apple, nanche, tejocote, and the soursop also originated there. Different flowers were also introduced to other civilizations: the poinsettia; the dahlia with its 43 species, decreed Mexico's national flower in 1963; the Mexican marigold and orchid; the daisy; amaranth, sage, tuberose, the arum lily, magnolia, the spurred anoda, the lily; the *nopalxochitl* or German Empress, *zompantle* (Erythrina americana), and *quiote* (agave stalk), among many others. Displays and sales of rural produce in open-air markets have always been a captivating experience for all of the senses.

The word *tianguis* comes from the Náhuatl *tianquiz(tli)*, meaning "market." The Mexica ran the famous tianguis in Tlatelolco, whose "regulated order, and its administration and control by government employees, were admired by Cortés and other conquerors. Measurements, quality, and transactions were constantly inspected by people at one end of the large square, stationed there to administer the workings of the entire market."[1] Barter was the most common form of commercial transaction, although cocoa beans were also used as a currency. In smaller settlements, the general market was held every five days, and there were specialized markets in certain places: fattened dogs could be got at Alcoman; jewels, feathers, and precious stones at Cholula; pottery, fine clothing, and painted jícaras at Texcoco; gold, silver, and polished stones at Xochimilco; slaves at Azcapotzalco. Although metal coins were introduced by the Spaniards, open-air markets continued to be held periodically in public squares all over New Spain. According to the historian Jorge Olvera, "The atmosphere that reigned in the squares was more like a fair, where crowds gathered but not necessarily for the purpose of consuming. They were meeting places where people could chat and discuss current events."[2]

1. *Diccionario Porrúa de historia, biografía y geografía de México*, 6th edition (México: Porrúa, 1995), 2206.

2. Jorge Olvera Ramos, *Los mercados de la Plaza Mayor en la Ciudad de México* (Mexico: Ediciones Cal y Arena, 2007), 16.

Sellers with their goods, town criers, and costumes became emblematic figures of the markets, and the chroniclers, travelers, and engravers of the nineteenth century left grand testimonies of them as popular types. With the advent of photography and the first postcards, a larger array of characters were portrayed, journeying from faraway regions to sell their produce. They ranged from vendors of ice-creams to coal **(fig. 21)**, biscuits, butter, chickens, fruit **(fig. 20)**, baskets **(fig. 18)**, fish, cages, candles, sweets, bacon, eggs, flowers, pots, pans, rods **(fig. 28)**, reed mats, and other goods.

After the Revolution, painters, illustrators, and advertisers all printed and circulated the idea of a Mexican paradise inhabited by beautiful indigenous women offering up exotic flowers and sumptuous fruits in precious baskets and trays **(figs. 02, 04 to 06 and 09 to 15)**, who could be casually encountered at the open-air market **(figs. 25, 29 and 30)**. On November 21, 1969, the government launched the first tianguis or "markets on wheels" so that city dwellers could purchase their fruit and vegetables directly from farmers. More than 1,500 of these mobile markets continue to exist in Mexico City.

01 *Mexican Art & Life*, no. 4, October 1938. Mexico, DAPP. Cover by Carlos Orozco Romero JO

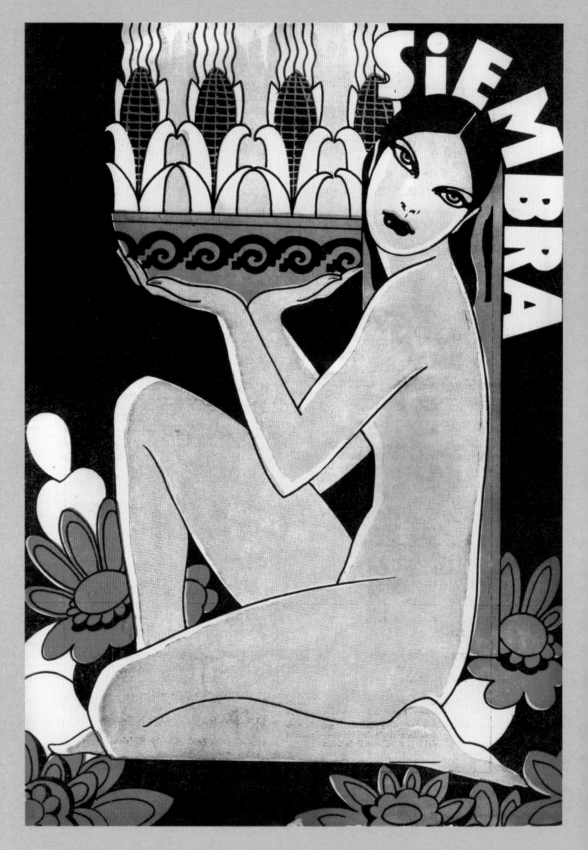

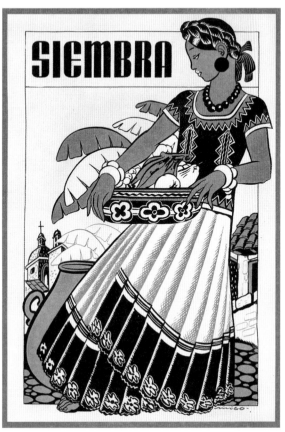

03

04

02 *Siembra*, year I, vol. 1, no. 2, May 15, 1943. Mexico, Confederación Nacional Campesina Cover by Carlos Stahl RLQ

03 *Mexican Folkways*, vol. 3, no. 1, February–March 1927. Mexico, Frances Toor Cover by A. L. RLQ

04 *Vea*, year V, no. 219, Mexico, January 6, 1939. Page 13: "Trópico," drawing by Isidro López Guerrero MLC

05 *Siembra*, year II, vol. 2, no. 10, January 1, 1944. Mexico, Confederación Nacional Campesina Cover by Iñigo RLQ

05

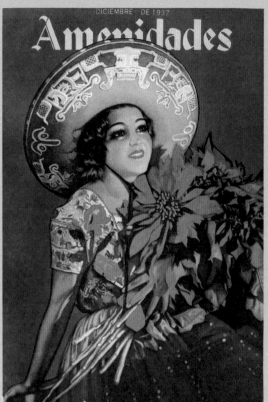

06

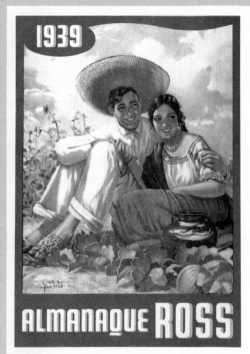

07

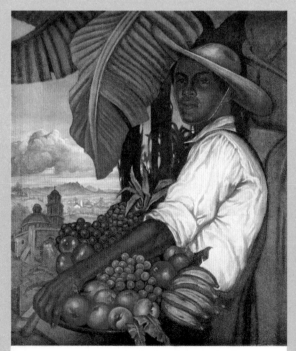

VENDEDOR DE FRUTAS.-Dibujo por Ernesto García Cabral.

08

06 | *Amenidades*, year VII, no. 74, December 1937, Mexico, Editorial Sayrols, S.A. | RR

07 | *Almanaque Ross. 1939*. Mexico. Printed by Offset Galas México | Cover by García Arévalo | RR

08 | *Revista de Revistas*, year XXV, no. 1303, May 5, 1935. Mexico, Excélsior, Cía. Editorial, S.A. | Cover: "Vendedor de frutas," drawing by Ernesto García Cabral | RLQ

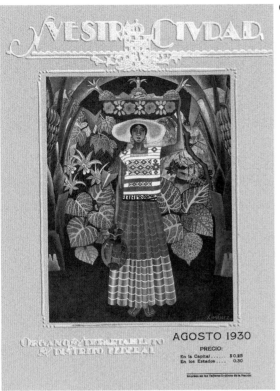

09

09 *Nuestra Ciudad*, year I, no. 5, August 1930. Departamento del Distrito Federal. Mexico, printed by Talleres Gráficos de la Nación. Cover by Alfredo Ximénez JO

10 *México*. Asociación Mexicana de Turismo / Mexican Tourist Association, [n.d.]. Printed in Mexico by Offset Galas Postcard RR

11 *Almanaque dulce. 1939*. Mexico, Unión Nacional de Productores de Azúcar, S.A. de C.V., 1939 Cover MLC

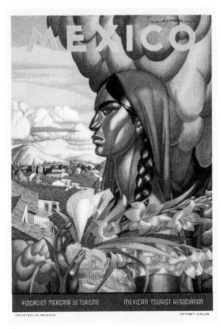

10

11

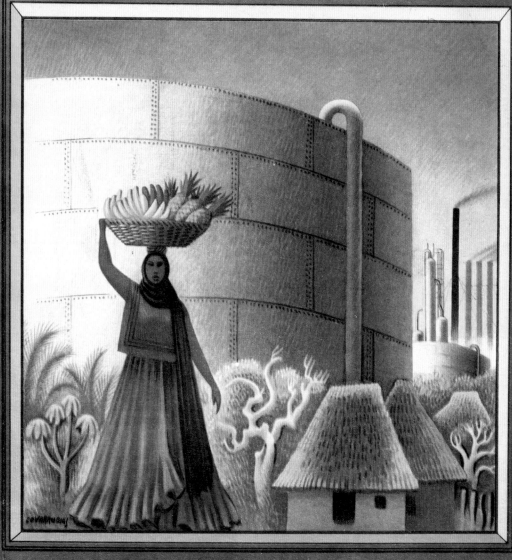

One Dollar a Copy OCTOBER 1938 Ten Dollars a Year

12

12 *Fortune*, year XVIII, no. 4, October 1938
Cover by Miguel Covarrubias BSA

13 *Mexico. Hotel Regis, Mexico D.F.* El
Modelo, Mexico, July 28, 1930 Tourist
brochure Front and back cover drawings
by Ernesto García Cabral JO

14 *Revista de Revistas*, year XXXVI,
no. 1725, June 27, 1943. Mexico, Excélsior
Cía. Editorial Cover by Ernesto García
Cabral RLQ

15 *Revista de revistas*, year XVIII, no. 933,
March 18, 1928. Mexico, Excélsior Cía.
Editorial Cover drawing by Ernesto
García Cabral RR

16 *Hoy*, year II, vol. 7, no. 77, August 13,
1938. Mexico, Talleres Fotograbadores y
Rotograbadores Unidos, Editorial Hoy
Photo caption on cover: "Fishermen from
Pátzcuaro," photo by Enrique Díaz RLQ

13

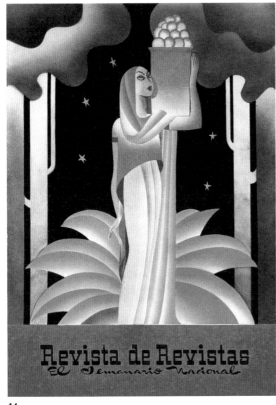

14

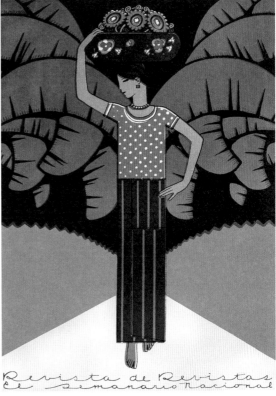

15

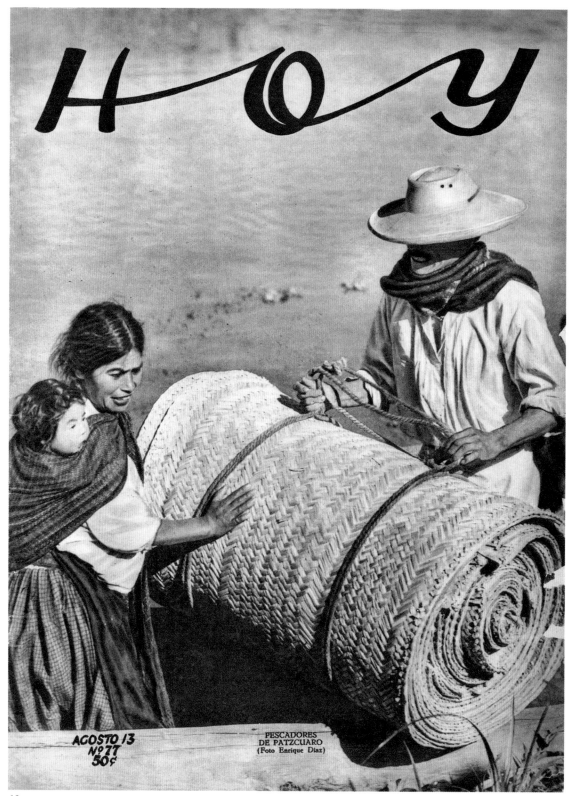

HOY

AGOSTO 13
Nº 77
50¢

PESCADORES
DE PATZCUARO
(Foto Enrique Díaz)

16

17 *Mole rico de guajolote*, ca. 1925. Published in Mexico by J. G Hatton Postcard, RR

18 *Tipos mexicanos. Vendedor de canastas*, [n.d.]. Published in Mexico by Félix Martín Postcard MLC

19 *Tipos mexicanos. Una tamalera*, [n.d.]. Published in Mexico by Félix Martín Postcard JO

20 *Un frutero. Torreón, Mexico*, [n.d.]. Published in Mexico by Sonora News Company Postcard JO

17

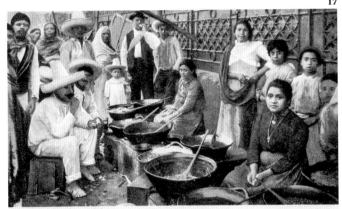

Mole rico de guajolote.

3135. J. G. Hatton, Mexico.

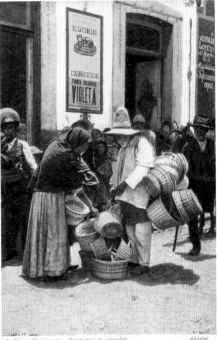

7, Tipos Mexicanos. Vendedor de canastas. MEXICO

18

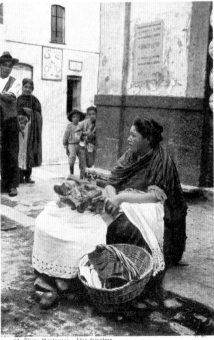

14. Tipos Mexicanos. Una tamalera. MEXICO

19

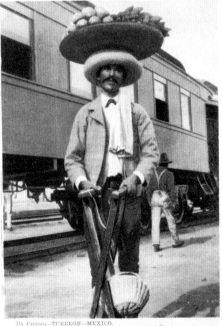

Un Frutero—TORREON—MEXICO.
SONORA NEWS COMPANY, CITY OF MEXICO, 827

Here we are in Mexico *Clara*

20

Carboneros y sus novias.

I. G. Hatton, Mexico No. 3362

21

24 >

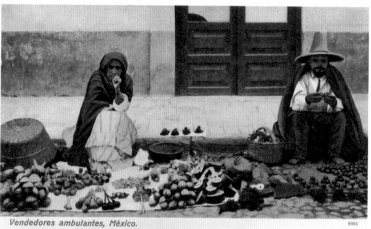

Vendedores ambulantes, México.

8064

J. G. Hatton, México, D. F.

22

23

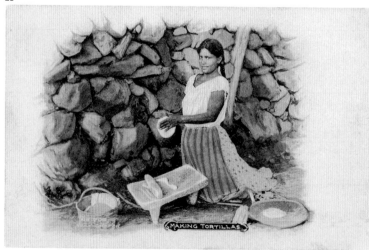

MAKING TORTILLAS

21 | *Carboneros y sus novias*, [n.d.].
Published in Mexico by J. G. Hatton |
Postcard | RLQ

22 | *Vendedores ambulantes, Mexico*,
[n.d.]. Published in Mexico by J. G. Hatton |
Postcard, | RLQ

23 | *Making tortillas*, [n.d.]. Published in
USA by Fred Harvey | Postcard | JO

24 | *Jueves de Excélsior*, February 13, 1930.
Mexico, Excélsior Cía. Editorial, S.A. |
Photo caption on cover: "See the lovely,
distinguished Miss Guillermina Cortez
Zamora from Veracruz," | RLQ

25 | *Mexico en Rotograbado*, May 9, 1929.
Mexico, Excélsior Cía. Editorial, S.A. |
Caption on cover: "One day at the market
of the picturesque city of Taxco, Guerrero.
Photo by Hugo Brehme." | RLQ

26 | *Revista de Revistas*, no. 525, Mexico,
May 30, 1920 | Cover: "Mexican scenery.
A fruit stand." Drawing by Roberto
Montenegro | MLC

2ª. SECCIÓN DE

Jueves de Excelsior

Director Manuel Horta

26ª. Sección del Estado de Veracruz

La bella y distinguida Señorita
GUILLERMINA CORTEZ ZAMORA
de Veracruz, Ver.

México en Rotograbado

Suplemento de Jueves de Excelsior

3a. Sección del Estado de

GUERRERO

Un día de mercado en la pintoresca ciudad de Taxco. Gro.

Foto de Hugo Brehme

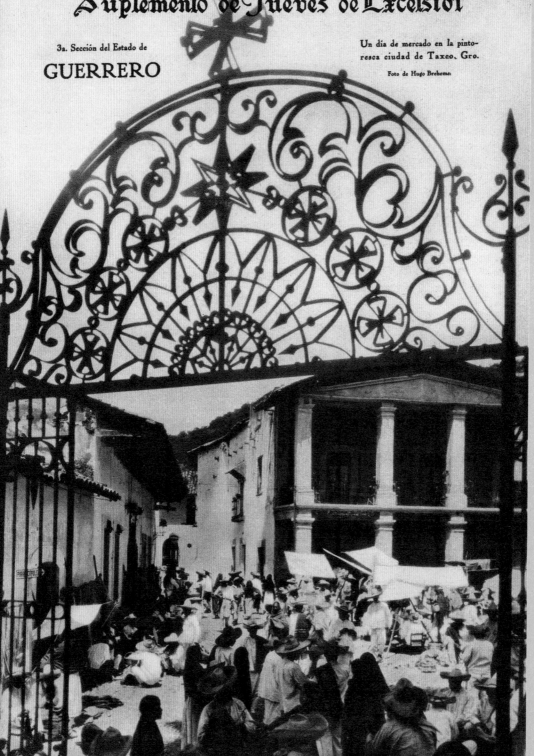

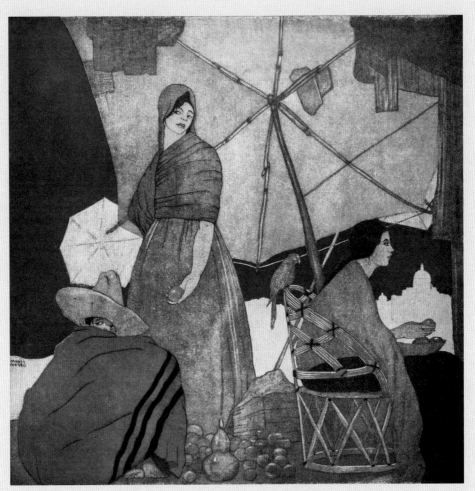

Escenas mexicanas: Un "puesto" de fruta.
Dibujo original de Roberto Montenegro, especial para este periódico.

REVISTA DE REVISTAS
EL · SEMANARIO · NACIONAL

NÚMERO 525. MEXICO, 30 DE MAYO DE 1920. EN LA CAPITAL: 25 CTVS.

25 26

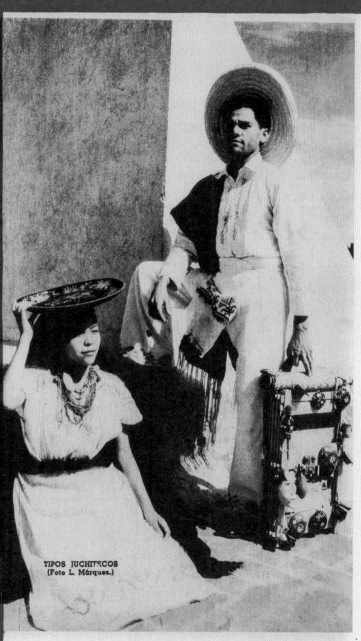

MAPA

Nº 92 NOV 1941

EN ESTE NUMERO

XOCHICALCO

EL 2º ARTICULO

SOBRE

CHICLE

Concurso de Fotográfias

30¢

TIPOS JUCHITECOS
(Foto L. Márquez.)

29

No. 24. Varilleros

hland & Ahlschier Sucr., Mexico

27 28

30

27 *Mapa*, vol. VIII, no. 92, Mexico, November 1941. Cover: "Tipos juchitecos," photo by Luis Márquez RR

28 *Varilleros*, [n.d.]. Published in Mexico by Ruhland & Alschier Sucr. Postcard RLQ

29 *Mapa*, vol. II, no. 20, November 1935. Mexico, Editorial Mercurio Cover: Tianguis in Taxco, photo by R. García RR

30 *A Market. Somewhere in Mexico*, [n.d.]. Mexico Postcard JO

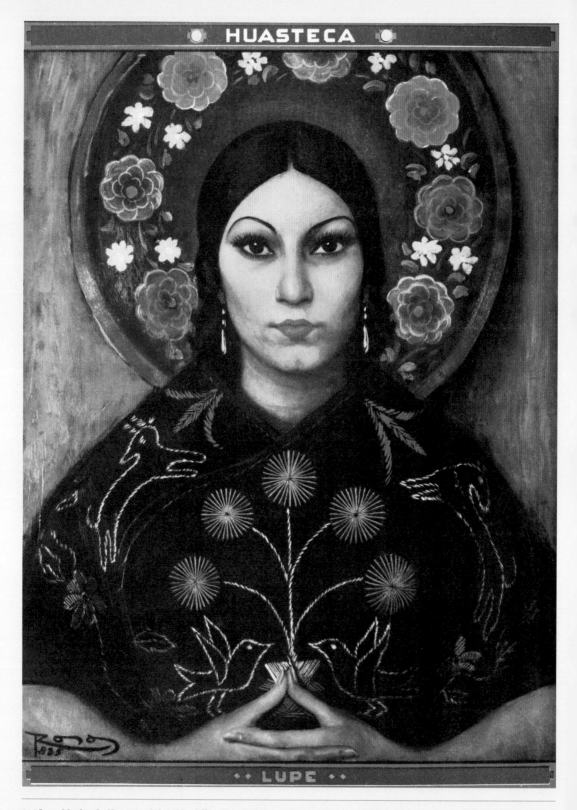

01 | *Lupe*. Mexico, La Huasteca. Printed by Offset Galas México | Calendar (January 1935), with illustration by Ignacio A. Rosas | RR

TYPICAL COSTUME

During the 1920s, Mexican traditional costume appeared to exist solely in three states: Oaxaca, Puebla, and Jalisco. Tehuana clothing was considered the most beautiful, while the china poblana dress and the charro were thought to represent the entire nation. No royal decree was needed to uphold the prominence of these three models; they were simply repeated again and again by the government and media, and the process took root. The costumes advertised the ideal of the Mexican nation and its people to the outside world: the charro symbolized joy and wildness; the china, beauty and color; and the Tehuana, exoticism.

The story began some time before, in 1919, when the Russian ballerina Anna Pavlova came to Mexico and danced *La fantasía mexicana* (The Mexican Fantasy) before a large audience. Anna Pavlova wore a china poblana dress, with dancer Alexander Volinine in a charro outfit, and the two danced a *jarabe tapatío* (hat dance) together. The dance marvelled its audience and was considered to have dignified folk art. Intellectuals and artists appropriated the spectacle as an ideal representation of Mexicanness. On the centenary of the Mexican Independence, the painter Fito Best Maugard organized a jarabe folk dance in Chapultepec with 300 chinas partnered by the same number of charros, while the Secretariat of Public Education was simultaneously encouraging the dance in all of Mexico's public schools.

The charro outfit originated during the viceroyalty of New Spain, as the clothing of the few indigenous men allowed to ride horses, who were known at the time as *cuerudos* ("leather-skinned"); the figure of the mule driver was also an important influence, but it was the nineteenth-century *chinaco* (liberal soldier) who was to become the model for the outfit. By the second half of the century, the charro was being worn by the owners of the large haciendas, and even Emperor Maximilian adopted it. During the Porfirio Díaz dictatorship, hundreds of rural police on horseback in charro outfits took part in the September 16 parade, but after the Revolution, the situation changed, and the charro took on symbolic value associated with the figure of general Emiliano Zapata. Mexico in 1920 was largely a rural nation, and the charro became the prime representation of Mexicanness; later, sound film introduced the figure of the singing charro, and the costume was soon compulsory wear for the musicians known as mariachis, who still wear it today.

The china poblana design is attributed to a mythical character named Catarina de San Juan and to a certain type of nineteenth-century woman called a *china*; what we do know is that, as historian Ricardo Pérez Monfort comments, "By the 1930s, there was no longer any doubt that the china poblana dress was what the essential Mexican woman must wear. Artistic and historical rationales, different types of authentication, literary references, and, in particular, the construction and consensus of the cultural model for Mexicanness all concluded that the china poblana was the highest representation—that is, the classical stereotype—of the Mexican woman. This was proclaimed by politicians, writers, artists and cultural agents, teachers and poets. In cultured, literary as well as popular spheres, there was no better garment than the china poblana for the true Mexican woman"[1] **(figs. 02, 12 to 17 and 21)**. The dress continues to be used in September's Independence Day festivities, dances, and for children's fancy dress.

1. "La china poblana como emblema nacional," *Artes de México*, No. 66 (August 2003), 48.

The Tehuana dress is originally from the Istmo region in Tehuantepec and Juchitán, Oaxaca; in 1946, the artist Miguel Covarribias wrote, "It is one of the loveliest things in the country, so picturesque and delightful, elegant, and fascinating; it lights up the plain, arid view with brilliant tones of color and pleasant, graceful silhouettes. In it, all Zapotec women are queens […] It is the most popular, most beautiful regional dress. And no musical comedy or carnival in Mexico City could be complete without the sheen of synthetic Tehuanas."[2] From 1937 to 1967, there was also an image of Estela Ruiz in Zapotec dress circulating on many thousands of ten-peso bills. But when interest in linking Mexicanness to the exotic faded, the Tehuana dress returned to its origins **(figs. 26 to 30 and 39)**.

2. *El sur de México* (Mexico: Instituto Nacional Indigenista, 1980), 304.

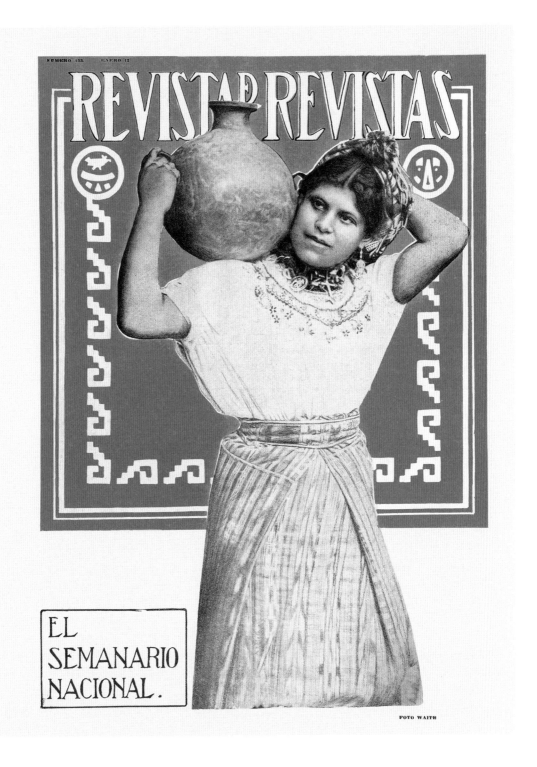

03

02 *La china princesa*. Mexican song by María Conesa. Music by master
Federico Ruiz. Lyrics by José Elizondo. Mexico, Published by Casa
Alemana de Música, S.A., [n.d.] Score Cover: María Conesa RLQ

03 *Revista de Revistas*, Mexico, year
IV, no. 153, January 12, 1913. Cover,
photo illustration by Waith MLC

MAYO 22
No. 13
30¢

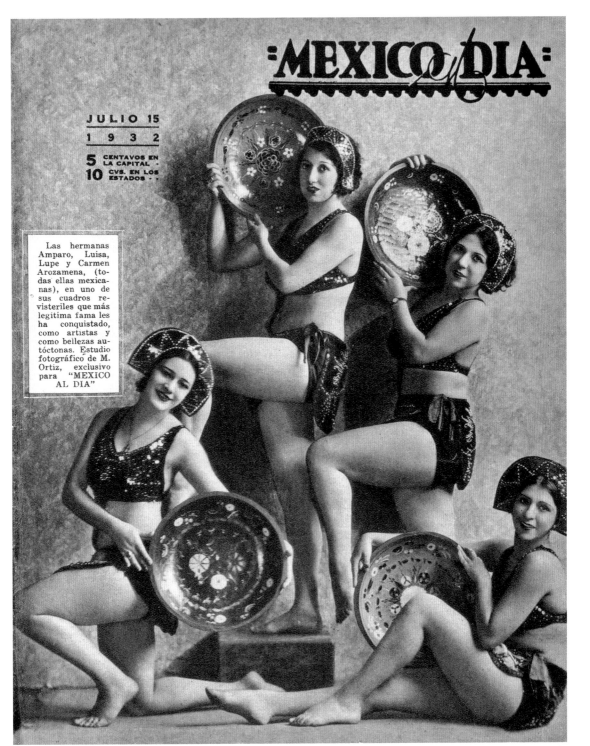

JULIO 15
1 9 3 2
5 CENTAVOS EN
LA CAPITAL -
10 CVS. EN LOS
ESTADOS - -

Las hermanas Amparo, Luisa, Lupe y Carmen Arozamena, (todas ellas mexicanas), en uno de sus cuadros revisteriles que más legitima fama les ha conquistado, como artistas y como bellezas autóctonas. Estudio fotográfico de M. Ortiz, exclusivo para "MEXICO AL DIA"

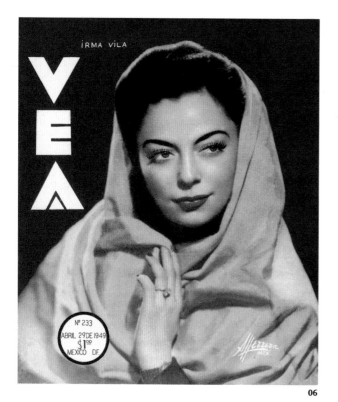

06

07

08

04 *Hoy*, year I, vol. 1, no. 13, May 22, 1937. Mexico, Talleres Fotograbadores y Rotograbadores Unidos Cover | RLQ

05 | *México al Día*, year VI, no. 86, July 15 1932. Mexico, Editorial Zig-Zag | Caption on cover: "The sisters Amparo, Luisa, Lupe, and Carmen Arozamena (all of them Mexican) in one of their most famous magazine compositions, which has brought them renown as artists and autochthonous beauties." Photo by Martín Ortiz MLC

06 | *Vea*, period 2, no. 232, April 29, 1949. Mexico, Editorial Salcedo | Cover showing Irma Vila, photo by Armando Herrera | RLQ

07 | *Tipo india del Estado de México / Indian Woman from the State of Mexico*, 1937. Series Arco Iris. Published in Mexico by Fischgrund | Postcard | Photo by Luis Márquez | JO

08 | *Trova Mexicana*, no. 40, February 1959. Mexico, published by Luz María Roji | Cover showing Alba sisters | RR

09 | *Revista de Revistas*, national weekly, year XXVI, no. 1359, Mexico, May 31, 1936. | Cover: Edith Rodríguez | RR

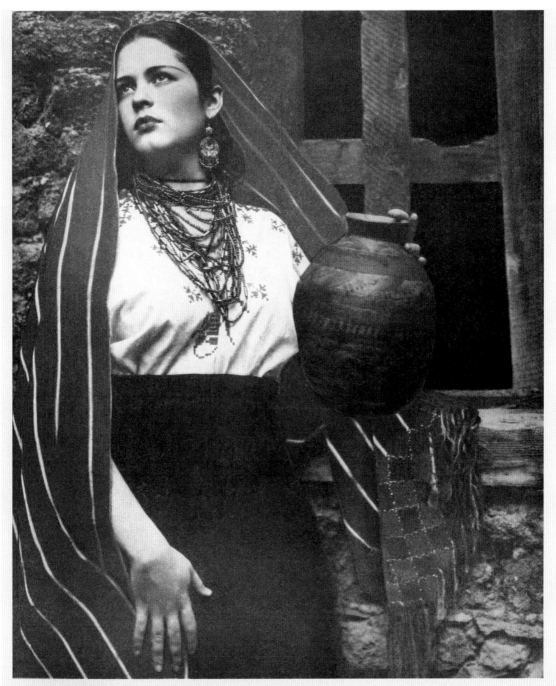

SEÑORITA EDITH RODRIGUEZ, DE LA SOCIEDAD DE URUAPAN, MICHOACAN.

REVISTA DE REVISTAS
el semanario nacional

20 **CTS. EN LA CAPITAL**
25 **CTS. EN LOS ESTADOS**

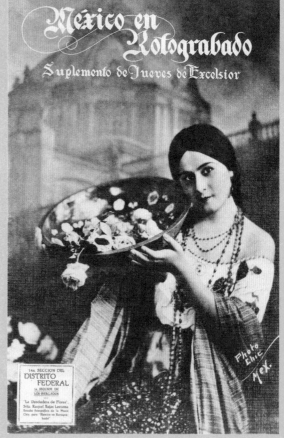

12 | *La Prensa*, illustrated morning daily, Sunday edition, vol. I, no. 311, Sunday, July 7, 1929. Mexico, La Prensa, Rotogravure section | Photo caption on cover: "The 'Mexico Lindo' trio whose members, the beautiful, charming Mexican singers Lina Gilbert and Eugenia and Eloisa del Mar, return from their triumphant tour of Canada and the United States, where each performance was met with unprecedented success, to our city, where they are being enthusiastically welcomed and celebrated by their legion of fans." | RLQ

10 | *Jueves de Excélsior*, no. 195, March 4, 1926. Mexico, Excélsior Cía. Editorial, S.A. | Cover: Lupe Rivas Cacho | Photo by Antonio Garduño | RLQ

11 | *México en Rotograbado*, Section 14, Mexico City, May 3, 1928. Mexico, Excélsior Cía. Editorial, S.A. | Photo caption on cover: "'Flower seller.' Miss Raquel Rojas Lecuona. Photo Chic Studio for Mexico in Rotogravure" | RLQ

LA PRENSA
Diario Ilustrado de la Mañana

TOMO I MEXICO, D. F., DOMINGO 7 DE JULIO DE 1929 **NUM. 311**

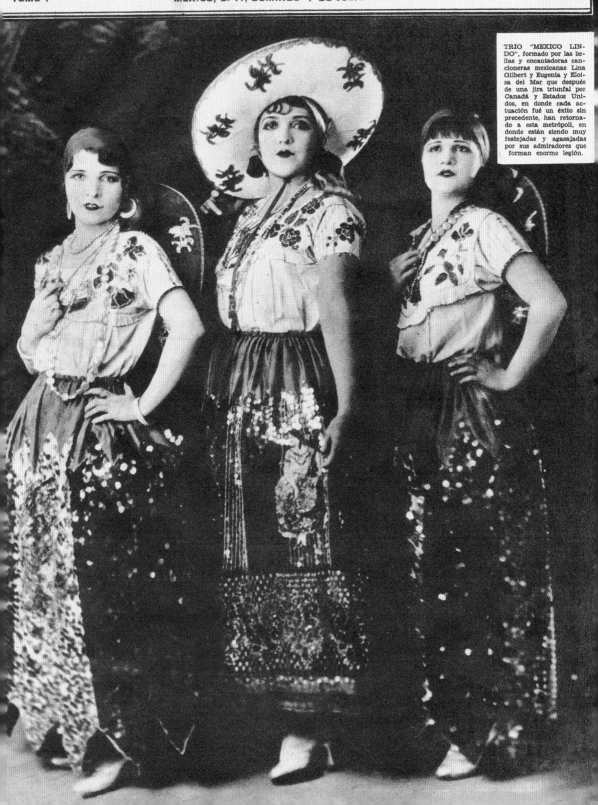

TRIO "MEXICO LINDO", formado por las bellas y encantadoras cancioneras mexicanas Lina Gilbert y Eugenia y Eloísa del Mar que después de una jira triunfal por Canadá y Estados Unidos, en donde cada actuación fué un éxito sin precedente, han retornado a esta metrópoli, en donde están siendo muy festejadas y agasajadas por sus admiradores que forman enorme legión.

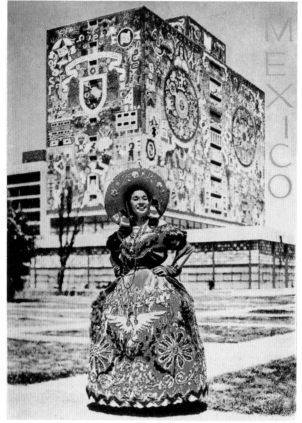

13

14

13 | *México*, 25th anniversary edition, ca. 1956. Mexico, Editorial Fischgrund | Photos by Luis Márquez, Osorno Barona and Armando Brehme | Guidebook | Cover by Luis Márquez | RR

14 | *Charro y china poblana*, [n.d.]. Mexico | Postcard | Photo by Yáñez | RLQ

15 | *China poblana*, [n.d.]. Mexico | Postcard | Photo by Yáñez | RLQ

16 | *China poblana*, [n.d.]. Mexico | Postcard | Photo by Yáñez | RLQ

17 | *China poblana, México / Mexican china poblana*, [n.d.]. Published in Mexico by Félix Martín | Postcard | JO

15

16

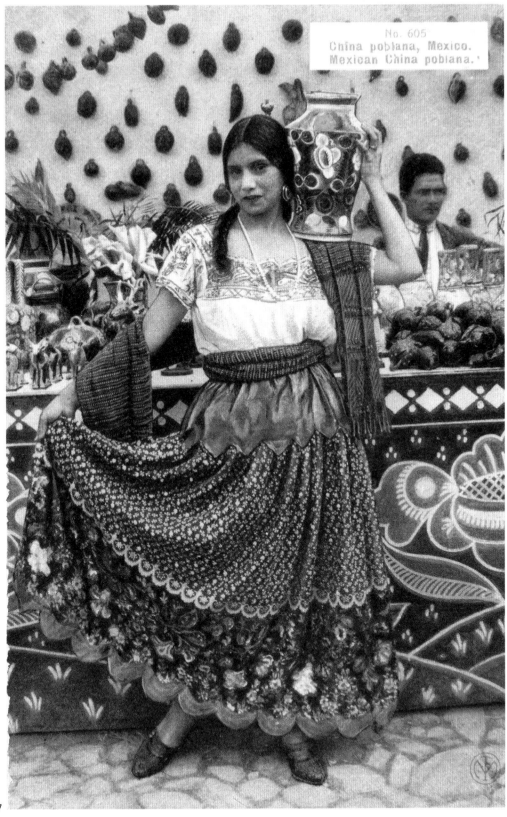

No. 605
China poblana, Mexico.
Mexican China poblana.

17

MANUEL VELA

18 | *Trova Mexicana*, no. 47, April 1, 1960. Mexico,
published by Luz María Roji | Cover: Manuel Vela | RR

Canciones con Acompañamiento de Guitarra
Revista mensual de la canción
Editada por: L. M. Roji
Oficinas: Toledo 137 Col. Alamos.　　　México, D. F. Teléfono: 19-31-84

En este número:

ESPINITA
TU CARTA
SIN TEMOR NI VERGÜENZA
LUNA, LUNA, LUNA
NUNCA JAMAS
QUE MAS DA
MUJER HILANDERA
ESTUPIDO CUPIDO
DEJAME
VIDAS DISTINTAS
LAMENTO EN LAS MONTAÑAS
VENCIDA
EL BARDO
MUCHO CORAZON

PRECIO $1.50

No. 4

DORA MARIA

19 | *Trova Mexicana*, no. 4, January 1955. Songs with guitar accompaniment.
Mexico, edited by Luz María Roji | Cover: Dora María | RR

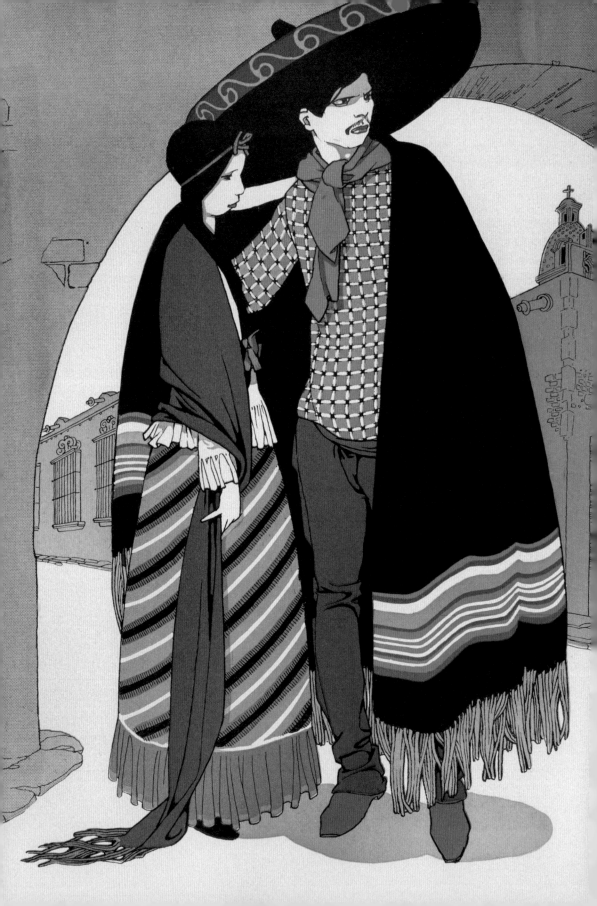

20

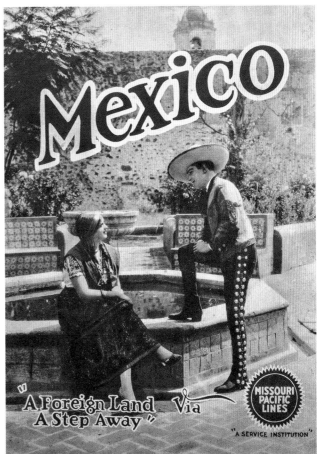

21 22

20 *Revista de Revistas*, year XVII, no. 900,
Mexico, August 7, 1927. "Excelsior",
Compañía Editorial S.A. Cover drawing
by Ernesto García Cabral RR

21 *Charro y china poblana, México*,
[n.d.]. Mexico Postcard Photo by
Hugo Brehme JO

22 *Mexico, "A Foreign Land Via a Step
Away"*. Missouri Pacific Lines, [n.d.]
Tourist brochure RR

23 *Merendero de charros, Monterrey, N.L.,
Mex.* 1930-1950. Mexico Postcard JO

24 *Charras mexicanas*, [n.d.]. Mexico
Postcard Photo by Yáñez RLQ

25 *Revista de Revistas*, year XI, no. 510,
Mexico, February 8, 1920 Photo caption
on cover: "Antonio Moreno, the 'Spanish
Adonis of the film screen,' outfitted in
the Mexican 'charro,' with the popular
composer Miguel Lerdo de Tejada.
(Exclusive photo for this weekly)" RLQ

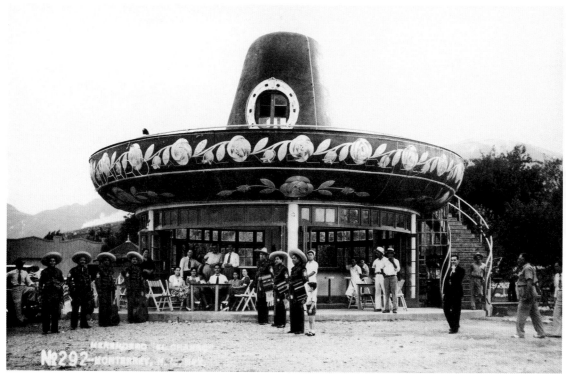

23

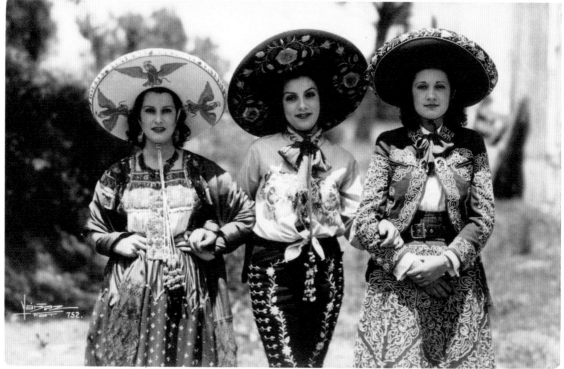

24

25 >

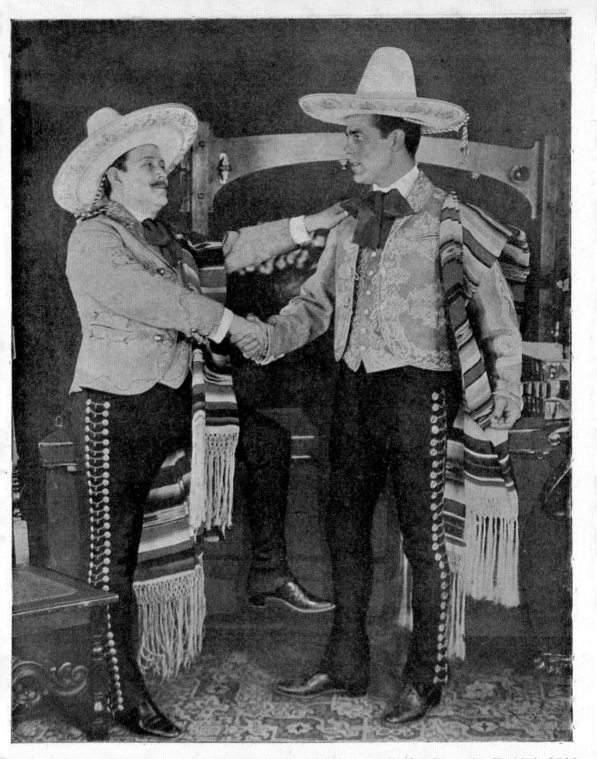

...onio Moreno, "el Adonis castellano de la pantalla" vistiendo el traje de "charro" de México en compañía del popular compositor Miguel Lerdo de Tejada.

(Fotografía exclusiva para este semanario.)

REVISTA · D · REVISTAS
·EL · SEMANARIO · NACIONAL·

...UMERO 510 MEXICO, 8 DE FEBRERO DE 1920. EN LA CAPITAL, 25 CTS.

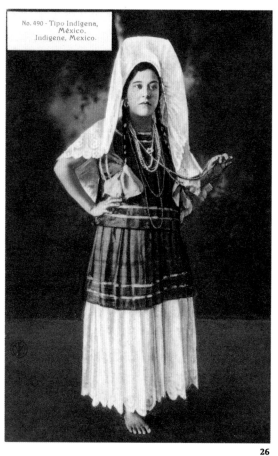

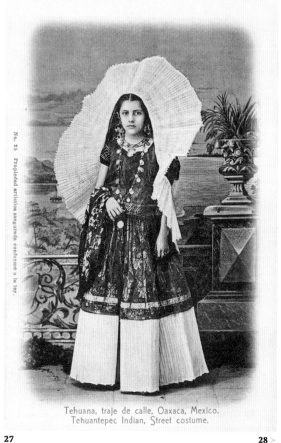

26 27 28 >

ꗃodern ꗃexico

VOL. VII, NO. 3. ST. LOUIS, MO.. U. S. A., and MEXICO CITY, MEXICO, JUNE, 1899. PRICE, 10 CENTS.

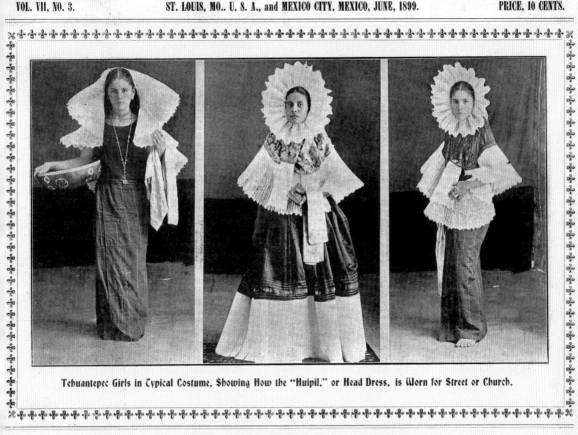

Tehuantepec Girls in Typical Costume, Showing How the "Huipil," or Head Dress, is Worn for Street or Church.

Contents for June.

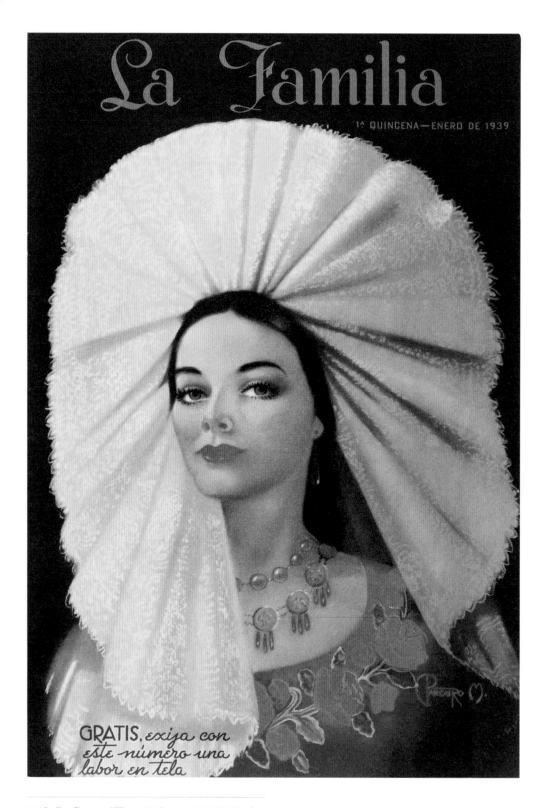

La Familia

1ª QUINCENA—ENERO DE 1939

GRATIS, exija con este número una labor en tela

29 | *La Familia*, year VIII, no. 97, January 15, 1939, Mexico,
Editorial Sayrols, S.A. | Cover drawing by Panduro M. | RR

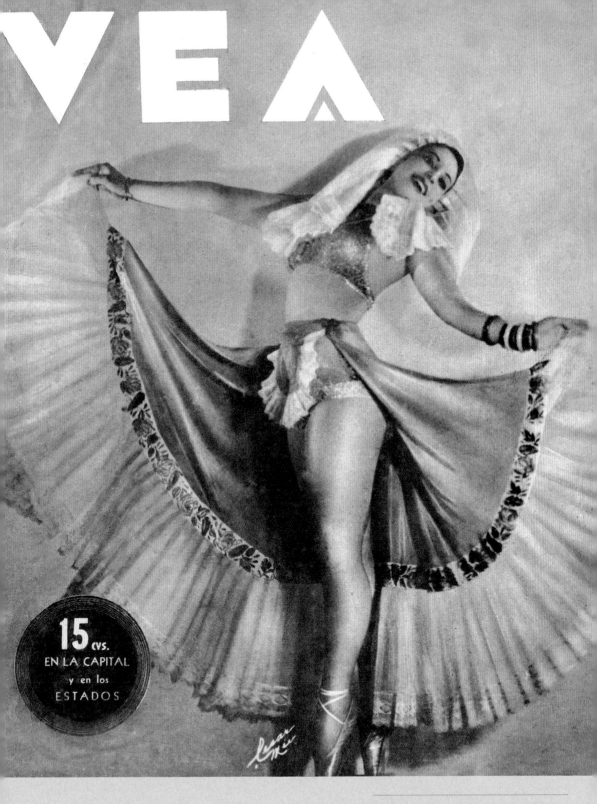

VEA

15 cvs.
EN LA CAPITAL
y en los
ESTADOS

30 | *Vea*, year III, no. 113, Mexico, December 25, 1936. | Back cover photo by Casas, Mexico | MLC

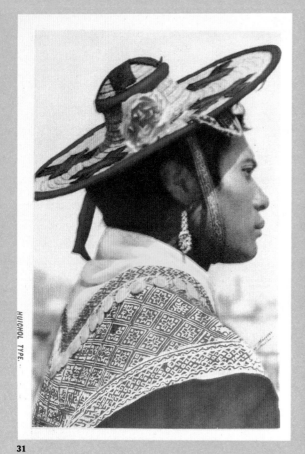

HUICHOL TYPE.

31

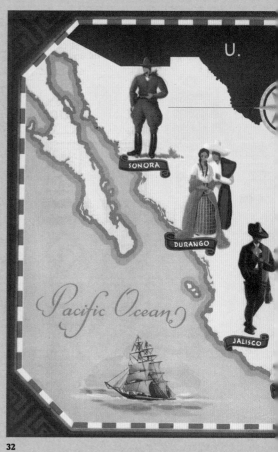

U.

SONORA

DURANGO

JALISCO

Pacific Ocean

32

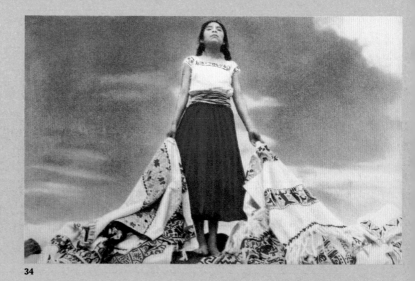

34

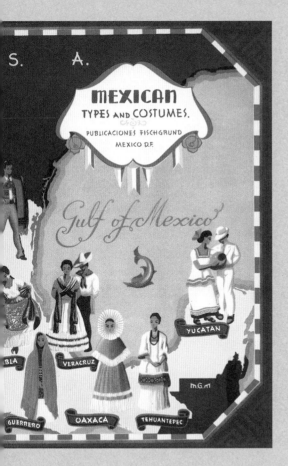

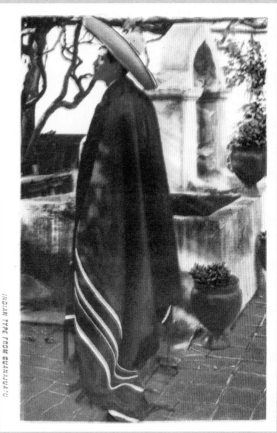

INDIAN TYPE FROM GUANAJUATO

33

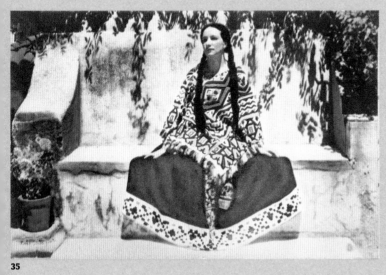

35

31 | "Huichol Type." *Beautiful National Types of Mexico*. MGM, [n.d.] | Envelope with postcards | Photo by Luis Márquez | RR

32 | *Touring Mexico*, with 13 Litographed Picture Maps. Mexico, Publicaciones Fischgrund, 1939 | Double-page spread map: "Mexican Types and Costumes" | RLQ

33 | "Indian Type from Guanajuato." *Beautiful National Types of Mexico*. MGM, [n.d.] | Envelope with postcards | Photo by Luis Márquez | RR

34 | *Telas mexicanas*, 1937. Series Arco Iris. Published in Mexico by Fischgrund | Postcard | Photo by Luis Márquez | RR

35 | *Tipo de mujer del estado de Michoacán*, 1937. Series Arco Iris. Published in Mexico by Fischgrund | Postcard | Photo by Luis Márquez | RR

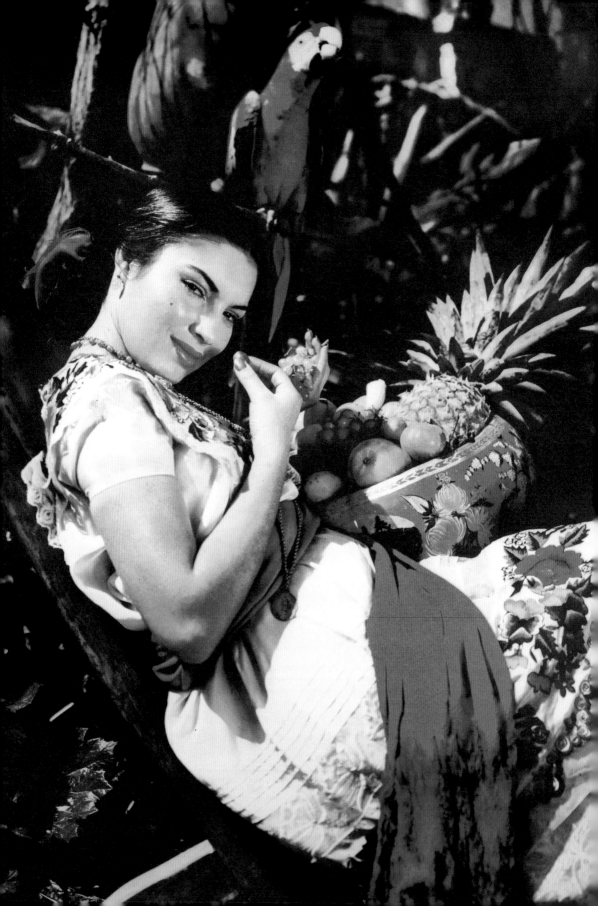

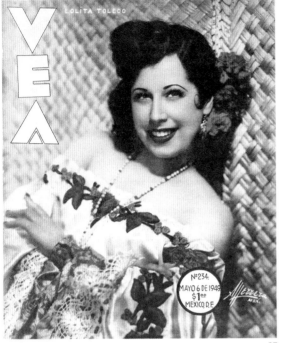

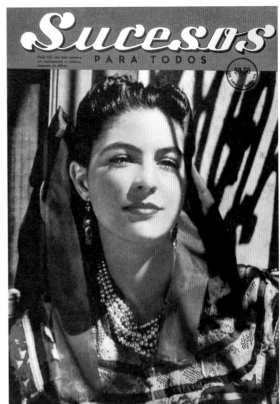

36

37

38

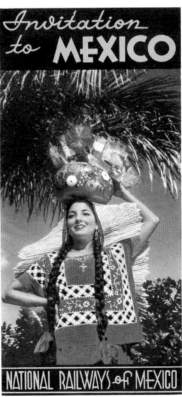

36 "Mestiza yucateca." Free gift included in *La Prensa*. Mexico, [n.d.] Poster Photo by Luis Osorno Barona RR

37 *Vea*, no. 234, May 6, 1949. Mexico, Editorial Salcedo Cover: Lolita Toledo, photo by Armando Herrera MLC

38 *Sucesos para Todos*, no. 781, January 20, 1948. Mexico, Libros y Revistas, S.A. RR

39 *Invitation to Mexico*. National Railways of Mexico. Printed by Offset Galas, Mexico, [n.d.] Tourist pamphlet JO

39

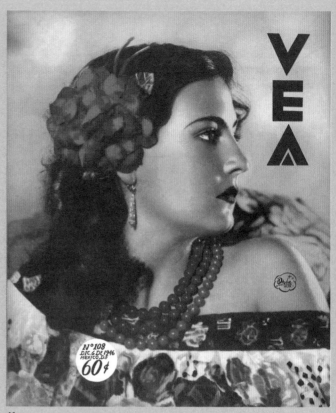

41

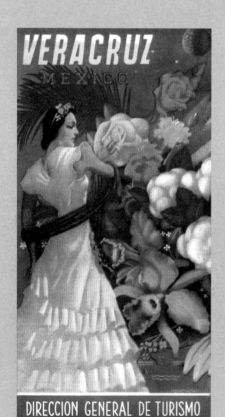

40

40 | *Veracruz, México*. Asociación Mexicana de Turismo. Departamento de Turismo de la Secretaría de Gobernación. Printed by Offset Galas | Tourist brochure | Cover | RR

41 | *Vea*, year II, vol. 3, no. 108, period 2, Friday, December 6, 1946. Mexico, Editorial Salcedo | Cover by Otylia Mex. | RR

42 | *Papel y Humo*, year IV, no. 5, June 1935. Mexico, Cía. Manufacturera de Cigarros "El Águila," S.A. | MLC

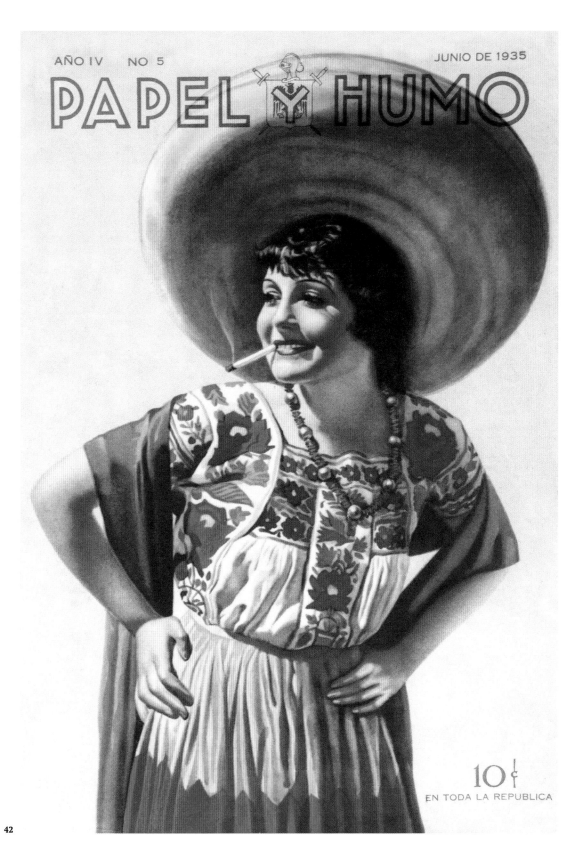

MEXICO SOUTH

THE ISTHMUS OF TEHUANTEPEC

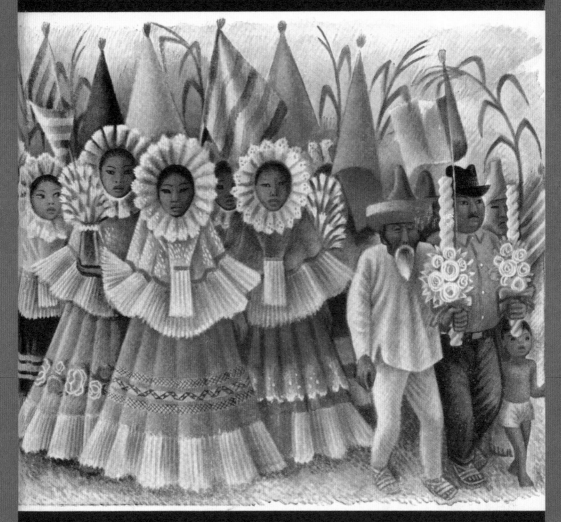

MIGUEL COVARRUBIAS

author of "Island of Bali"

FIESTA

Ancient Mexico was populated by religious civilizations that dedicated several days of the year to their gods; the Mexica, for instance, held nineteen festivals each year, and other celebrations every four, eight, and fifty-two years. On their arrival, the Spaniards imposed Catholicism, their calendar of saints' days and corresponding festivities, and the ancient gods were demonized and their worship prohibited. During the sixteenth century, evangelizing clerics introduced traditional Spanish dances along with other indoctrination tactics; the legendary drama of *Moros y cristianos* (Moors and Christians) was one of these, and sometimes the Moors were simply replaced by the Aztecs, as in the *Danza de la pluma* (Feather Dance), still practiced as the last number of the indigenous traditional Guelaguetza celebrated in the state of Oaxaca **(figs. 02 to 05)**. Three hundred years of Spanish domination served to consolidate the Catholic festive calendar, with each person, trade, community, settlement, or city having its own patron saint. The anticolonial rupture brought in non-religious celebrations to mark the great events of the nineteenth and twentieth centuries, like the anniversaries of Independence, the Constitution, and the Revolution.

The equestrian tradition known as charreria **(figs. 19 to 21)**, in which different horseriders carry out a series of maneuvers to show off their skills and strengths, is a fundamental part of Mexican festivities and is considered the national sport. The state of Hidalgo is the cradle of the tradition, but it first became popular after the Revolution, when the former landowners emigrated to Mexico City and Guadalajara, set up associations, related charro to national culture, and established a common liking for it. This was rather ironic, seeing that in the 1920s the revolutionaries had fought against the charros for the land to be given back to its legitimate owners, the peasants. This demand was incorporated into Article 27 of the 1917 Constitution, leaving many of the caciques without their land. But it was not long before the landowners had achieved reimbursement and imposed their fascination with charrería as a national emblem of the new order. President Manuel Ávila Camacho decreed the 14th of September as the *Dia del charro* (Charro Day), and since 2016, it has been considered Intangible Cultural Heritage by the United Nations.

The bullfight as a celebration in which a man on foot or horseback is pitted against a fierce bull in a ring originated in Spain and expanded to France, Portugal, and Hispanic America. It became highly popular in Mexico in the twentieth century owing to the fame of bullfighters such as Rodolfo Gahona, Silverio Pérez, Carlos Arruza, and Eloy Cavazos and constant visits by celebrated Spanish matadors. The advertising of the bullfight was heavily assisted by illustrators such as Ernesto *El Chango* García Cabral **(figs. 22 and 23)**, and many photojournalists also played an important part. Mexico is currently one of the eight countries not to have banned the festival, and each year 12 bullfighting events are held in the states of Tlaxcala, San Luis Potosí, Guanajuato, Aguascalientes, Jalisco, Colima, Hidalgo, Puebla, and Mexico City.

Festivities in Mexico would not be complete without showbusiness. Celebrities have been admired and been cause for commotion since the nineteenth century, but it was inventions like the film camera and the radio that introduced singers, dancers, and actors to mass audiences. In the 1920s, Dolores del Río **(fig. 31)** was the first Latin American actress to triumph in Hollywood, and she had an outstanding career in American film. In 1930, the radio became the main medium for news and advertising, and two years later *Santa,* the first sound film, came out. Divas and gallant men took their turns as icons of all that was Mexican. This was the starting point for the new allure of celebrities in published media all over the country, a formula whose success has continued to the present day.

01 Miguel Covarrubias, *Mexico South: The Isthmus of Tehuantepec.* New York, Alfred A. Knopf, 1946 Cover by Miguel Covarrubias MLC

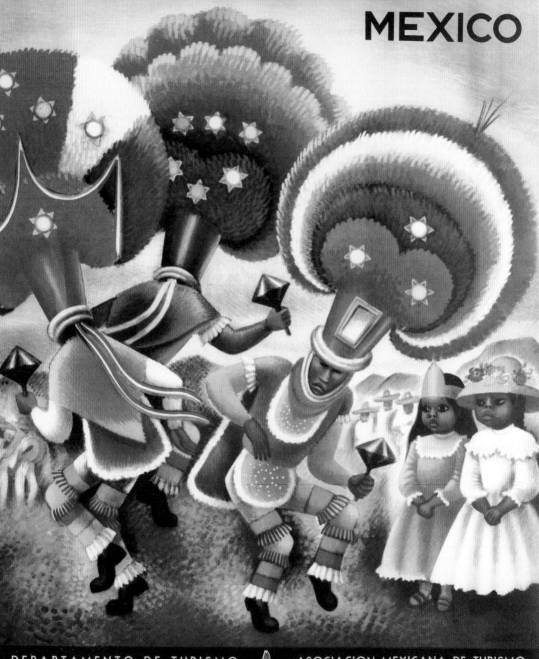

OAXACA
MEXICO

DEPARTAMENTO DE TURISMO
DE LA
SECRETARIA DE GOBERNACION ASOCIACION MEXICANA DE TURISMO
MEXICAN TOURIST ASSOCIATION

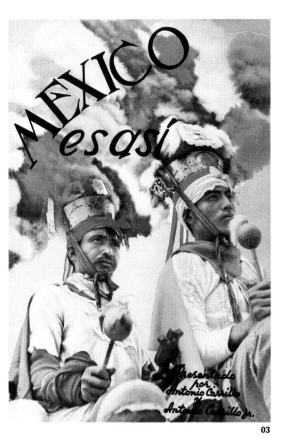

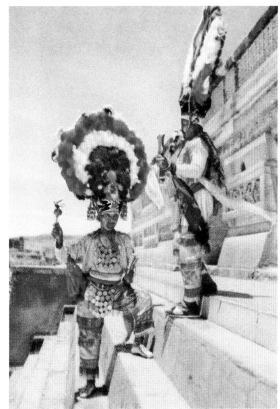

03

04

02 *Oaxaca, México.* Departamento de Turismo de la Secretaría de Gobernación. Asociación Mexicana de Turismo / Mexican Tourist Association Poster: "Oaxaca Plume dancers," illustrated by Miguel Covarrubias RR

03 *México es así.* Graphic edition by photographers Antonio Carrillo Sr. and Antonio Carrillo Jr., Mexico, Talleres Gráficos de la Nación, 1946 RR

04 *Invitation to Mexico.* National Railways of Mexico. Printed by Offset Galas, Mexico, [n.d.] Tourist pamphlet Image on inside JO

05 *Mexico*, 25th anniversary edition, ca. 1956. Mexico, Editorial Fischgrund Photos by Luis Márquez, Osorno Barona and Armando Brehme Guidebook Back cover: Luis Márquez RR

06 *Mexican Art & Life*, no. 2, April 1938. Mexico, DAPP, Talleres Gráficos de la Nación. Cover with watercolor by Emilio Amero JO

07 & 08 *México en el Arte*, October 1948. Mexico, Instituto Nacional de Bellas Artes, Secretaría de Educación Pública Cover and back cover: Raúl Anguiano RLQ

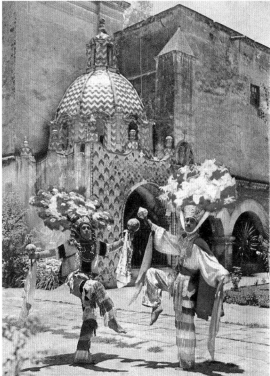

05

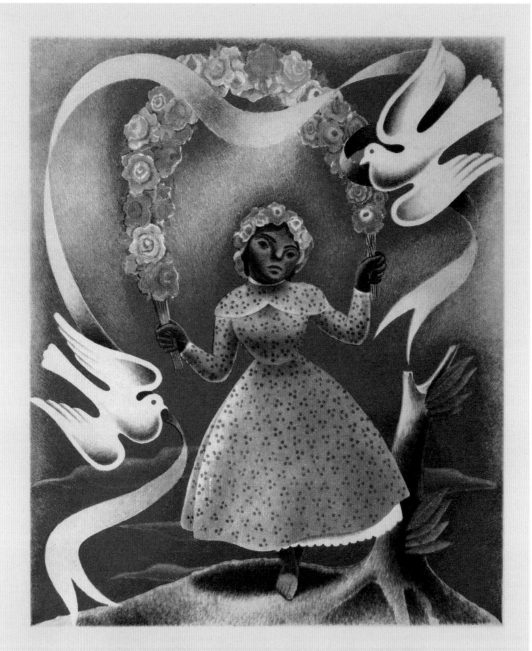

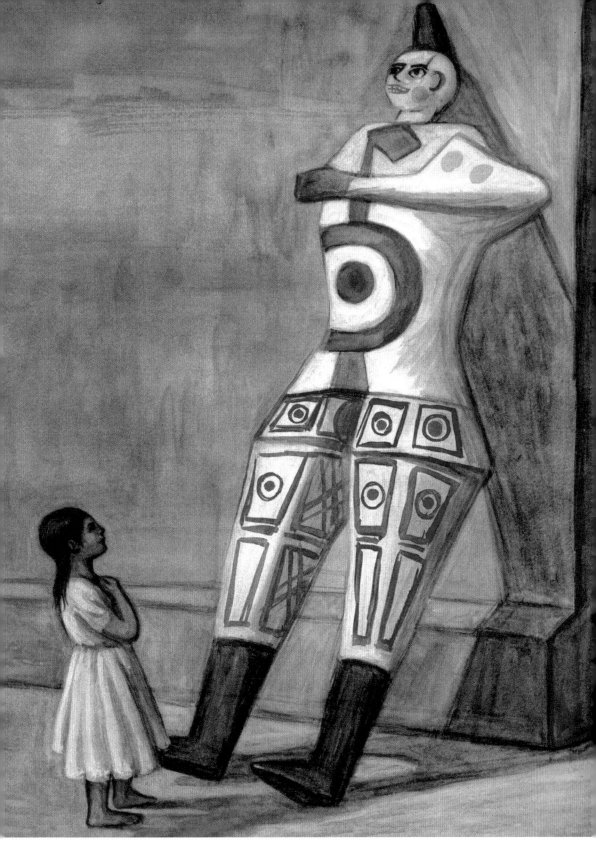

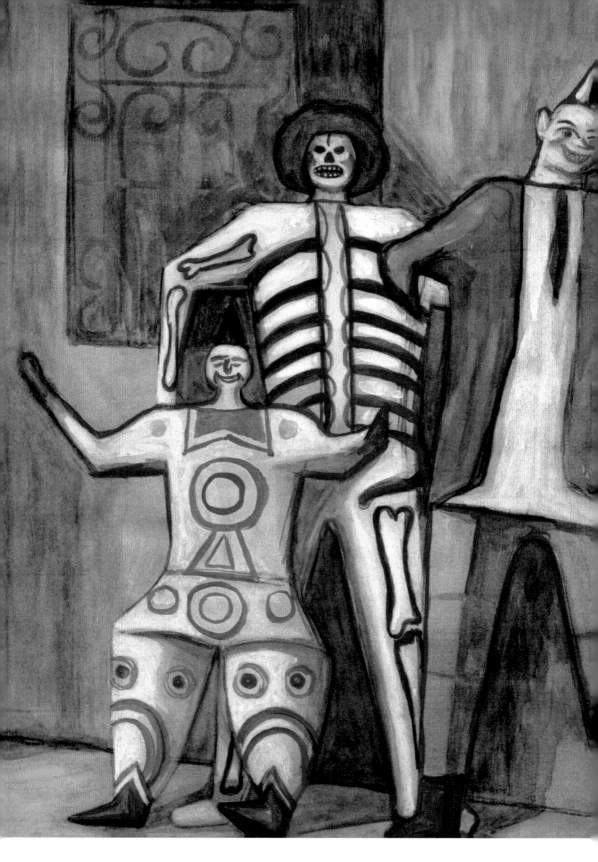

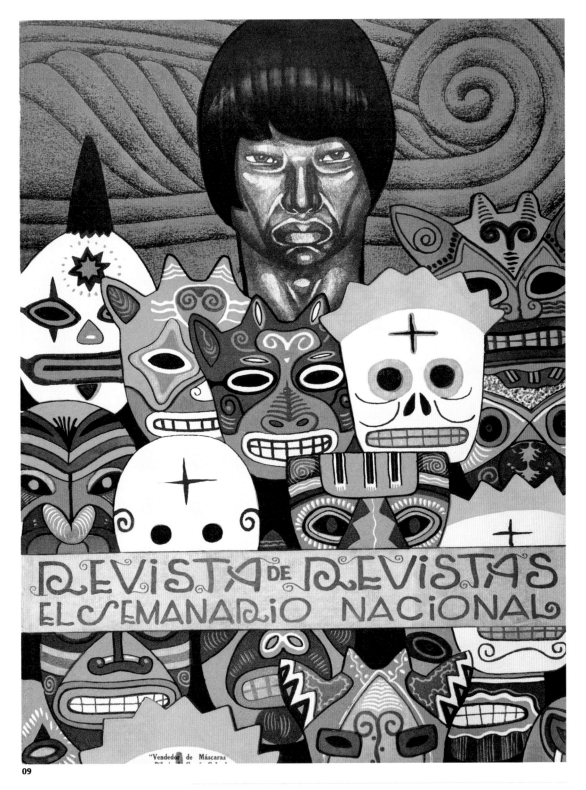

09

09 *Revista de Revistas*, year XVII, no. 864, Mexico, November 28, 1926. Excélsior, Compañía Editorial, S.A. Cover: "Vendedor de máscaras," drawing by Ernesto García Cabral MLC

< 08

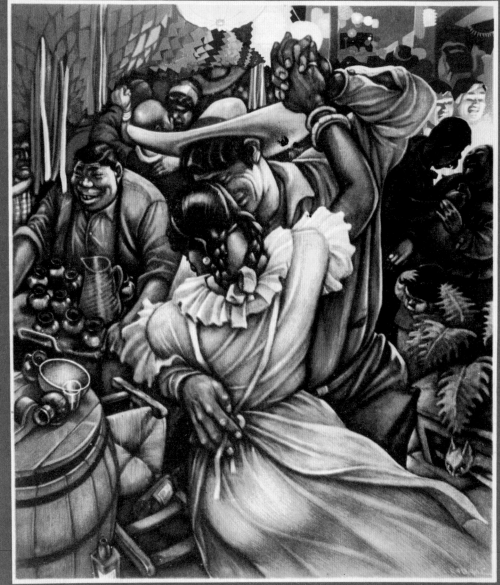

10 | *Huasteca / Posada de barriada.* (Twelve national prints by different Mexican artists. No. 12). Printed by Offset Galas México for Huasteca Petroleum Co., Mexico, December 1936. | Drawing by Ernesto García Cabral | MLC

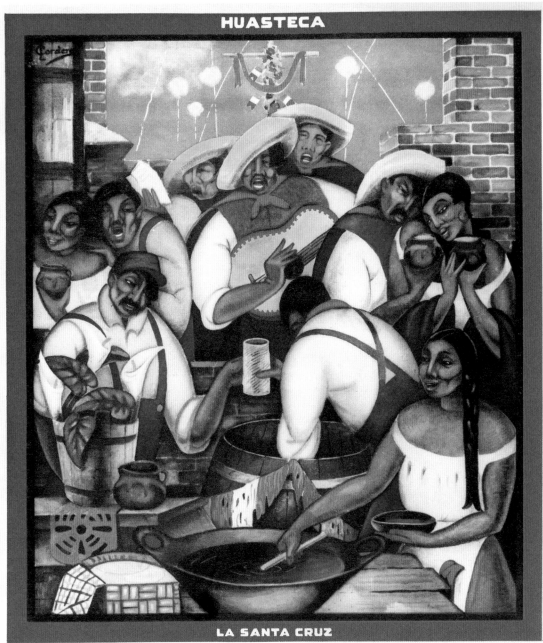

11 *Huasteca / La Santa Cruz*. (Twelve national prints by different Mexican artists. No. 5). Printed by Offset Galas México for Huasteca Petroleum Co., Mexico, May 1936. Drawing by Juan Leonardo Cordero JO

NATIONAL DANCE
OF MEXICO

JARABE TAPATLO
MEXICO

12

13

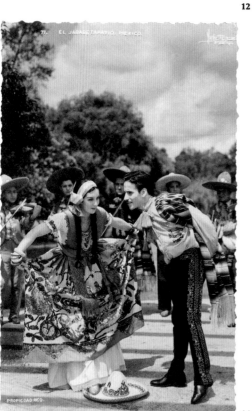

14

12 | *National Dance of Mexico. Jarabe tapatío, México*. Mexico, [n.d.] | Christmas card, with drawing by Toledo | MLC

13 | *Revistas de Revistas*, year IX, no. 427, Mexico, July 7, 1918. | Cover: "El 'Jarabe,'" drawing by Ernesto García Cabral | MLC

14 | *El jarabe tapatío, México*, [n.d.]. Mexico | Postcard | Photo by Yáñez | JO

15 | *Bailes mexicanos*. Printed by Offset Galas, Mexico, ca. 1939 | Cover with drawing by Ernesto García Cabral | MLC

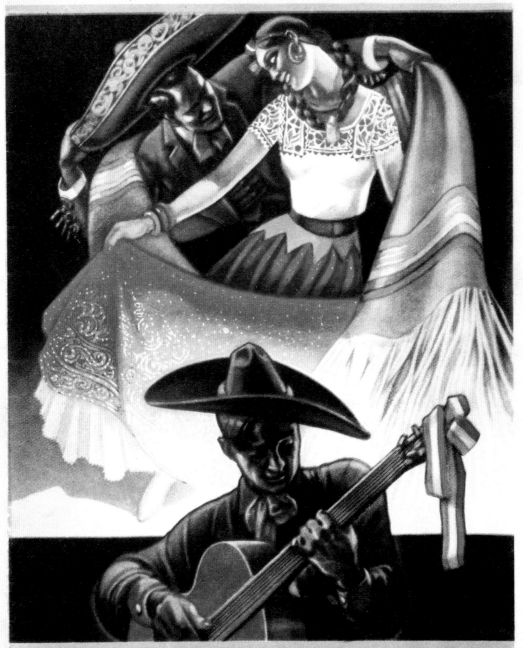

Bailes Mexicanos

16

16 | *Cancionero Ross*. Mexico. Envases Plegadizos, S.A., ca. 1945 | Cover by Vicente Morales | RR

17 | *Cancionero Mejoral. Las 100 mejores canciones de México*, Mexico, [n.d.] | Cover | RR

18 | *Holiday magazine*, vol. II, no. 3, March 1947. Curtis Publishing Company | Cover drawing: "Mexico," by Julio de Diego | RR

17

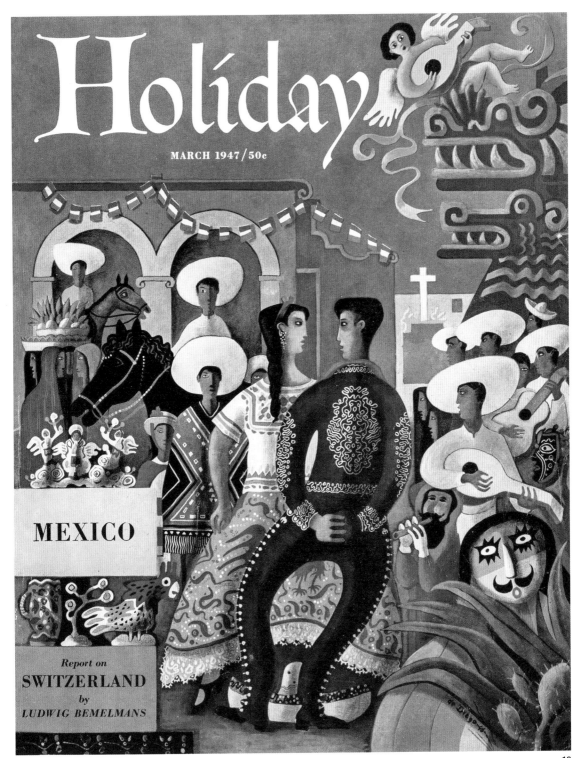

Holiday

MARCH 1947/50c

MEXICO

Report on
SWITZERLAND
by
LUDWIG BEMELMANS

19 | *Revista de Revistas*, Sunday, September 16, 1923. Mexico, Excélsior Cía. Editorial | Cover drawing by Ernesto García Cabral | RR

20 | *Revista de Revistas*, year V, no. 207, Mexico, February 15, 1914. | Cover drawing: "El Charro," by J. Antonio Vargas | MLC

21 | *Revista de Revistas*, year XIV, no. 667, February 18, 1923. Special issue dedicated to the State of Guanajuato | Cover drawing by Ernesto García Cabral | RR

19

21 >

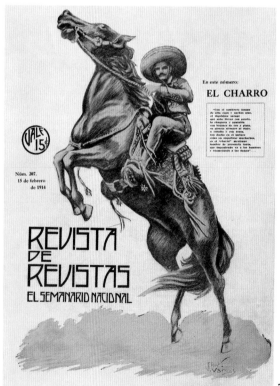

20

22 | *Revista de Revistas*, year XVIII, no. 928, February 12, 1928. Mexico, Excélsior Cía. Editorial | Cover drawing by Ernesto García Cabral | RR

23 | *Revista de Revistas*, year XVII, no. 905, September 11, 1927. Mexico, Excélsior Cía. Editorial | Cover drawing by Ernesto García Cabral | RR

REVISTA DE
REVISTAS
SEMANARIO NACIONAL
NUMERO ESPECIAL DEDICADO
AL ESTADO DE GUANAJUATO.

Dibujo de García Cabral.

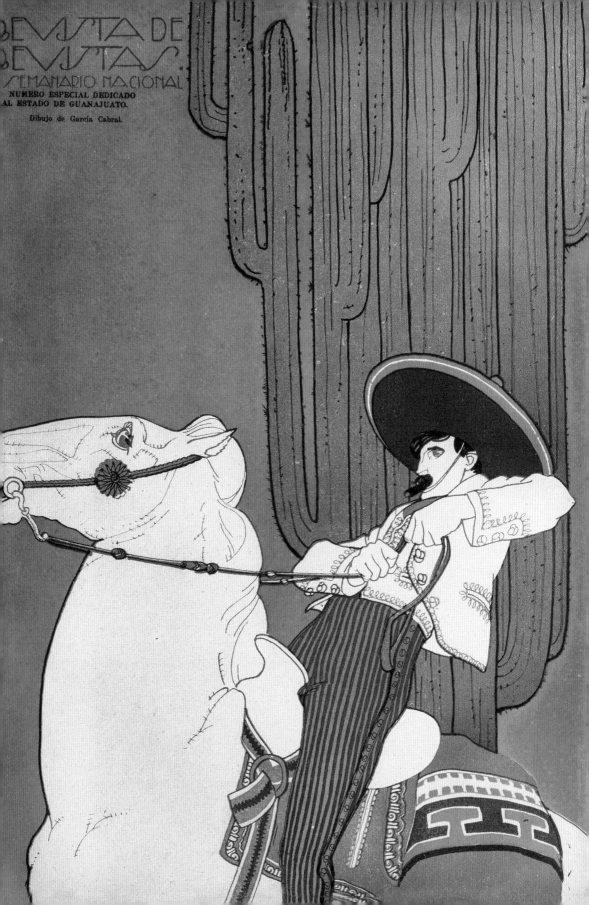

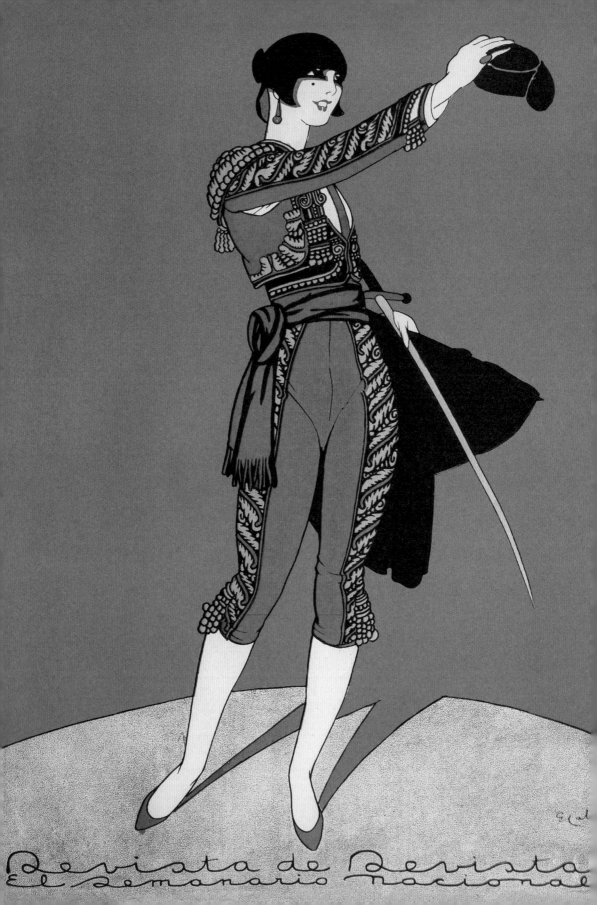

Revista de Revistas
El Semanario Nacional

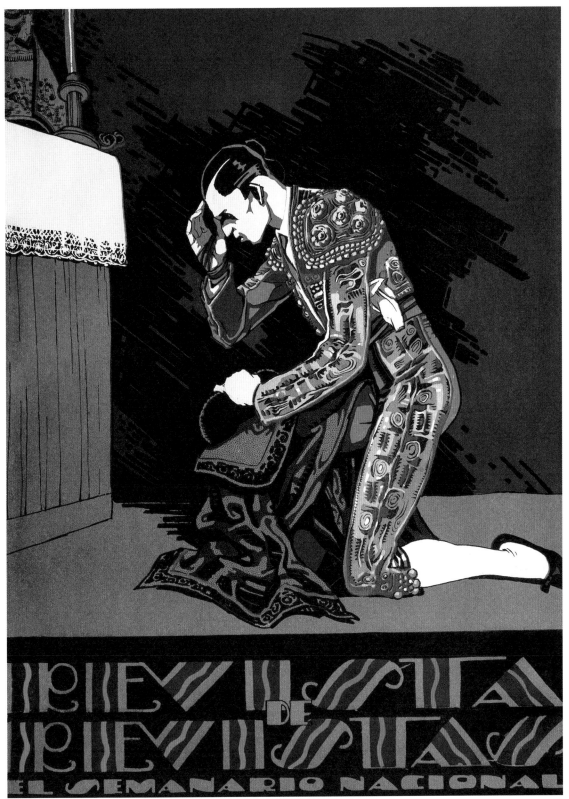

Suerte de banderillas.
Un buen par de Patarterillo.

24

28 & 29 >>

28 | *Papel y Humo*, year II, no. 8, September 1933. Issue dedicated to the State of Hidalgo. Mexico, Compañía Manufacturera de Cigarros El Águila, S.A. | Cover by A. Gómez R. | RR

29 | *Rotográfico*, year III, vol. II, no. 132, August 15. 1928. Mexico, "El Universal" rotogravure workshop | Cover showing Lola Salvi | RR

27 >

Troupe of Bullfighters entering the Ring. Plaza de Toros, Tijuana, Mexico.

In addition to the interest of the Bullfight, the Bullfighters resplendent in their bright costumes literally covered with heavy gold braid is an impressive sight indeed.

25

J. K. 53. México. Regist. Pelea de Gallos.

26

24 | *Suerte de banderillas. Un buen par de Patarterillo*, ca. 1910 | Postcard | RLQ

25 | *Troupe of Bullfighters entering the Ring*, Plaza de Toros Tijuana, Mexico, [n.d.]. Published in San Diego, California, USA, by Eno & Matteson | Postcard | RR

26 | *Pelea de gallos*, ca. 1925. Published in Mexico by J. K. | Postcard | RR

27 | *El Universal Ilustrado*, year II, no. 84, December 13, 1918. Mexico | Photo caption on cover: "Gaona, the great Caliph exiled from his lands in Mexico and León, because—according to a subtle representative—our burnt-out Petronius was not part of the revolution," Tostado Grabador | RLQ

EL UNIVERSAL
◇◇ ◇ ◇ ILUSTRADO ◇ ◇ ◇◇

Costado, Grabador.

Gaona, el gran Califa desterrado
de sus tierras de México y León,
porque-según afirmó un diputado
sutil-nuestro Petronio requemado
no tomó parte en la revolución.

AÑO II. NUM. 84 20 **centavos en la Capital**

AÑO II SEPTIEMBRE DE 1933 NUM. 8

PAPEL Y HUMO

A ABSOLUTA

...ILIAS

Prec... ...ital, 5 cts.
En l... ...10 cts.

NUMERO
DEDICADO AL
EDO de HIDALGO

A. Gómez R.

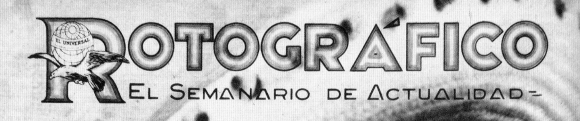

ROTOGRÁFICO

EL SEMANARIO DE ACTUALIDAD

LOLA SALVI

«Estrella» de la Fox,
languidecía en los estudios. Hoy
triunfa en Los Ángeles, Cal.

30 *Papel y Humo*, year II, no. 10, November 1933. Issue dedicated to the State of Morelos. Mexico, Compañía Manufacturera de Cigarros El Águila, S.A. Cover showing Toña la Negra, illustration by A. Gómez R. RR

31 *Todo*, year II, no. 87, April 30, 1935. Mexico, Editorial Todo. Cover showing Dolores del Río RR

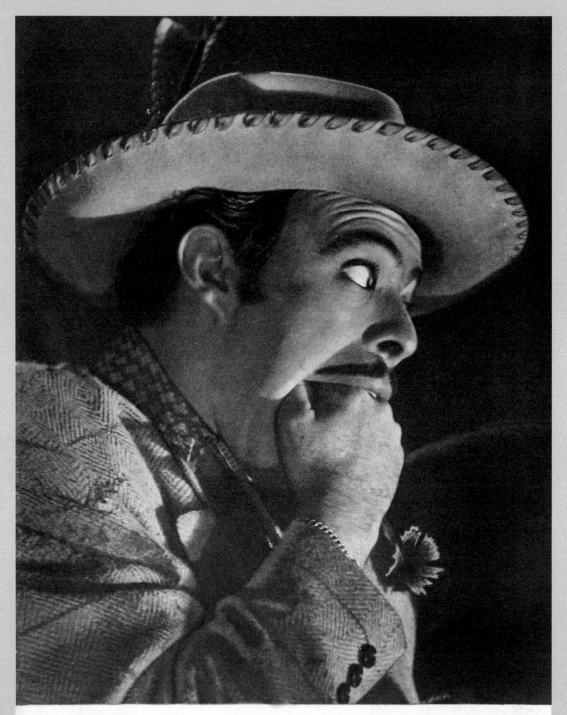

REVISTA DE REVISTAS PRECIO 30¢

TIN-TAN
en su estupenda interpretación, junto con su carnal MARCELO,
en la película de mucho miedo y grandes risas:
"HAY MUERTOS QUE NO HACEN RUIDO"
Grandioso estreno en el CINEMA PALACIO.

32

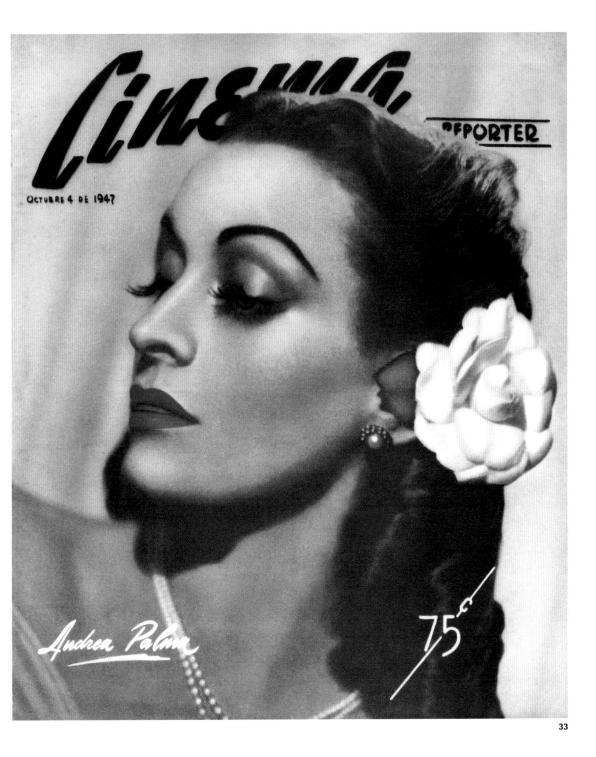

CINEMA REPORTER

OCTUBRE 4 DE 1947

Andrea Palma

75¢

33

Revista de Revistas, year XXXVIII, no. 1893, September 22, 1946. Mexico, Excélsior Cía. Editorial, S.C.L.| Photo caption on cover: "TIN-TAN in his fabulous performance with his blood brother MARCELO, in the terrifying, hilarious film 'HAY MUERTOS QUE NO HACEN RUIDO.' Grand prémiere at CINEMA PALACIO." MLC

33 *Cinema Reporter*, year XV, no. 481, October 4, 1947. Mexico, Editorial Salcedo Cover: Andrea Palma, illustration by Caballero RLQ

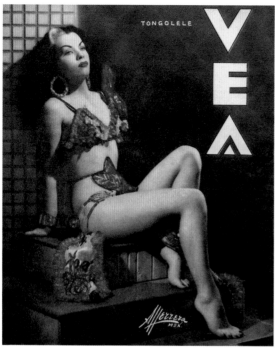

34

34 | *Vea*, period 2, no. 252, September 9, 1949. Mexico, Editorial Salcedo | Cover: Tongolele, photo by Armando Herrera | RR

35 | *Vea*, period 2, no. 252, September 9, 1949. Mexico, Editorial Salcedo | Back cover: Amparo Arozamena, photo Armando Herrera | RR

36 | *Vea*, period 2, no. 254, September 23, 1949. Mexico, Editorial Salcedo | Cover: Katana, photo by Armando Herrera | RR

35

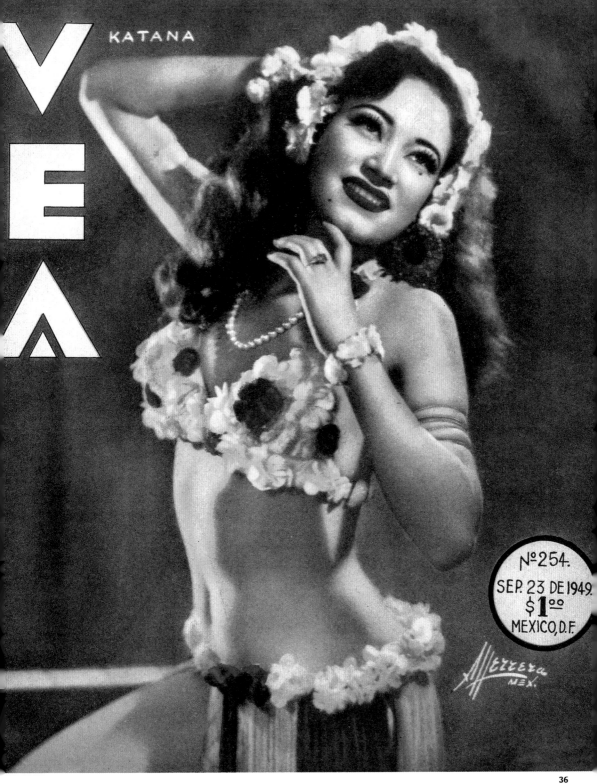

KATANA

N° 254.
SEP. 23 DE 1949.
$1.00
MEXICO, D.F.

36

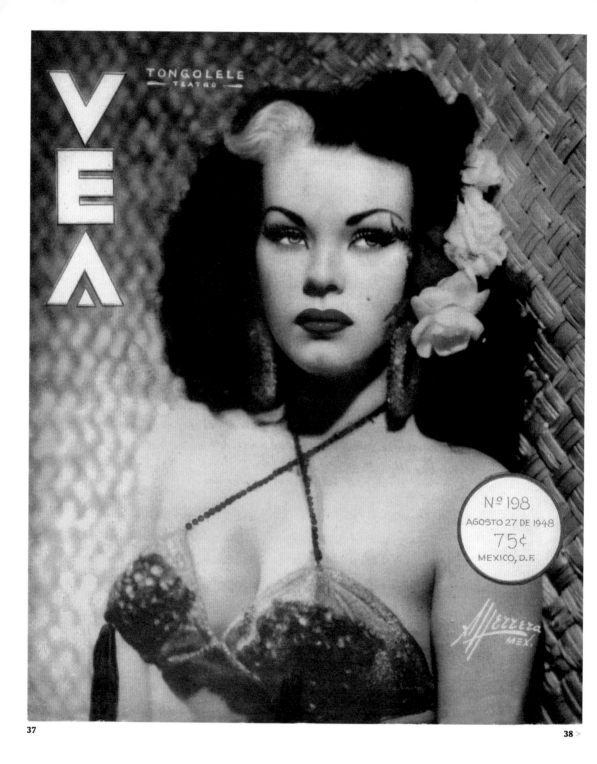

37

38 >

37 | *Vea*, no. 198, August 27, 1948. Mexico, Editorial Salcedo | Cover: Tongolele, photo by Armando Herrera | RLQ

38 | *México al Día*, year VI, no. 87, Mexico, August 1, 1932. | Caption on cover: "In praise of Mexicanism (for the *sarape*), by Amparito Arozamena. Photo by Martín Ortiz exclusively for this magazine." | MLC

:MEXICO al DIA:

AGOSTO 1º

1 9 3 2

5 CENTAVOS EN
LA CAPITAL -
10 CVS. EN LOS
ESTADOS - -

Un alarde de me-
xicanismo (por el
sarape), de Am-
parito Arozame-
na. Foto de Mar-
tín Ortiz, exclu-
siva p a r a esta
Revista.

01

ALLEGORIES

The most ancient symbol in Mexican history is an eagle devouring a snake on a nopal cactus **(fig. 02)**. It alludes to the founding of the city of Tenochtitlán. The second most ancient in order of appearance is the Virgin of Tepeyac **(figs. 19 to 21)**. So it is not surprising that both of these were used at the outbreak of the War of Independence. As historian Enrique Florescano points out, "After September 1810, the flag of the armies of Hidalgo would be the first to carry the emblem of the eagle and the serpent with the image of the Virgin of Guadalupe."[1] Eleven years later, at the end of the struggle, Agustín de Iturbide decided on the motif, layout, and colors of the Mexican flag, on which green was to represent independence; white, the purity of Catholicism; and red, the union between Americans and Europeans. Decades later, President Benito Juárez changed these meanings so that green became the symbol of hope; white, of unity; and red, the blood of the national heroes. The colors continue to signify these attributes.

1. Enrique Florescano, *Imágenes de la patria a través de los siglos.* (Mexico, Taurus, Secretaría de Cultura de Michoacán, 2005), 103.

The many cacti and agave that enhance the Mexican landscape are essential allegories for the nation. More than a third of them worldwide are found in Mexico, and among the hundreds of these, the most important symbol is the nopal **(figs. 01 and 07 to 09)**. Not only does the cactus appear on the national coat of arms, but it is also edible, as is its fruit the prickly pear and its flower. Its root is utilized, and the parasite that feeds on it, the cochineal, is used as a dye. Mexican cacti also include the saguaro, the cereus, and other giant cacti **(figs. 10 and 11)**. Around 200 species of agave also exist, of which more than 75 percent are found in the country; they are highly valued because of the alcoholic beverages that can be made with them: pulque, tequila, and mezcal are the quintessential national drinks.

The allegory of the Patria was inherited from the New Spanish era, when the territory was represented by a woman in indigenous clothing and a *xiuhuitzolli* (triangular tiara) or a feathered headdress. After the Independence, there were few changes to the attributes of the upper part of her image, but her costume became a white tunic and red cloak in the Greek style. From the mid-nineteenth century onwards, the Patria alternated her crown between a laurel wreath and the Phrygian liberty cap, which was soon given preference up until the early years of the Revolution. In the 1920s, Ernesto *El Chango* García Cabral made the pioneering move on the cover of *Revista de Revistas* of darkening the figure's skin color **(fig. 16)**. Afterwards, the allegory of the Patria was not seen so often, perhaps because of the proliferation of other national emblems that came into circulation. In 1946, Jorge González Camarena made the painting *La vendimia nacional* (National Harvest), which was to be printed on calendars. In it, the Patria—white-skinned with wavy hair and Western features, occupies the center of the image. In 1954, Camarena used the same allegory for a postage stamp design on the occasion of the first centenary of the Mexican national anthem **(fig. 17)**. Finally, in 1961, he achieved greater success with his painting *La Patria,* which was used on the cover of free textbooks issued by the Secretariat of Public Education **(fig. 18)**. The work portrays a brown-skinned woman with straight, dark brown hair, almond-shaped eyes, and *olmec lips*. The image immediately caught on to the public imagination and was printed over ten years on the covers of more than 400 million primary school textbooks.

01 *Mexico. The Faraway Land Nearly.* Asociación Mexicana de Turismo. Printed by Offset Galas, Mexico, 1939 Guidebook with photos by Brehme, Márquez, Mantel, and Yáñez Cover by Jorge González Camarena JO

02 *Revista de Revistas,* national weekly, year II, no. 136, Mexico, September 15, 1912. Cover by Jorge Enciso MLC

03 *Jueves de Excélsior,* the newspaper of daily life, no. 144, Mexico, Thursday, March 12, 1925. Caption on cover: "Señorita Villarreal, who represented Mexico at the George Washington celebrations in Laredo, Tex." Photo: García Studio, Laredo, Texas RR

JUEVES DE EXCELSIOR

EL PERIODICO DE LA VIDA NACIONAL
Director. GONZALO ESPINOSA

Número 144 **Vale 10 ctvs.**

MEXICO, D. F., JUEVES 12 DE
MARZO DE 1925.

SEÑORITA VILLAREAL,

que representó a México en las fiestas
de Jorge Washington, celebradas en
la ciudad de Laredo, Tex.
Studio García, Laredo, Texas.

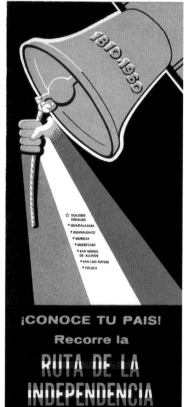

04

05

04 | *¡Conoce tu país! Recorre la Ruta de la Independencia. Dolores, Hidalgo -Guadalajara -Guanajuato -Morelia -Querétaro -San Miguel de Allende -San Luis Potosí -Toluca.* Mexico, Departamento de Turismo, [n.d.] | Map | Cover | RLQ

05 | *Old Mexico. A Most Useful Guide for Travelers.* English Spanish. / *Guía ilustrada del visitante Old México. El libro de mayor utilidad para el viajero.* September 1924 | Cover | JO

06 | *Futuro*, no. 49, March 1940. Mexico, Universidad Obrera de Mexico | Cover by Josep Renau | RLQ

FUTURO

Marzo de 1940 20 Centavos

NVESTRA CIVDAD

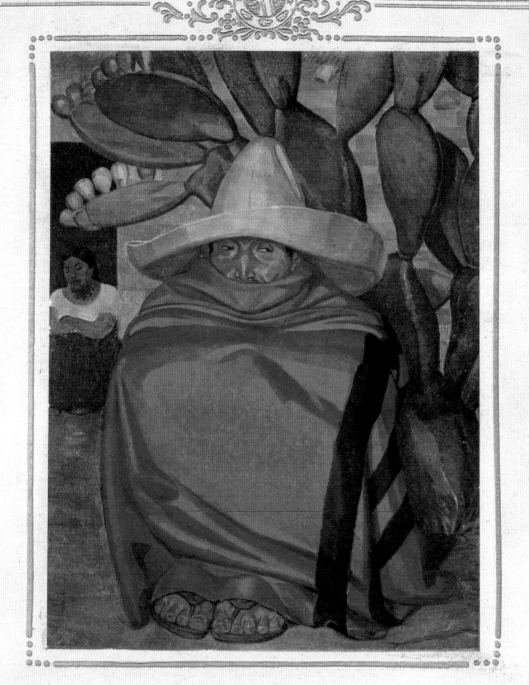

ORGANO DEL DEPARTAMENTO DEL DISTRITO FEDERAL

JUNIO 1930

PRECIO:
En la Capital $ 0.25
En los Estados 0.30

Impreso en los Talleres Gráficos de la Nació

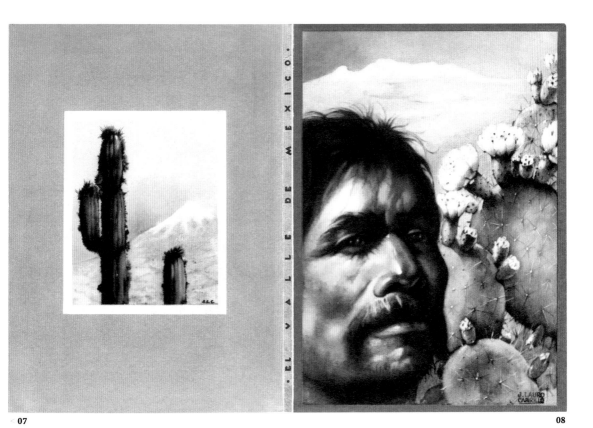

07

08

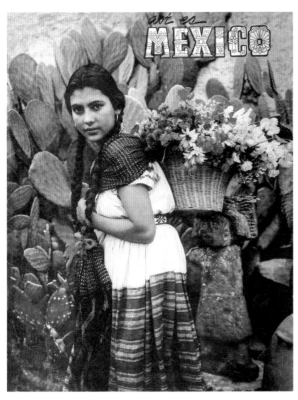

09

07 *Nuestra Ciudad*, official magazine for Departamento del Distrito Federal, vol. I, no. 3, June 1930. Mexico, Talleres Gráficos de la Nación Cover: "El sarape rojo," oil painting by Alberto Garduño RLQ

08 *El Valle de Mexico*, no. 1, 1937. Mexico, Publicaciones Pro turismo del Departamento Autónomo de Prensa y Publicidad (dapp) Front and back covers by J. Lauro Carrillo RLQ

09 *Así es México*, Mexico, September 1941. Special issue of the official magazine for the II Congreso Interamericano de Turismo in the Mexican capital. Cover photo by Luis Márquez RR

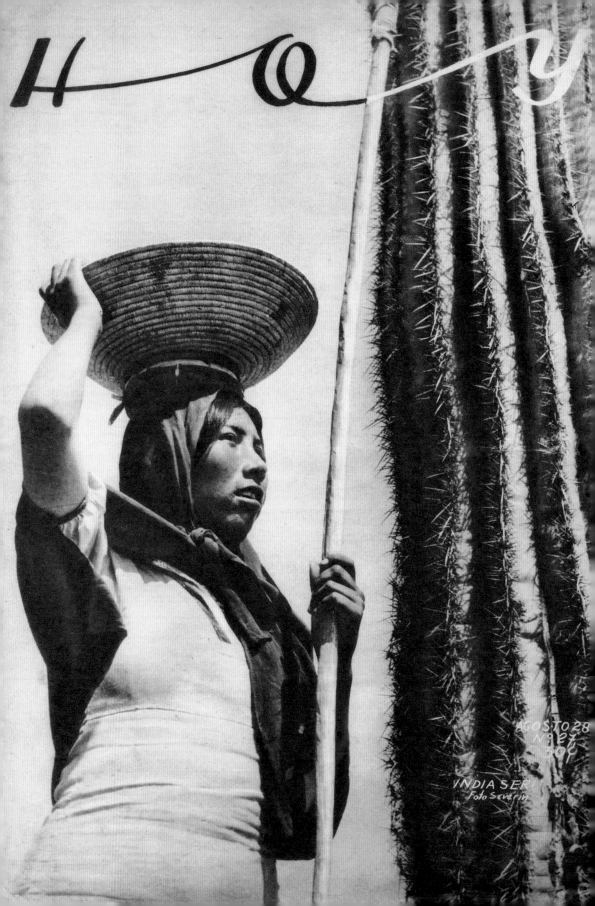

H O y

AGOSTO 28
Nº 27
30¢

INDIA SERI
Foto Severin

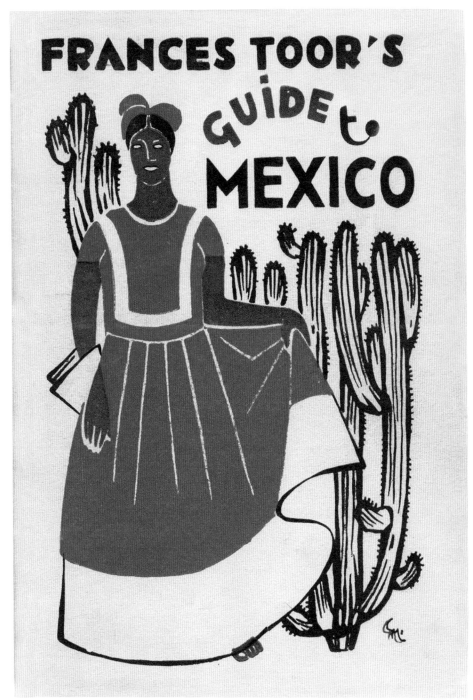

10 11

TRAVEL in MEXICO

12

13

12 *Travel Mexico*, Mexico, [n.d.] Guidebook Front and back cover drawing by Carlos Mérida RR

13 *Modern Mexico*, vol. 8, no. 12, May 1937. Published monthly by the Mexican Chamber of Commerce Cover by F. Cornejo RR

14 *Mexico*, New York, International Telephone & Telegraph Corporation, 1930 Cover RLQ

15 *Jueves de Excélsior*, no. 326, Mexico, September 6, 1928. Caption on cover: "These are the true *chinas poblanas*—not those who call themselves that and fake our traditions," declare our ace historians Don Luis Castillo Ledón and Don Nicolás Rangel at last Sunday's magnificent competition at Lomas de Chapultepec, where the cream of the crop of our charros and chinas paraded. María Elena Medina and Rosa Pérez Rulfo, with their classical braids and silk shawls from Tenancingo, awed us all with their sovereign grace and traditional humility at a party that would have made Fidel himself dance the *jarabe*. Unidentified photographer RR

MODERN MEXICO

May
1937

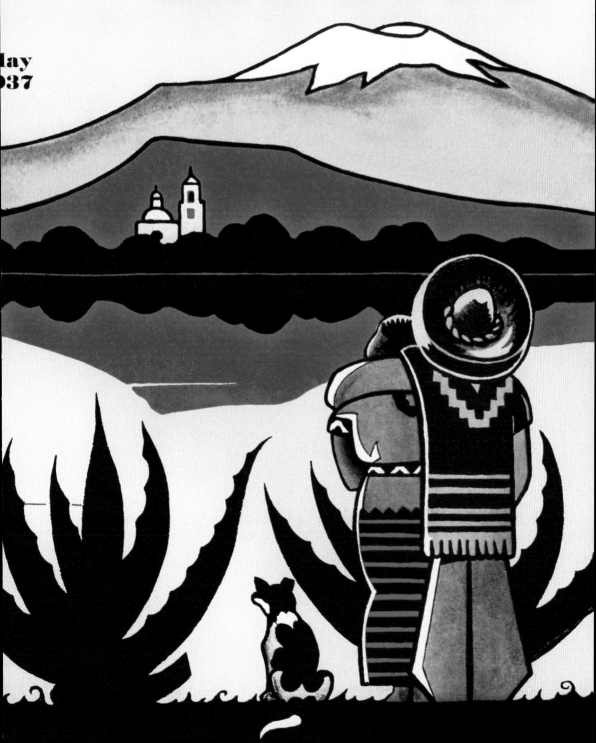

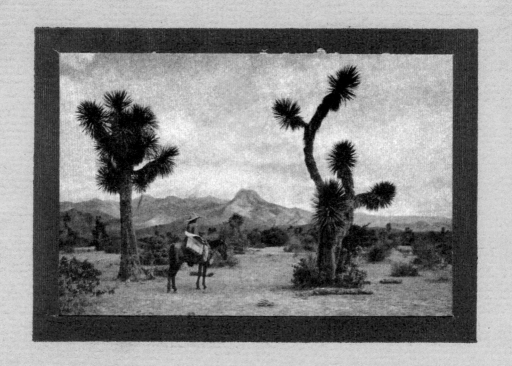

MEXICO

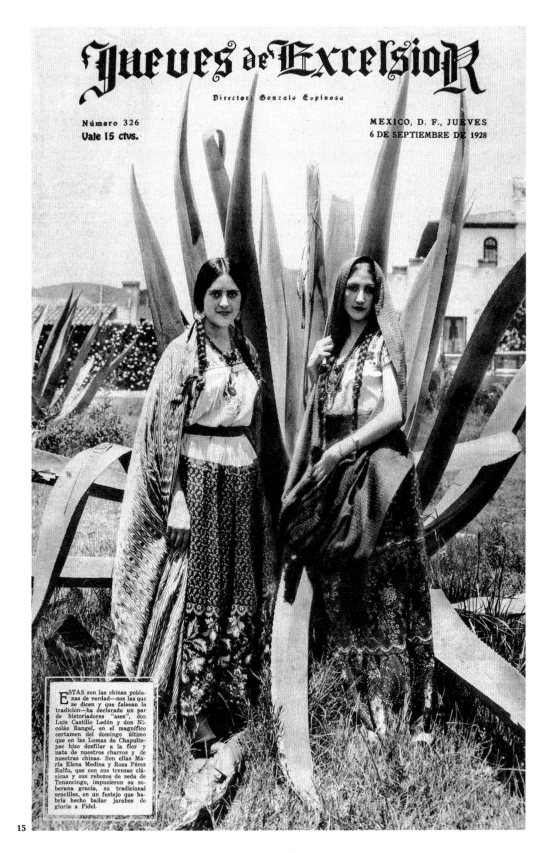

Jueves de Excelsior

Director: Gonzalo Espinosa

Número 326
Vale 15 ctvs.

MEXICO, D. F., JUEVES
6 DE SEPTIEMBRE DE 1928

ESTAS son las chinas poblanas de verdad—nos las que se dicen y que falsean la tradición—ha declarado un par de historiadores "ases", don Luis Castillo Ledón y don Nicolás Rangel, en el magnífico certamen del domingo último que en las Lomas de Chapultepec hizo desfilar a la flor y nata de nuestros charros y de nuestras chinas. Son ellas María Elena Medina y Rosa Pérez Rulfo, que con sus trenzas clásicas y sus rebozos de seda de Tenancingo, impusieron su soberana gracia, su tradicional sencillez, en un festejo que habría hecho bailar jarabes de gloria a Fidel.

REVISTA DE REVISTAS
EL SEMANARIO NACIONAL

16 *Revista de Revistas*, year XIII, no. 645, Mexico, September 17, 1922. Cover by Ernesto García Cabral MLC

17 *1854. 1er Centenario del Himno Nacional. 1954. Ciña ¡oh patria! tus sienes de oliva.* Correo Aéreo Mexico [35 centavos]. Talleres de Impresión de Estampillas y Valores, Mexico, 1954 Postage stamp, with drawing by Jorge González Camarena MLC

18 *Mi cuaderno de trabajo de tercer año. Geografía.* Comisión Nacional de los Libros de Texto Gratuitos, Secretaría de Educación Pública. Mexico, July 1961. Cover by Jorge González Camarena. Reproduction of a painting showing the progress of the Mexican nation, driven by her history and the three forces of culture, agriculture, and industry, led by her people MLC

17

16

18

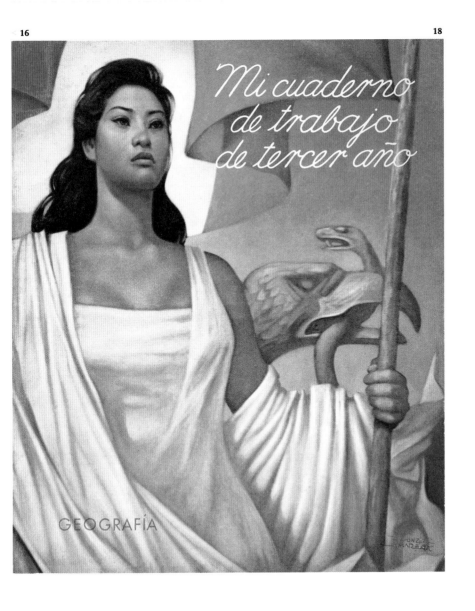

19

20

21 >

19 | *Almanaque Guadalupano. Santoral y astronómico para las Repúblicas de "México" y "Cuba,"* year 1913. Gift from the Fábrica de Magnesia Márquez "Padre" to its patrons. Printed and edited by Instituto Italiano d'Arti Grafiche de Bérgamo, Italia, 1913 | Cover | RR

20 | *Sagrario de Guadalupe: subida al Tepeyac y La Vela,* ca. 1911. Published in Mexico by J. K. | Postcard | RLQ

21 | *Sucesos para Todos,* no. 878, Mexico, December 13, 1949. Published by Libros y Revistas, S.A. | RR

No. 878 DICIEMBRE 13 de 1949

Sucesos
PARA TODOS

$.70

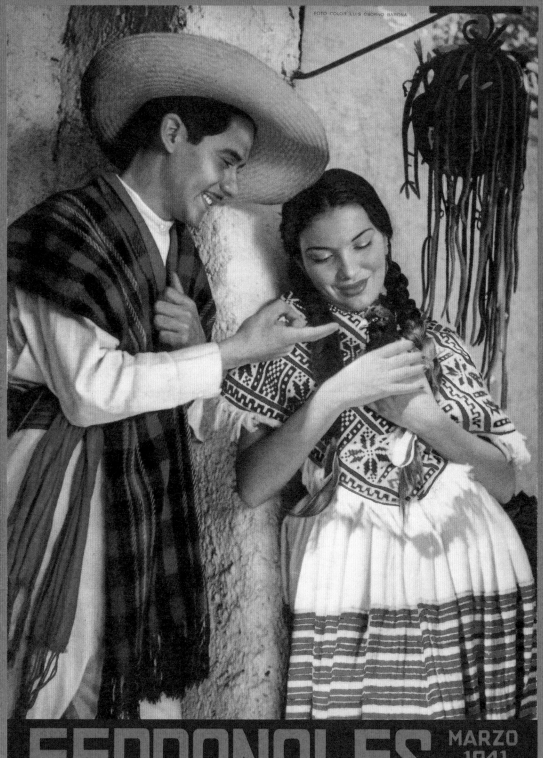

FERRONALES

MARZO
1941
25 ¢

OFFSET-GALAS MEX.

MEXICO'S PHOTOGRAPHIC CHARM

JAMES OLES

In the immediate post-revolutionary period, Mexican artists and intellectuals as well as government bureaucrats and business owners conspired in the creation of a cohesive national identity from disparate regional parts that would, at least theoretically, resolve the social divisions and political tensions fostered during the Porfiriato and exacerbated by an almost decade-long civil war. State-sponsored muralism was certainly the most prominent artistic language of the time, but all modes of visual discourse, and especially popular culture, were essential in shaping identity. Some of this imagery was refreshingly modern and progressive, but, as Adriana Zavala has noted, much of it simply updated and repackaged Catholic or Porfirian antecedents, more often than not reaffirming standard gender roles, exoticizing or essentializing race, and even promoting European standards of beauty, notwithstanding the ubiquity of traditional costumes.[1] Though images designed primarily for outsiders are often more transparently racist or sexist, those intended for Mexicans alone are hardly innocent or naïve.

At the end of the nineteenth century, in Mexico as elsewhere, printed images derived from photographs (rather than actual photographs, of course) began to appear in a diverse array of mass circulated newspapers and journals. Magazine covers and single-sheet supplements in newspapers, most of them published in Mexico City, were mainly designed to capture the attention of residents; postcards and other forms of travel propaganda, like brochures and posters, were primarily intended for tourists or armchair travelers, often from the United States. The language of the publication, or accompanying texts and captions, sometimes—but not always—gives us a sense of distinct consumer markets, but the allure of rural landscapes and traditional folkways seems to have seduced citizens and foreigners in equal measure. That these images continue to seduce contemporary viewers is largely due to nostalgia: they depict an untroubled and timeless Mexico that never really existed in the past and provide an escape from our troubled and globalized (which is to say increasingly, though not totally, homogenized) present.

This essay provides some initial observations about the role of one particular medium—color photography, or more specifically, the mass reproduction of photographic images in color—in creating and reinforcing that idealized image of Mexico in the first half of the twentieth century.[2] Several caveats are in order, however. Given shared subject matter and overlapping systems of production and distribution, it is difficult to separate out any single medium or support from the turbulent storm of images that circulated in this period. For example, in the 1920s and 1930s, such popular types as *china poblanas* and *tehuanas* were appearing simultaneously—and in similar poses—as both photographs *and* paintings on the covers and interiors of mass distributed publications (**figs. 02 and 03**).[3] There are certainly important historical, material, and contextual differences between photographs and paintings; or between hand-painted photographs and photographs printed from color filmstock; or between real photographs—made by hand using special papers in the darkroom—and photographic reproductions—printed by machine in far greater numbers. And there are also crucial differences between the work of professionals and amateurs, or between art and commercial photographers, that are often reflected in market value. But since the same icons, clichés, and stereotypes were shared again and again by varied practitioners across all these media, limiting the field of inquiry can inhibit a more complete understanding of the role of visual culture in shaping attitudes towards race, class, and gender.

Nevertheless, given their prevalence and impact, there seems some merit in at least temporarily isolating photographic images in color from the wider storm of images of Mexico to better understand how they were created and distributed, how they shaped the national *imaginaire*, and how they reinforce or contradict discourse in other media.

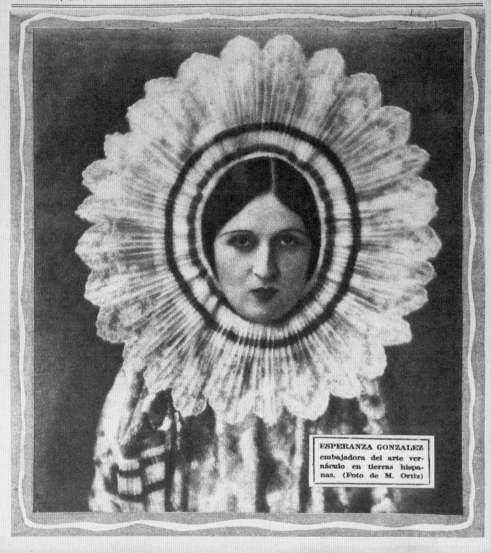

La Revista mensual de mayor circulación en la República. Tiro certificado: 25,000 ejemplares.

TOMO V. NUM. 49.

Registrado como artículo de 2a. clase con fecha 18 de julio de 1926.

MEXICO, D. F. DICIEMBRE DE 1930. Director: LUIS C. PEREDO.

ESPERANZA GONZALEZ
embajadora del arte vernáculo en tierras hispanas. (Foto de M. Ortiz)

02 03 >

01 | *Ferronales*, vol. XII, no. 3, March 1941. Staff magazine of Ferrocarriles Nacionales de México. Printed by Offset Galas | Cover photo by Luis Osorno Barona | JO

02 | *México al Día*, vol. V, no. 49, Mexico, December 1930 | Photo caption on cover: "Esperanza González, ambassador of the popular arts in Spanish lands", photo by Martín Ortiz | MLC

03 | *Álbum de música popular mexicana*, n° 2. Mexico, A. Wagner and Levien, Sucs., 1933 | Cover by Andrés Audiffred | RLQ

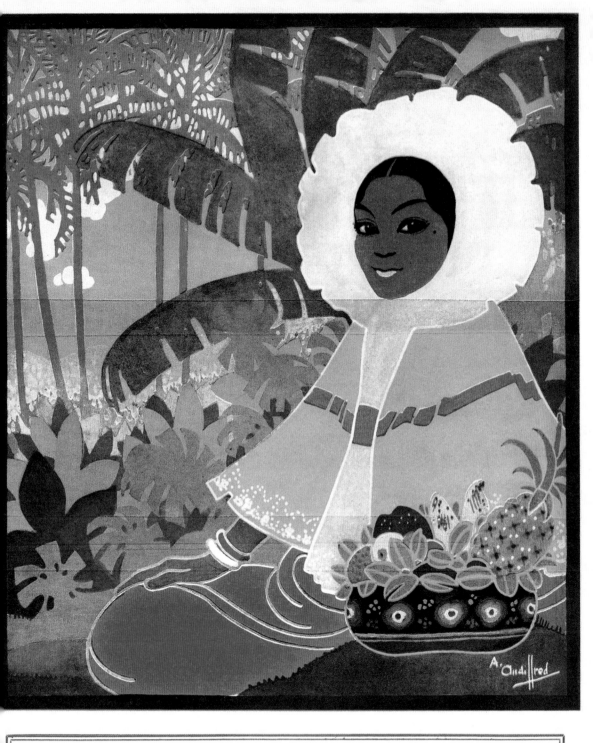

Album de Música Popular Mexicana No. 2

Album of the most Popular Mexican Music No. 2

A. WAGNER Y LEVIEN, SUCS., S. en C.

México, D. F.

1a. Ven. Carranza, 21. Apartado 353.

Puebla. Monterrey. Guadalajara. Veracruz.

Propiedad de los Editores para todos los Países. Depositado conforme a la Ley 1933 Copyright 1933 by
A. Wagner y Levien Sucs., S. en C., México, D. F.

FRIEDRICH HOFMEISTER, LEIPZIG.

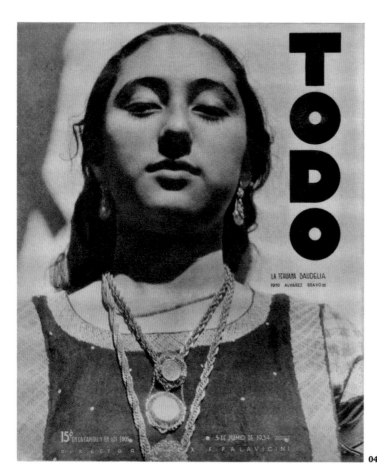

04 | *Todo*, year I, no. 40, July 5, 1934. Mexico, Editorial Todo | Cover: "La tehuana Baudelia," photo by Manuel Álvarez Bravo | RLQ

05 | *The National Geographic Magazine*, vol. XLIII, no. 3, March 1923. Published by the National Geographic Society, Hubbard Memorial Hall, Washington, D.C. | "In the Land of the Montezumas," pp. 276-277 | JO

04

Art historians and curators sometimes distinguish between "colored" and "color" photographs, between those where color is *added* subsequently, whether through hand-tinting or mechanical processes, and those where color is *integral* to their production, generally through the use of light-sensitive chemicals that record color information at the time of exposure (although photographs were colored from the very beginning, true color photography was widespread only after the mid-1930s). Visually and conceptually, the distinction is crucial; for example, one might contrast the unreal colorization of a black-and-white original to the more or less "accurate" colors of Kodachrome slide transparencies or Kodacolor and Ektachrome paper prints. But my concern here is the printed photograph rather than the photographic object, and the mass circulation of such images rather than their physical status as rare or even unique objects. In many ways, these were the images that mattered more, even if today they are valued less. Although scholars (and the art market) often privilege the work of avant-garde figures like Tina Modotti or Manuel Álvarez Bravo, at the time their images were familiar to only a select few cognoscenti, mainly through arty magazines with limited runs like *Forma* and *Mexican Folkways*, with rare exceptions **(fig. 04)**. By contrast, mass-produced postcards, often showing similar subjects and even compositions, with images by Hugo Brehme, Sabino Osuna, or the (usually) anonymous photographers working for the Sonora News Company, filled shop windows and newsstands across the country and cost a penny to purchase and another to mail. For most people, photography was only visible through its commercial reproduction.

In fact, apart from a few "real photo" postcards, none of the images discussed in this essay are photographs properly considered but are instead copies, either derived from monochromatic originals or—if printed after the invention of the Autochrome in the early 1900s—based on actual color photographs.[4] Whether these originals were compromised or improved by available technology is a value judgement that depends on the source material and quality of reproduction but also on the taste of the viewer. From the perspective of the art world, these color images might be considered cheap or distracting kitsch, pandering to what David Alfaro Siqueiros famously (and misogynistically) called "typists' taste" in the 1924

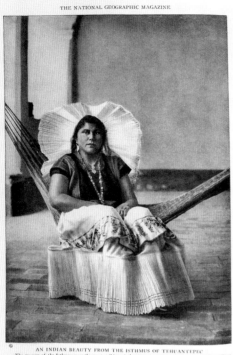

AN INDIAN BEAUTY FROM THE ISTHMUS OF TEHUANTEPEC

The women of the Isthmus wear the most striking of the many costumes to be found in the Republic of Mexico. In addition to her headdress, *huipil grande*, this native wears a colored waist and flowered skirt, with a wide stiff ruffled hem (see also Color Plate V).

XII

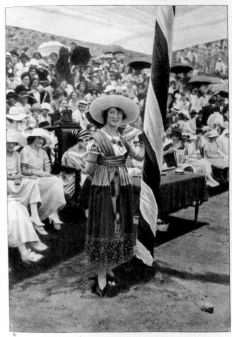

A FÊTE-DAY GATHERING AT JALAPA

The señorita in the central foreground is wearing her *China Poblana* costume, which is in sharp contrast to the latest fashions of the Queen of the May and her ladies of honor in the new stadium, on the occasion of a national holiday celebration.

XIII

05

manifesto of the Union of Technical Workers, Painters, and Sculptors or to the worst exoticist impulses of the tourist trade. Yet more generously, color was not only more attractive to consumers but also—even if it was artificially applied and exaggerated—provided a more intimate and tactile connection to the observed world, especially when the subject, in particular Mexico's traditional costumes and folk art, were distinctive precisely for their unabashed chromophilia.[5]

Many of the photographic images discussed in this essay were ignored or disdained—from the moment of their production—as insufficiently documentary or insufficiently artistic, corrupted by a "facile picturesqueness" that veered into exoticism or even racism.[6] They were entertaining rather than serious, a supposed conceptual defect that was revealed not only by their subjects and compositions, but also by the very fact that they were reproduced in color. Actually, although no one had much of a problem with color as regards *painting*, when it came to photography, color itself, whether applied or intrinsic, made an image seem even more artificial, theatrical, and exoticizing, compounding its sins. Until the 1970s, with few exceptions, photographers everywhere

with artistic ambitions avoided color, which they associated with the advertising industry. Even the critical acclaim for new color photography in the United States and Europe in the 1970s, and the eventual replacement of the gelatin silver print by digital color, would not fully remove the stain of commercialism from these images from the past.[7] Indeed, one could argue that, for decades, black and white photography resided in the international realm of "art," whereas color photography was consigned to either the mundane world of "advertising" or the local territories of "anthropology," as in the pages of *National Geographic* **(fig. 05)**.[8] And yet, given photography's "truth value," however elusive, no medium had more of an impact or appeal; the addition of color to the equation not only updated old tropes, it seduced audiences even more, despite the disdain of elites.

The photographic images in color reproduced in this book range in subject from the deeply folkloric and local (rural landscapes, traditional crafts, the so-called "India Bonita") to the ultra-modern and cosmopolitan (factories and flappers, the commercial boulevards of the capital), and—if we focus on photography's formal qualities—from sentimental pictorialist

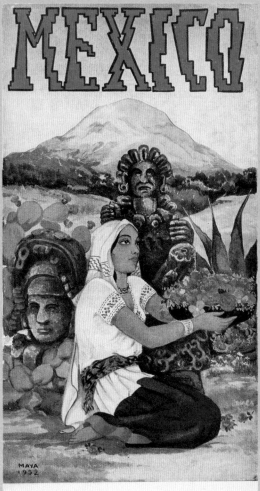

06

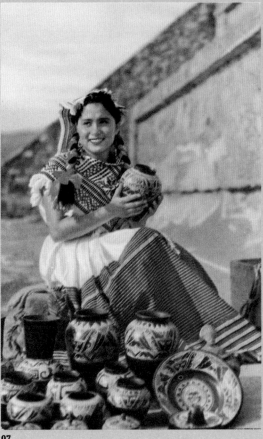

07

conventions meant to appeal largely to a female audience to the emphasis on fragments, oblique angles, and crisply rendered surfaces that typified a more aggressive "new vision."[9] However, as Deborah Dorotinsky warns, focusing on the extreme poles of either spectrum (iconographic or formalist) risks excluding the literal middle, namely that vast pool of images— like those of her immediate subject, photographer María Santibáñez—that were neither that local nor that cosmopolitan, neither that old-fashioned nor that modern, but that instead asserted middle-class taste and, for that reason, predominated in the mainstream press, prompting the wrath of nationalists and modernists alike.[10] All of the images in this book, and especially the photographs, were meant to comfort rather than unsettle, to confirm rather than challenge.

Whether through the medium of photography or other modes of visual culture, a variety of non-textual signs coalesced over time into clear categories and sub-categories of cultural difference, representing distinct facets of what is often called *mexicanidad*, or Mexicanness, but that might also be productively analyzed in terms of Mexicanicity, a term that emphasizes the artificial construction and commercial genealogy of such identity-forming images.[11] These categories generally feature a particular *place* (pre-conquest archaeological sites; the canals of Xochimilco, Ixtaccíhautl, and Popocatépetl; but also urban monuments and colonial churches), *persona* (identified by costume—*charros, chinas, tehuanas*—or occupation— street vendors, *molenderas, tlachiqueros*, and folk artists), *product* (Michoacán lacquerware, Saltillo sarapes, Tlaquepaque ceramics, and even the humble *petate*), or *plant* (above all, the prickly pear and organ pipe cactus).[12] Frequently, these categories—often referring to specific regional identities—collapse into a single purely "Mexican" image, where nature, identity, and material culture align, where even the typography and framing are inspired by pre-Hispanic or local folk sources **(figs. 06 and 07)**.[13]

However, in other images, visual signs of modernity—which, because it is more international, might be opposed to Mexicanicity—complicate matters. This is evident, for example, in the photographs of half-naked pinups in high heels and cropped hair, who pose with striped sarapes or wear *huipiles grandes* from Tehuantepec, modified to show off their dancers' legs or recline invitingly in front of panoramas showing the pyramid of Cholula or other tourist sites (a recurring image on the covers of *Vea*). Modernity also intrudes in more formal terms—tasteful art-deco lettering, for example, or the use of flat constructivist shapes and

jarring cubist compositions, especially montage—or through the medium itself, for no matter how traditional or "timeless" the image, there is nothing more expressive of contemporaneity than photography and systems of mass reproduction, like postcards and magazines. These images allude not only to the racial and cultural *mestizaje* that played such a crucial role in the establishment of an official Mexican identity but also to a temporal synthesis: Mexicans, their makers imply, share not only indigenous and European traditions but ancient and modern ones as well. This fusion of place (here and there) and time (then and now) affirmed the self-identity of middle-class consumers: it symbolized a secure nation-state grounded in history but looking to the future and supported a tourist industry that used tradition as a lure while offering visitors every modern comfort.

Despite important continuities over time, this commercial production was never static but rather evolved in line with stylistic shifts that were taking place in the more formal worlds of art and design as well as through historical events and political transformations that impacted Mexico more broadly.[14]

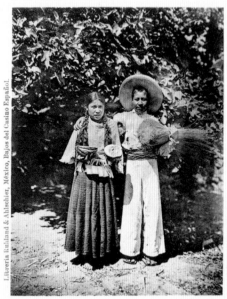

Librería Ruhland & Ahlschier, México, Bajos del Casino Español.

México Indígenas

09

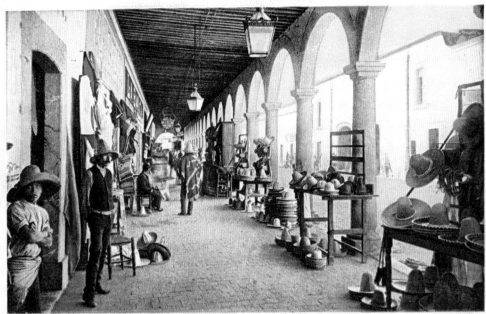

13253 PORTALES OF A MEXICAN MARKET.

10

Technologies were, of course, international, but they were applied locally, and despite some promising advances, there is still much we do not know about the evolution of production and distribution networks in Mexico.[15] Lagging somewhat behind other metropolitan centers, commercial printers in Mexico began reproducing photographic images at the very end of the nineteenth century in the form of halftones in black and white. The first such photograph appeared in a Mexican newspaper (*El Imparcial*) in 1897;[16] the first photographic postcard of a Mexican scene was published by Ruhland & Ahlschier that same year, though before the Revolution, most postcards were printed in Europe—mainly Austria, Germany, and Switzerland—and shipped to Mexico for sale **(fig. 08)**.[17] Black and white dominated at first, but publishers everywhere were eager to introduce color: as Richard Benson warns us, "We should not be naive about the reason for the development of color printing; it was entirely due to the belief that you had a better chance to sell someone something they didn't need if you advertised it in color rather than in drab old black and white."[18] Perhaps color images of Mexico, initially designed to better compete on the newsstand, postcard rack, or tourist office, confirming the longstanding trope that the nation was in fact more "colorful," ended up satisfying deeper psychological yearnings—providing a stronger sense of national

identity or a more enjoyable escape from home or office, via train or armchair—whether they were in fact necessary or not. This is particularly evident in an illustrated brochure for the Hotel Regis, where rural Mexico's intense colors are compared to the pallid (and polluted) cities of the north **(fig. 09)**.[19]

The Lumière Autochrome, the first practical form of color photography available to amateurs, was available in Mexico by around 1907, but only with the invention of the first readily available color processes—Kodachrome positive slides (1936) and Kodacolor negative film (1942) for printing on paper—could professionals and amateurs easily create true color photographs that could then be converted into print. Until then, photographic color was obtained either through hand-coloring black and white originals or converting them into color through commercial printing technologies that were rapidly evolving in the early twentieth century.[20] Among the first in Mexico to print photographs in color were the highly-competitive postcard publishers, who used an astonishing variety of technologies to attract tourists and collectors.[21] Although produced in Detroit, William Henry Jackson's photochroms (marketed as Phostint) were available in Mexico City by at least 1905 **(fig. 10)**; other postcards were produced using a variety of lithographic and offset presses or even individually hand-colored **(page 124: fig. 23)**, though we know little

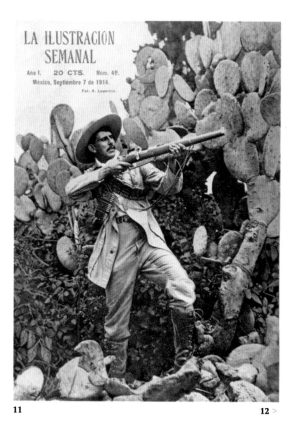

11 | *La Ilustración Semanal*, year I, no. 49, September 7, 1914. Mexico, Compañía Periodística Mexicana, S.A. | Cover photo by Abraham Lupercio | MLC

12 | *La Ilustración Semanal*, year I, no. 45, August 10, 1914. Mexico, Compañía Periodística Mexicana, S.A. | Cover by Tostado Grabador | MLC

about *who* was doing the coloring.[22] Photo-chromo-lithography and hybrid collotype became common in the postcard trade, while three- and four-color halftone plates—and later photo offset and process color—came to dominate magazine covers, usually leaving the photographs inside monochromatic, as they were invisible to the newsstand browser.[23] The unabated influence of the Casasola Archive means we generally imagine the Mexican Revolution in black and white, but color arrived soon enough to give soldiers' uniforms their supposedly "true colors" in the popular press, even if their rifle-ready poses were obviously faked **(figs. 11 and 12, and page 62: fig. 05)**.[24] Over time, these innovations facilitated the faster and more extensive reproduction of photographic images, increasing print quality and accuracy and providing publishers with better and cheaper access to color. In fact, by 1910 or so, offset presses, which used rubber cylinders to transfer an inked image from plate to paper or other material, could produce up to 6,000 sheets an hour, more than enough to accommodate what I expect were rather more limited print runs in Mexico.

In early commercial printing, photographs can often seem either muddied or, perhaps more enticingly, garish. A rural landscape by Antonio Garduño on the cover of *Arte y Letras* from 1914 **(fig. 14)** and a view of the Monument to Independence by the Guadalajara-born Carlos Muñana, printed on a cover of *El Universal Ilustrado* from 1918 **(fig. 13)**, both include a spectacular sunrise then impossible to capture on film, in each case clearly painted by hand.[25] By contrast, a pale color portrait by María Santibáñez on the cover of *Revista para Todos* from 1920 **(fig. 15)** was created using the three-color halftone process: the image was converted into three plates in cyan, magenta, and yellow, which overlap to create an illusion of color—the separation here is evident due to a slight misalignment during printing. By 1941, at least, offset printing allowed greater color intensity, as seen, for example, on the covers of *México al Día* and supplements from *La Prensa*, some of which directly credit the Kodachrome originals **(figs. 16, 17, 30, 31 and 35)**. Yet publishers still faced technical challenges: to obtain greater—and patriotic—vibrancy, someone extensively retouched Luis Osorno Barona's

La Ilustración Semanal

Año I. - Núm. 45. - Mexico, Agosto 10 de 1914. - 20 Cts.-Fot. Lupercio.

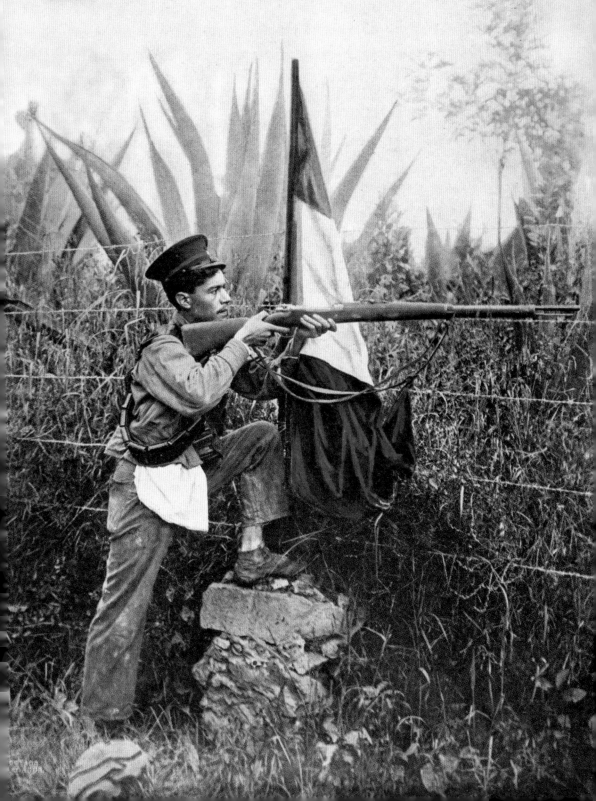

AÑO II. - NUM. 71

20 centavos en la Capital
En los Estados el precio
que fijen los Agentes

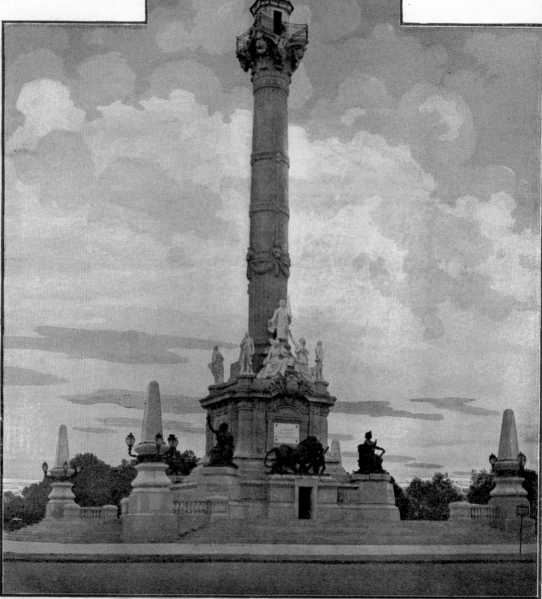

Tostado, Grabador

Fot. Muñana

EL MONUMENTO DE LA INDEPENDENCIA
En el Paseo de la Reforma

13 *El Universal Ilustrado*, year II, no. 71, Mexico, September 13, 1918 Photo caption on cover: "The Monument to Independence at Paseo de la Reforma," photo by Carlos Muñana RLQ

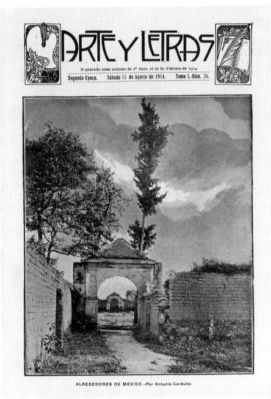

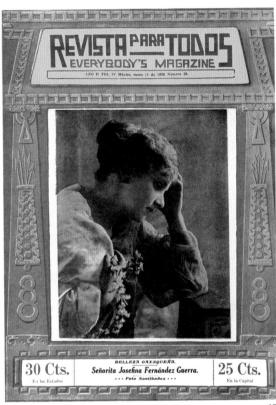

13 **14** **15**

14 *Arte y Letras*, vol. I, no. 26, August 15, 1914. Mexico, Compañía Periodística Mexicana, S. A., Cover: "Alredededores de México," photo by Antonio Garduño JO

15 *Revista para Todos*, year II, vol. IV, no. 20, Mexico, January 11, 1920 Caption on cover: "Oaxacan beauty. Miss Josefina Fernández Guerra," photo by María Santibañez JO

16 "The Virgin of Guadalupe, Mexico's dear mother, being fervently admired by the lovely obsidian eyes of these young women, who proudly show their brown faces, copies of the Virgin's". *La Prensa*, Mexico, December 7, 1941 Poster JO

17 "The indigenous woman of Mexico, a type unique in the world for her strong personality. Sobriety and languor are characteristics that make her stand out like a violet among other flowers. We have here a gracious indigenous woman smiling for our readers." *La Prensa*, Mexico, November 30, 1941 Poster RR

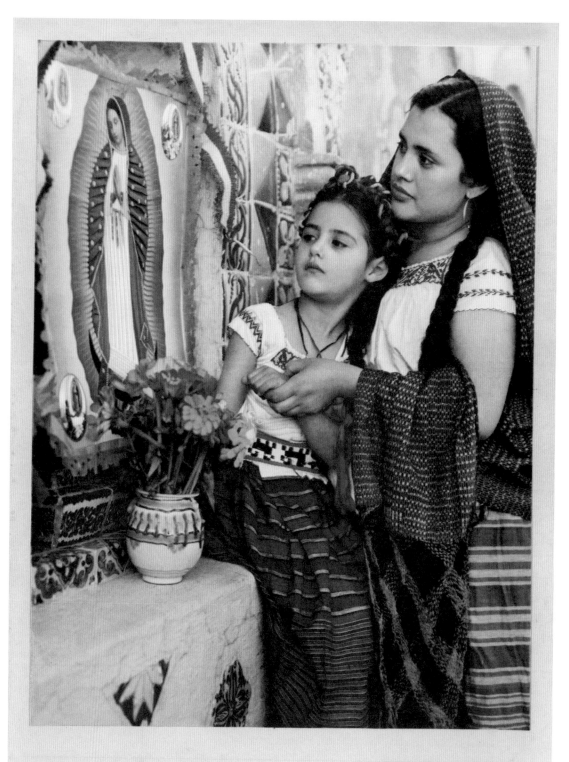

LA VIRGEN DE GUADALUPE, la madrecita de México, es admirada fervientemente por los encantadores ojos de obsidiana de estas muchachas, quienes lucen con orgullo sus rostros morenos que copiaron a la Virgen.

LA PRENSA
Diario Ilustrado de la Mañana
MEXICO, D. F., DICIEMBRE 7 DE 1941

16

17 >

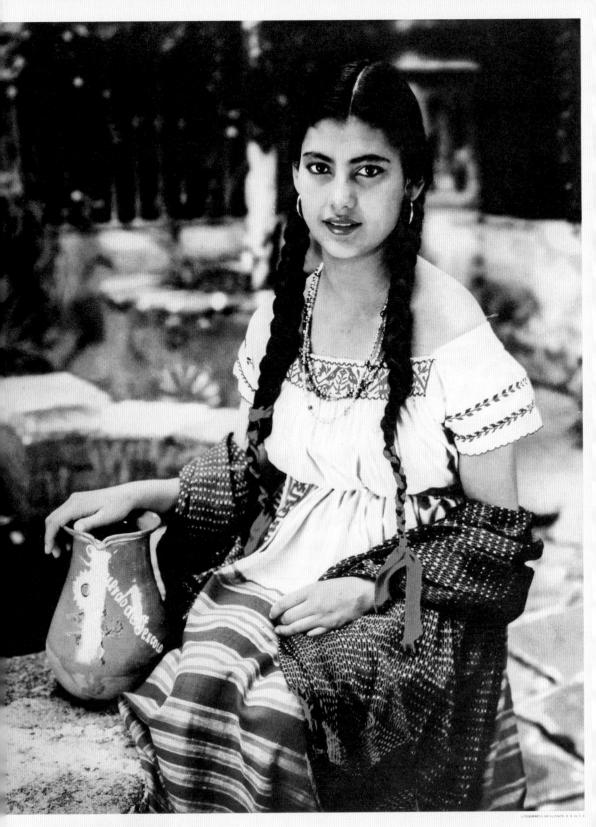

LITOGRAFOS MEXICANOS. S. A. M. C. V.

La indita de México, tipo único en el mundo por
su fuerte personalidad. La sobriedad y la languidez
son características que la hacen resaltar como la vio-
leta entre las demás flores. He aquí una graciosa in-
dita que sonríe para nuestros lectores.

LA PRENSA
Diario Ilustrado de la Mañana
MEXICO, D. F., 30 DE NOVIEMBRE DE 1941

color photograph of rural lovers before it appeared on the cover of the official magazine of Ferrocarriles Nacionales de México, evident especially on the woman's triangular *quechquemitl* and striped skirt **(fig. 01)**. By the 1960s, color was so ubiquitous—so uninteresting, perhaps—that printers sought more eye-catching processes, such as lenticular prints, seen on Arthur Rothstein's "xographs" for the covers of *Venture* magazine as well as in a series of 3D postcards published locally but printed in Japan, produced just in time for the 1968 Olympics **(fig. 18)**.

Indeed, behind any single mass-reproduced photograph, there are innumerable creative, technological, commercial, and sometimes political decisions beyond the purely aesthetic: How much were photographers paid? Who selected the images? What were the specific methods by which originals were converted into print form at printing houses like those of Santiago Galas and Ezequiel Álvarez Tostado, both of which opened in 1913, or less familiar businesses such as Imprenta Mundial, Litógrafos Mexicanos, or Offset Mayli?[26] Not only who hand-colored black and white photographs, but also who checked the color proofs? What were the specific production and distribution networks and what were the costs? How were images received by locals or visitors? Even authorship itself is often in question in a visual world where photo credits are either absent or unreliable, and where piracy—perhaps more than legal copying—was common, where images reappear across media. Indeed, the extended scholarship on just one famous image—the 1911 black-and-white photo-portrait of Emiliano Zapata in Cuernavaca—reveals a complicated and unsettled history that we might expect applies in many other contexts.[27] Close analysis of any particular image thus requires careful attention not only to the publisher, but to the credit lines, captions, and signatures that provide clues to how color photographs reached the masses.[28]

Shaped by chromophobic prejudices elsewhere in the world, Mexican "art" photographers resisted color until the 1980s, with few exceptions; even Manuel Álvarez Bravo, who began experimenting with color in the early 1940s, privileged black and white in his exhibitions and publications.[29] Those working in color tended to be commercial pictorialists and portraitists who preferred hand-tinting, such as Hugo Brehme and Luis Márquez, innovators with access to sophisticated laboratories and healthy advertising budgets (Anton Bruehl, Nickolas Muray), or local photojournalists (Juan Guzmán, Luis Osorno Barona, Walter Reuter). Some of these figures are better

18 | *Venture Magazine*, The Traveler's World, vol. 5, no. 7, September 1968 | Cover: "The Indigenous woman of Mexico, a type unique in the world for her strong personality. Sobriety and languor are characteristics that make her stand out like a violet among other flowers. We have here a gracious Indigenous woman smiling her for our readers." | JO

19 | *México, 1959*. | Calendar | Cover: "Escenificación de un rito azteca," photo by Hermann Grathwohl | RR

MEXICO
1959

ESCENIFICACION DE UN "RITO AZTECA"
FOTO *H. Gastrunkl*

EL UNIVERSAL ILUSTRADO

ESPERANZA IRIS
la reina de la Opereta en traje de
chiapaneca

AÑO II. - NUM. 57

Precio: 40 cts. en la Capital

EN FOLLETIN: "EL BUEN MOZO"
DE MAUPASSANT: "LA MUERTE DE
LA REINA MARIA ANTONIETA"
DE FUNCK-BRENTANO

20

documented than others and earned credit in period publications, but others are more mysterious. For example, a 1959 calendar identifies the six photographers, but their names—H. (Hermann) Grathwohl, A. Erosa, G. Alvarado, Rolf Schaur (or Schauer), O. Politzer, and Dr. E. Gómez Goyzueta—lead nowhere in Google **(fig. 19)**.[30] It may be that details and questions concerning authorship, production, and distribution are less compelling to anyone but a few scholars, but they are pesky reminders that photographs did not magically appear on the newsstand or at the travel agency, but rather were commissioned, imagined, framed, cropped, edited, manufactured, labeled, and circulated, even if their commercial, technological, and authorial origins distract us from the subject's immediate visual delight.

The recurring clichés and stereotypes present throughout this publication—and beyond—demand both diachronic and synchronic analyses beyond simple delight. Faced with the iconographic affluence of projects such as this, however, it is difficult to give full attention to any single image; indeed, their commercial status and frequent anonymity seems almost to preclude—or deter—careful art historical exegesis.

And yet many of the commercial images—however charming or seductive on the surface—do merit closer readings, and as the objects of our attention depend more on haphazard survivals and flea-market finds than on complete archival collections, we perhaps need not worry too much about being comprehensive: the sheer repetition of subjects, poses, costumes, and props saves us from purely arbitrary paths of interpretation.

Not surprisingly, many were inspired by paintings and prints, often in shows at the Academy of San Carlos that were promoted in the same pages of the magazines. For example, the cover of *El Universal Ilustrado* showing a girl with blue hydrangeas **(fig. 21)** must have been inspired by Alfredo Ramos Martínez's contemporaneous *Paisaje con niña y hortensias* (1916; Museo Nacional de Arte). It is even easier to find parallels to the paintings of Saturnino Herrán—whose *La criolla del rebozo* (1916; Museo de Aguascalientes) anticipates the 1930s covers of *Vea*, for example **(page 56, fig. 21)**—or Diego Rivera, whose iconic flower sellers and Tehuanas, themselves in dialogue with photography, print media, and even vaudeville shows, were revisited again and again by more commercial artists and photographers. The question for future scholars of this material may be to explore, in greater detail, the complex creative networks that connect such images, directly or not.

I conclude by returning to Luis Osorno Barona's 1941 cover for *Ferronales* showing a traditionally dressed couple leaning against the corner of a masonry wall **(fig. 01)**. This photograph—a Kodachrome slide printed by Offset Galas—provides an especially fruitful point of departure, an escape not only from news of the Second World War but even from the accelerated modernity implied by the publisher, the National Railways of Mexico. His photograph updates a painting by José Agustín Arrieta known as *The Happy Marriage* (1850; private collection), though his feminist inversion is perhaps accidental; almost a century later, it is the *woman* who holds the bird captive in her hand. And yet, the scene is somewhat more unsettling, even troubling. The false color intensity artificially nationalizes the woman's Nahua costume, which seems, like the man's sarape, produced from industrial rather than natural dyes. Osorno Barona's image further enacts the racist trope of the lighter-skinned woman being courted by the darker-skinned man, a path back to whiteness already evident in the casta paintings of the colonial period.[31]

Notwithstanding the woman's dark braids, her light-skinned face, plucked eyebrows, and intense

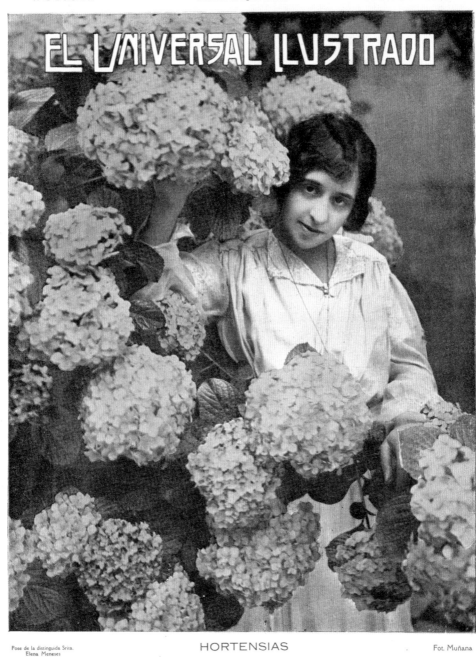

México, 3 de Agosto de 1917

Precio: 40 centavos en la Capital

EL UNIVERSAL ILUSTRADO

Pose de la distinguida Srita.
Elena Meneses

HORTENSIAS

Fot. Muñana

21

20 | *El Universal Ilustrado*, year II, no. 57, Mexico, June 7, 1918 | Caption on cover: "Esperanza Iris, queen of the operetta, in costume from Chiapas," photo by Carlos Muñana | RR

21 | *El Universal Ilustrado*, year I, no. 13, Mexico, August 3, 1917 | Photo caption on cover: "'Hortensias'. The distinguished Srta. Elena Meneses poses for us," photo by Carlos Muñana | RLQ

EL MUNDO ILUSTRADO

México, 21 de junio de 1914

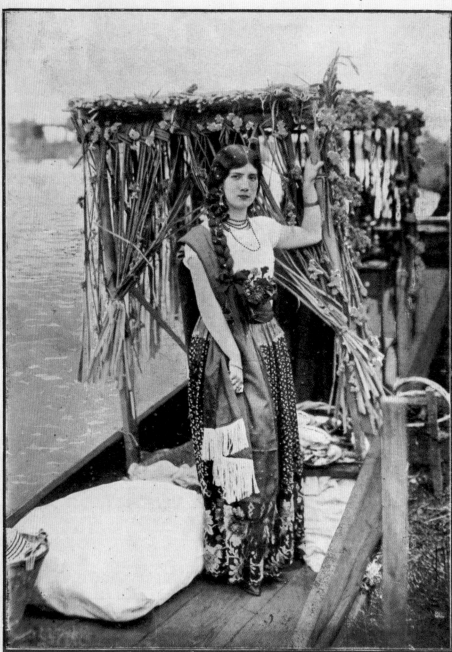

Señorita Luz López, en traje de fantasía, dama distinguida de nuestra buena sociedad.

lipstick reveal the subject here as a glamorous urban model performing rather than embodying indigeneity, as compared, for example, to the image by Ruhland & Ahlschier **(fig. 08)**. The photograph might thus be situated within an extended history of cultural cross-dressing in Mexico, in which women—and far more rarely men—appear in a costume associated with a different ethnicity or social class, a fashion that gained traction in the early years of the century.[32] Wealthy hacendados had already appropriated and embellished the charro's costume during the Porfiriato, but after 1910, we increasingly find elite women posing in indigenous costumes as a visual statement of cultural—though not racial—*mestizaje*. In 1914, the same year Saturnino Herrán depicted his wife (mis)wearing a *huipil grande* in *La tehuana* (Museo de Aguascalientes), we find other women dressed as popular types on the covers of illustrated magazines, accompanied by captions that remind viewers of their "distinguished" social status **(figs. 22 and 23)**. These studio portraits echo those of similarly dressed vaudeville stars who appeared on a series of publicity shots published by the Compañía Fotográfica Mexicana (CFM) in the 1920s. Sometimes these costumes are more associated with indigenous culture, as is the case of the woman wearing a *quechquemitl* on the cover of *Arte y Letras*, or in Osorno Barona's photograph, and sometimes more with mestizo culture, as are all those *china poblanas*, including the one on the cover of *El Mundo Ilustrado*. Again and again, we find color deployed to idealize rural populations, eliding their poverty, hyping their Mexicanicity, but also reinforcing a necessary distance. The brilliantly colored costumes highlight just how pale the models' skin actually was and served as a reminder of the racial and cultural chromophobia of the people at the top.

As testified by the majority of the images in this book, color was an essential component of the "charm" that rural Mexico offered to bourgeois city dwellers—an alternative to the gray smoke and concrete of the modern metropolis. And because photographs, at least in theory, serve as mute testimony to reality—relying less on invention than observation, however idealized—it should be no surprise that color photography was deployed as soon as technically possible to capture a brilliant image of Mexico for popular consumption. Ironically, however, while color generally highlighted the anti-modern or local and was associated with popular taste, color printing technologies were international, imbuing those same images with an inherent modernity and sophistication. The photographs discussed here are filled with

Srta. García Sancho, de distinguida familia tapatía. Fot Lup Good

22 23

22 *El Mundo Ilustrado*, year XXI, vol. III, no. 51, Mexico, June 21, 1914 Caption on cover: "Miss Luz López dressed up in a costume, distinguished lady of our good society." RR

23 *Arte y Letras*, period 2, vol. I, no. 1, February 21, 1914. Mexico, Cía. Periodística Mexicana Cover by Andrés Lupercio RR

many such contradictions, and though we should be suspicious of their visual charm—after all, charm casts spells upon us, removing us from the logic and reason of the modern urban grind—they serve us well if they help to further reveal the economic, social, and racial politics behind the ongoing and contentious construction of Mexican national identity.

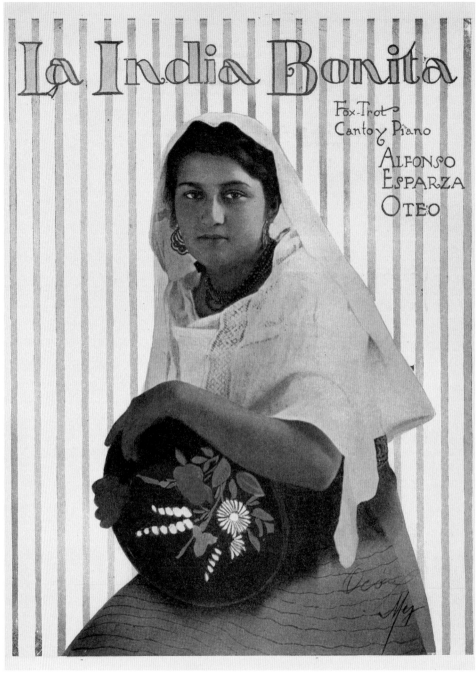

24

24 | Alfonso Esparza Oteo, *La india bonita*. Fox-trot, song and piano work. Mexico, *El Universal*, Mexico's greatest paper, [n.d.] | Cover by Juan Ocón | RLQ

25 | *Ferronales*, vol. XI, no. 10, Mexico, October 15, 1940. Staff magazine, Ferrocarriles Nacionales de Mexico. Printed by Offset Galas | RR

FERRONALES

OCTUBRE
1940
25 ¢

OFFSET-GALAS-MEX.

27

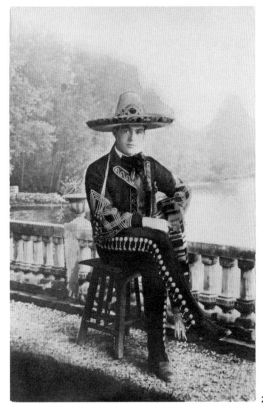

28

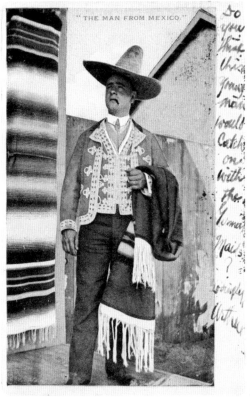

29

26 *Greetings from Tijuana Mexico*, ca. 1950.
Published in Chicago by Curteich & Co. Inc.
Postcard JO

27 *Retrato de charro*, ca. 1930-1950. Published
in Mexico by Cía. Mercantil "Fema" Postcard JO

28 *Retrato de charro*, Mexico, ca. 1930-1950
Postcard JO

29 *The Man from Mexico*, ca. 1910-1920
Postcard JO

30 "Jarabe tapatío". *La Prensa*, Mexico,
ca. 1940 Cartel Photo by Gustavo Arce JO

31 *México al día*, year XIV, no. 302, August 15,
1941. Mexico, Editora Mexicana, S.A. JO

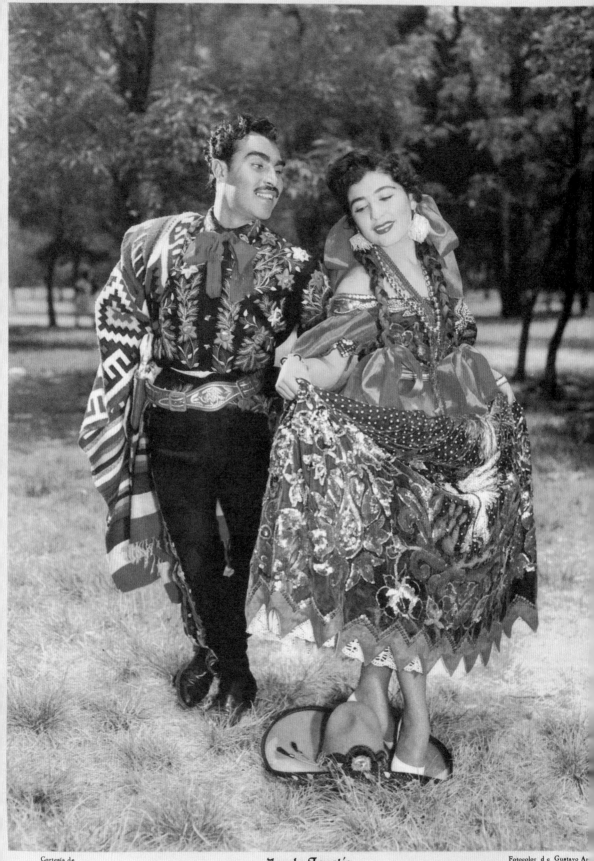

Jarabe Tapatío

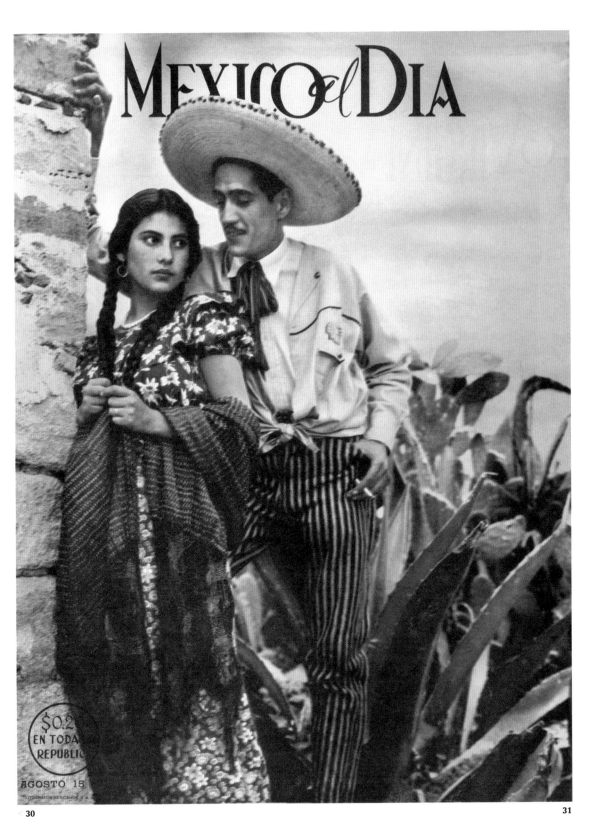

MEXICO el DIA

$0.2
EN TODA
REPUBLIC

AGOSTO 15

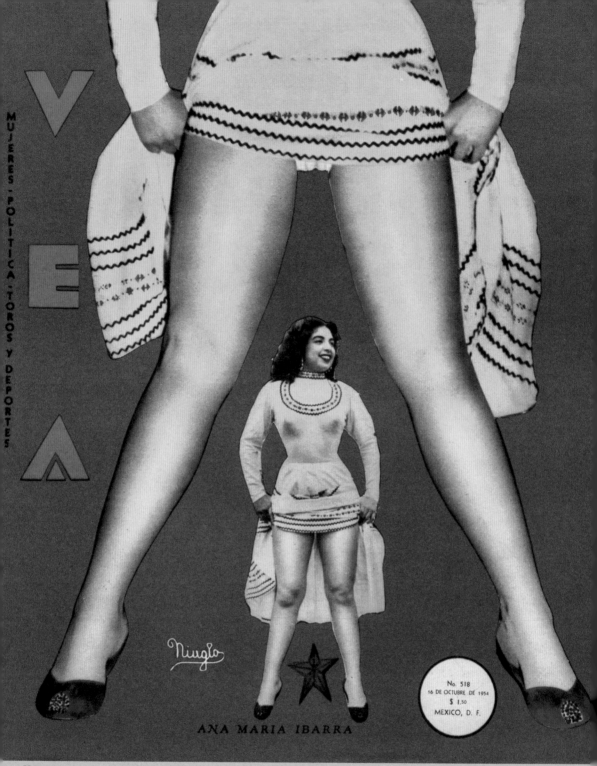

33

34

32 *Vea*, period 2, no. 518, October 16, 1954. Mexico, Editorial Salgado Cover: Ana María Ibarra, photo by Niuglo RR

33 *Vea*, period 2, no. 207, October 29, 1948. Mexico, Editorial Salgado Back cover showing Suhaila, photo by Armando Herrera RR

34 *Vea*, period 2, no. 221, February 4, 1949. Mexico, Editorial Salgado Back cover showing Tana Linn, photo by Armando Herrera RR

35 "La china poblana." *La Prensa*, Mexico, ca. 1940 Poster, photo by Chino Pérez JO

1. See Adriana Zavala, *Becoming Modern, Becoming Tradition: Women, Gender, and Representation in Mexican Art* (University Park, PA: Pennsylvania State University Press, 2010), chapter 4, for a far more complex elucidation of issues that I can only briefly mention here.

2. I would like to thank Deborah Dorotinsky and Lynda Klich for their insightful comments to an earlier version of this essay. I elaborate upon some of these ideas and technologies further in my introduction to the forthcoming exhibition catalogue *Mexichrome: Photography and Color in Mexico.*

3. For more on these types, see the 2003 issue of *Artes de México* dedicated to the *china poblana*; and Francie Chassen-López, "The Traje de Tehuana as National Icon: Gender, Ethnicity, and Fashion in Mexico," *The Americas* 71, no. 2 (October 2014), 281–314.

4. Real photo postcards (or RPPC) are photographic images, usually in gelatin silver, printed on postcard stock, and sometimes hand-colored. Many repeated the same subjects as postcards made using lithographic or offset technologies: a sub-category, however, consists of portraits and other non-commercial subjects done in the home or studio, which belong less to the history of image distribution discussed here than to the history of photography proper. As stated above, such disciplinary barriers, of course, are rather illusory. The term "color photograph" encompasses many different technologies. See Sylvie Pénichon, *Twentieth-Century Color Photographs: Identification and Care* (Los Angeles: Getty Conservation Institute, 2013).

5. This is the counterpart to the fear or rejection of color famously discussed by David Batchelor in *Chromophobia* (London: Reaktion, 2000).

6. John Mraz discusses the tension between "exotic-archaic" and modern modes of representation in the 1920s, noting that Modotti once referred to photographs of "colonial churches and *charros* and *chinas poblanas*" as "trash." John Mraz, *Looking for Mexico: Modern Visual Culture and National Identity* (Durham: Duke University Press, 2009), 76–91.

7. That, or perhaps art historians have thought color distracts from more essential issues. In his groundbreaking survey (first published in Spanish in 1994), Olivier Debroise barely mentions color; in more recent studies, John Mraz and Esther Gabara cover new critical terrain but ignore the role and process of color almost entirely. See Olivier Debroise, *Mexican Suite: A History of Photography in Mexico*, trans. and rev. in collaboration with the author by Stella de Sá Rego (Austin: University of Texas Press, 2001); John Mraz, *Looking for Mexico*; and Esther Gabara, *Errant Modernism: The Ethos of Photography in Mexico and Brazil* (Durham: Duke University Press, 2008).

8. One might compare this distinction to entrenched racial concepts, in which whiteness was considered universal (as in the bleached perfection of Greco-Roman monuments, or colonialist administrators for that matter) whereas non-whiteness (whether "black," "red," or "yellow") was associated with specific cultures or geographic territories.

9. Deborah Dorotinsky notes that especially during the Revolution, the spiritual melancholy of pictorialism provided an escape from political and economic realities. Deborah Dorotinsky Alperstein, "El género y la mascarada en la fotografía de María Santibáñez," *Revista do Instituto de Estudos Brasileiros* 71 (December 2018), 137. All cited essays can be found online.

10. Dorotinsky, "El género y la mascarada," 136.

11. *Mexicanidad*, a term is often translated as Mexicanness, implies a racial or cultural quality that is inherent or even spiritual, based as it is on the ideas of Manuel Gamio and José Vasconcelos, among others. By contrast, Roland Barthes used an advertisement for pasta as his point of departure for theorizing "Italianicity." "Rhetoric of the Image," in *Image, Music, Text*, ed. and trans. Stephen Heath (New York: Hill and Wang, 1977), 32–51.

12. The calla lily, watermelon (cut open to reveal its nationalist colors), and coconut palm are also common emblems in these images, though none are native to Mexico.

13. In this essay, I do not explore how images in general were cropped, framed, and collaged on the printed page or even postcard, though such manipulations also guided meaning.

14. Chronological frameworks—at least from a United States perspective, which is only part of the story told here—are emphasized in both Andrea Boardman, *Destination México: 'A Foreign Land A Step Away'*: U.S. Tourism to Mexico, 1880s–1950s (Dallas: DeGolyer Library, Southern Methodist University, 2001) and my own *South of the Border: Mexico in the American Imagination, 1914–1947* (Washington, DC: Smithsonian Institution Press, 1993).

15. Photobooks, book and magazine covers, calendar art, and postcards—all image-based products that relied on evolving reproduction technologies—have received recent attention. See *La leyenda de los cromos: el arte de los calendarios mexicanos del siglo XX en Galas de México* (Mexico City: Museo Soumaya, 2000); Horacio Fernández, *The Latin American Photobook* (New York: Aperture, 2011); *Mexico Illustrated, 1920–1950*, ed. Salvador Albiñana (Mexico City: Consejo Nacional para la Cultura y las Artes; Editorial RM, 2014). On postcards, see note 20. Nevertheless, the history of printing and distribution networks in Mexico remains fragmentary, generally to be found in blogs and websites rather than scholarly publications.

16. On the newspapers, see Rebeca Monroy Nasr, "Fotoperiodismo en el despertar del siglo XX mexicano: bajo la mirada del dictador," *Caravelle* 97 (2011): 87. On Ruhland & Ahlschier, see Arturo Guevara Escobar's comprehensive index: http://losprotagonistas-tarjetaspostales.blogspot.com/2012/01/letra-r-fotografos-y-productores-de.html.

17. See Susan Toomey Frost, *Timeless Mexico: The Photographs of Hugo Brehme* (Austin: University of Texas Press, 2011), 23.

18. Richard Benson, *The Printed Picture* (New York: The Museum of Modern Art, 2008), 228. See also David Pankow, *Tempting the Palette: A Survey of Color Printing Processes* (Rochester, NY: RIT Cary Graphics Arts Press, 2005).

19. The illustration compares a "romantic" sarape-clad guitarist to a standing and grimacing capitalist, a caricature with anti-Semitic features.

20. It is not always a simple matter to identify specific printing techniques. Metal photolithographic or halftone plates sometimes leave crisp lines on the margins (see, for example, the covers of *Arte y letras*); Benson, Pankow, and Petrulis (see notes 18 and 21) provide other visual clues, sometimes requiring a magnifying glass.

21. Postcards are perhaps the most studied of any commercial media in Mexico. See Guevara Escobar (note 16) and Isabel Fernández Tejedo, *Recuerdo de México: la tarjeta postal mexicana, 1882–1930* (Mexico City: Banobras, 1994); Teresa Matabuena Peláez et al., *Percepciones de México: a través del uso de la tarjeta postal* (Mexico City: Universidad Iberoamericana, 2014) and *Percepciones de México II: a través del uso de la tarjeta postal* (Mexico City: Universidad Iberoamericana, 2015); and the 1999 issue of *Artes de México* dedicated to the topic. See also Alan Petrulis, "A Guide to Color on Postcards," http://www.metropostcard.com/guidecolor.html.

22. Women were often employed in this occupation, but René d'Harnoncourt, later the director of The Museum of Modern Art, briefly

worked hand-painting postcards soon after emigrating to Mexico in 1926. Robert Fay Schrader, *The Indian Arts & Crafts Board: An Aspect of New Deal Indian Policy* (Albuquerque: University of New Mexico Press, 1983), 124.

23. Often a single color—pale green, say—was used for accents throughout the interior. Some magazines with a healthy budget—often federally funded—included color plates on the covers and in the interior spreads, among them *Irrigación en México* (1930–1946), produced by the Comisión Nacional de Irrigación, and *Nuestra Ciudad* (1930), a luxurious publication of the Mexico City government.

24. See, among other sources, Marion Gautreau, "*La Ilustración Semanal* y el Archivo Casasola: Una aproximación a la desmitificación de la fotografía de la Revolución Mexicana," *Cuicuilco* 14, no. 41 (September–December 2007): 113–142; and Daniel Escorza Rodríguez, "Arte y fotografía en la prensa mexicana. La primera exposición de arte de los fotógrafos de prensa," *L'Ordinaire des Amériques* 219 (2016). Many serials—*Jueves de Excélsior, Mapa, Todo, Boletín del Club de Viajes Pemex*—resisted the shift to color, whether for aesthetic or economic reasons.

25. Arturo Ávila Cano and José Antonio Rodríguez, "Pionero de la fotografía a contraluz," *El Universal*, May 2, 2016, https://www.eluniversal.com.mx/articulo/cultura/artes-visuales/2016/05/2/carlos-munana-un-pionero-de-la-fotografia-contraluz; see also José Antonio Rodríguez, Brenda Ledesma, and Arturo Ávila Cano, *100 años de fotografía en* El Universal (Mexico City: Secretaría de Cultura, 2016).

26. Since its acquisition by Grupo Carso, Galas de México has been featured in several publications (see note 15). Alvárez Tostado (1886–1948) was a press photographer during the Revolution, but there is little published on his prolific business, Tostado Grabador, housed after 1924 in a neocolonial building by Federico Mariscal.

27. On this image, see Ariel Arnal, "Construyendo símbolos: Fotografía política en México: 1865–1911," *Estudios Interdisciplinarios de América Latina y el Caribe* 9:1 (January–June 1998); Mayra Mendoza, "El Zapata de Brehme: el análisis de un caso," *Alquimia* 36 (May–August 2009): 83–85; Arturo Guevara Escobar, "En busca del fotógrafo de Zapata" (2010), http://fotografosdelarevolucion.blogspot.mx/.

28. To cite just one example, the March 24, 1924 cover of the magazine *Don Quijote* includes a photographic portrait of actress Emilia del Castillo, printed as a photogravure and pasted—by hand—to the gray rag paper cover. Specific credit is given to the photoengraver (A. Busnega or Buznega) and the printer, American Book, a company that later evolved into Byron C. Hill's American Bookstore (1927), but not the photographer, who might be Antonio Garduño, as he is credited throughout the interior spreads.

29. See *Manuel Álvarez Bravo in Color*, Aurelia Álvarez Urbajtel, James Oles, and Ramón Reverté, eds. (Mexico City: RM, 2020).

30. By the 1940s, photographs had become increasingly common on Mexican calendars, though paintings by the likes of Jesús Helguera and Eduardo Cataño would be more resilient than some might have expected. This was true on magazine covers as well, with some mass-market publications—*Revista de Revistas; Hoy*—using caricature and hand-drawn illustrations for decades, reminding us that modernity was often, but not always, photographic.

31. On this issue, see Stacie G. Widdifield's discussion of José Obregón's *The Discovery of Pulque* (1869) in *The Embodiment of the National in Late Nineteenth-Century Mexican Painting* (Tucson: University of Arizona Press, 1996), 130.

32. This is a complex topic, for different costumes connote different things to different people, and it is part of a wider study on the history of cross-cultural cross-dressing in twentieth-century Mexico. Frida Kahlo is surely the most famous of these cultural cross-dressers, though she adopted the practice as late as 1933, well after Anna Pavlova, María Conesa, Rosa Rolando, Aurea Procel, and other cultural figures had appeared publicly in the costume of the *Tehuana, china poblana*, or other rural or indigenous types. On Pavlova, and how the social practices of Mexico's rural underclass were refined for bourgeois audiences, see José L. Reynoso, "Choreographing Modern Mexico: Anna Pavlova in Mexico City," (1919) *Modernist Cultures* 9, no. 1 (May 2014), 80–98. See also Jocelyn Olcott, "'Take off that streetwalker's dress': Concha Michel and the Cultural Politics of Gender in Postrevolutionary Mexico," *Journal of Women's History* 21, no. 3 (2009), 6–59.

35

FOTO CHINO PEREZ LA CHINA POBLANA

Illustrations from page 1 to 13:

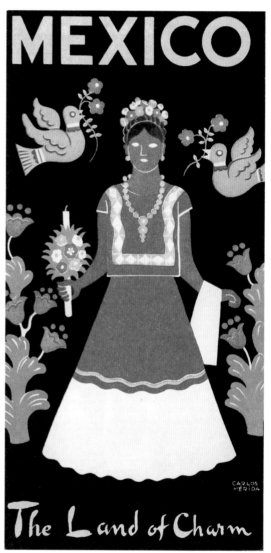

36

Mexico. The Land of Charm
First edition, 2022

Edition
Mercurio López Casillas

Creative Direction and Layout
Mercurio López Casillas
José Luis Lugo
Ramón Reverté

Editorial Direction
Mara Garbuno

Design
José Luis Lugo

Proofreading / Copy editing
Hanna Townsend
The Pillow Books

Translation
Toni Crabb
The Pillow Books

Scanning
Agustín Estrada, Araceli Limón,
Ana Belén Jarrin, Pablo López Luz,
Mahala Marcet

Photography, and prepress
Agustín Estrada & Araceli Limón

© **Texts**
Steven Heller
Mercurio López Casillas
James Oles

© **Illustrations**
The authors

Collections
Mercurio López Casillas MLC
Ramón López Quiroga RLQ
James Oles JO
Ramón Reverté RR
Museo Soumaya MS
Biblioteca Salvador Albiñana | BSA
Biblioteca Privada Valencia | BPV

© **2022**
RM Verlag, S.L.
c/ Loreto, 13-15 Local B
08029 Barcelona, Spain
www.editorialrm.com

© **2022**
Editorial RM, S.A. de C.V.
info@editorialrm.com

ISBN RM Verlag: 978-84-17975-51-7

Legal deposit: B 14307-2021

RM #411

Printed in Spain
Brizzolis, arte en gráficas

Cover
Oaxaca Plume dancers, s/f.
Drawing by Miguel Covarrubias
© María Elena Rico Covarrubias.

Acknowledgments
RM would like to thank Ramón López Quiroga Gallery,
Mercurio López Casillas, Salvador Albiñana and Museo
Soumaya for their invaluable support to this publication.
Without them, and without Mexico's antique book
salespeople, this publication would not have been possible.
We dedicate this book to the latter in order to make their
work visible, which is seldom recognized but so important for
preserving Mexican culture.

MEXICO. THE LAND OF CHARM

Was printed at Brizzolis, in Madrid, Spain.
Swift and Paneuropa fonts were used in its design.
4,250 copies were printed. Mexico. MMXXII.